Railroad Vision

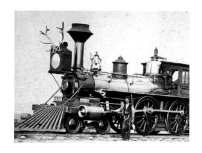

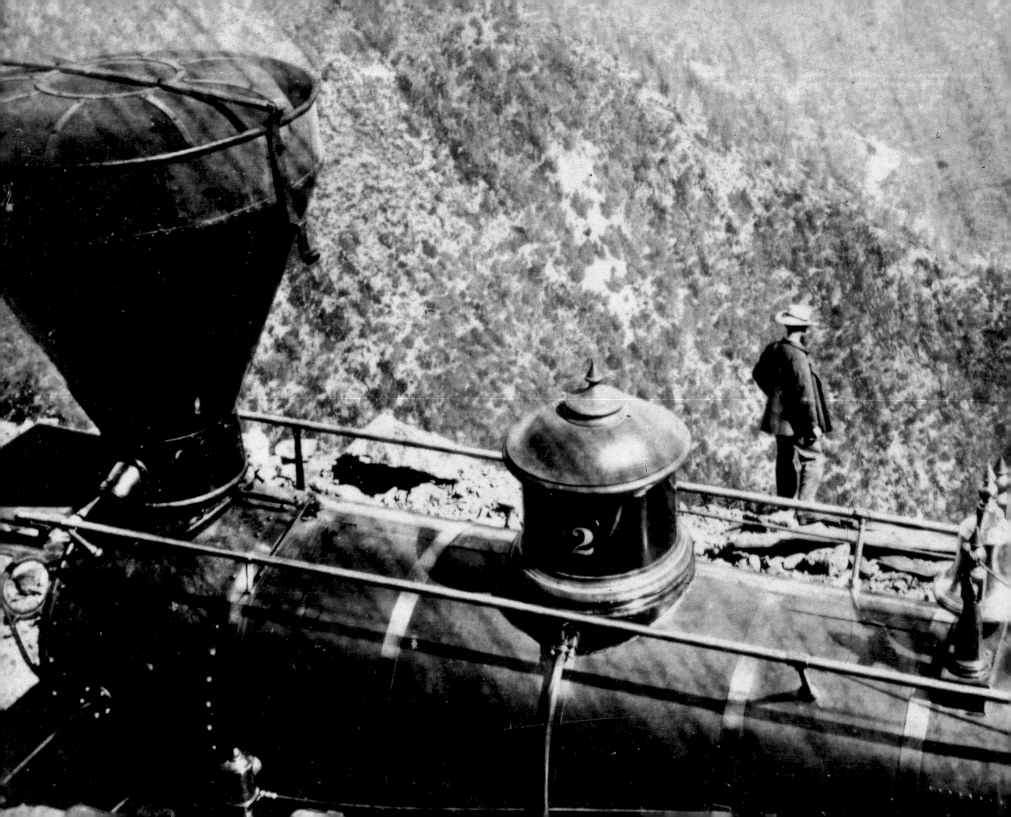

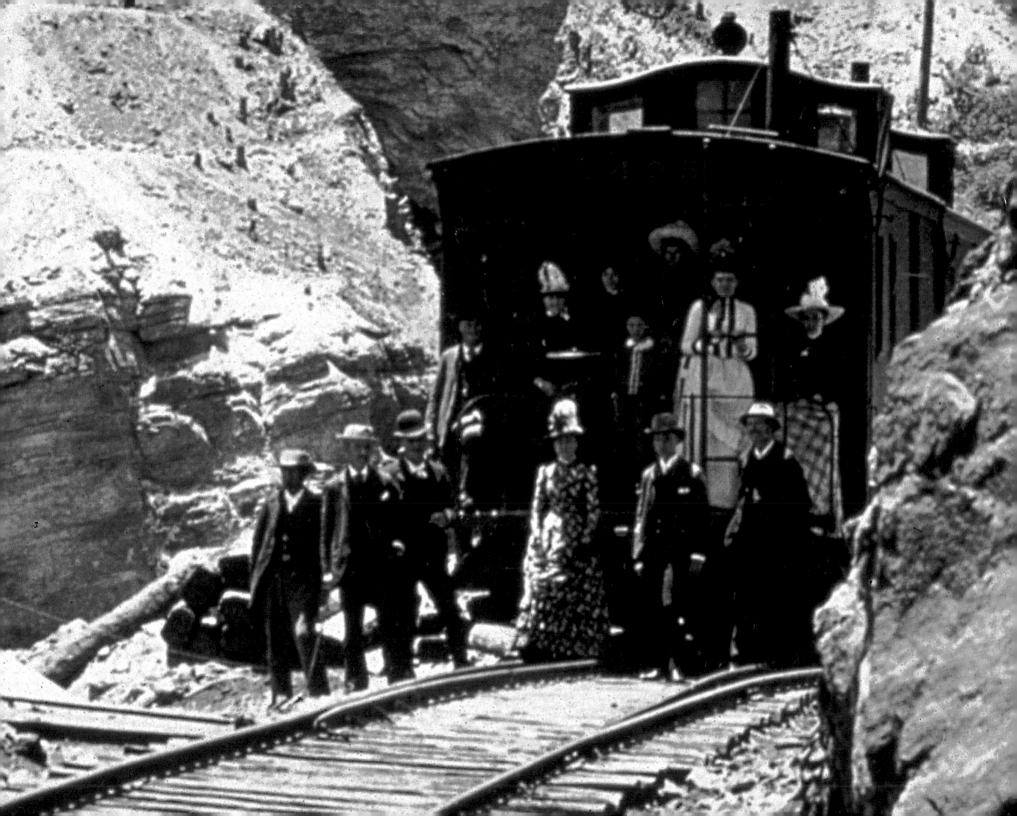

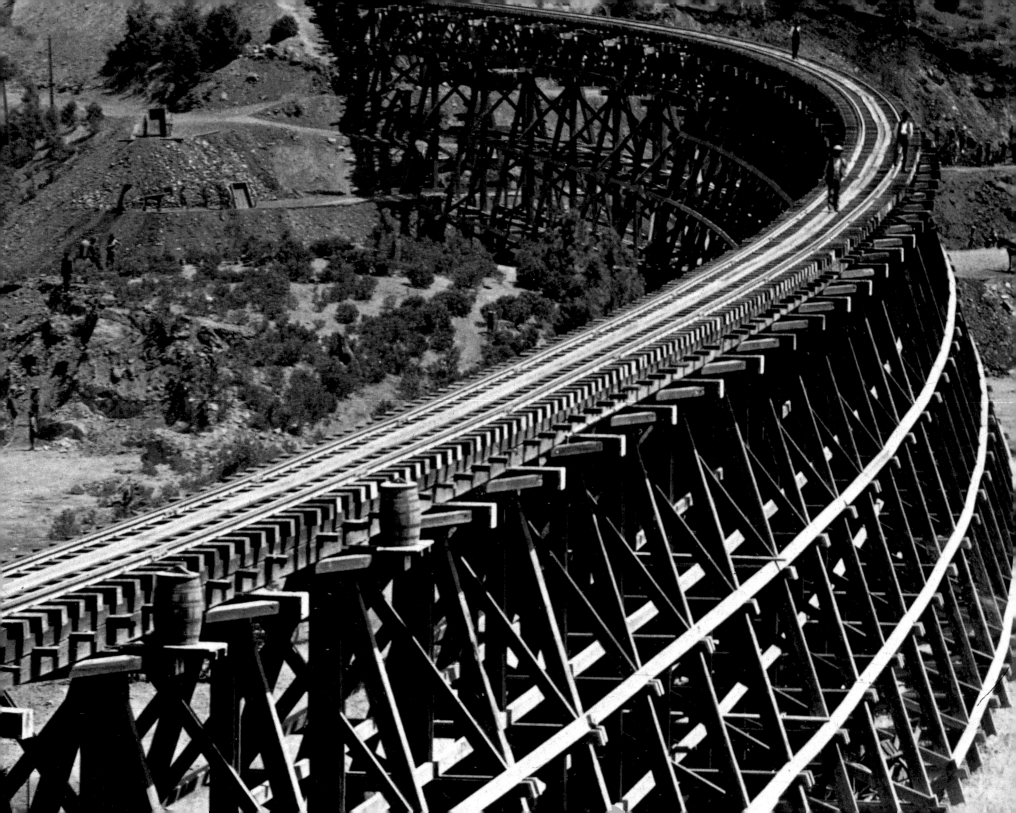

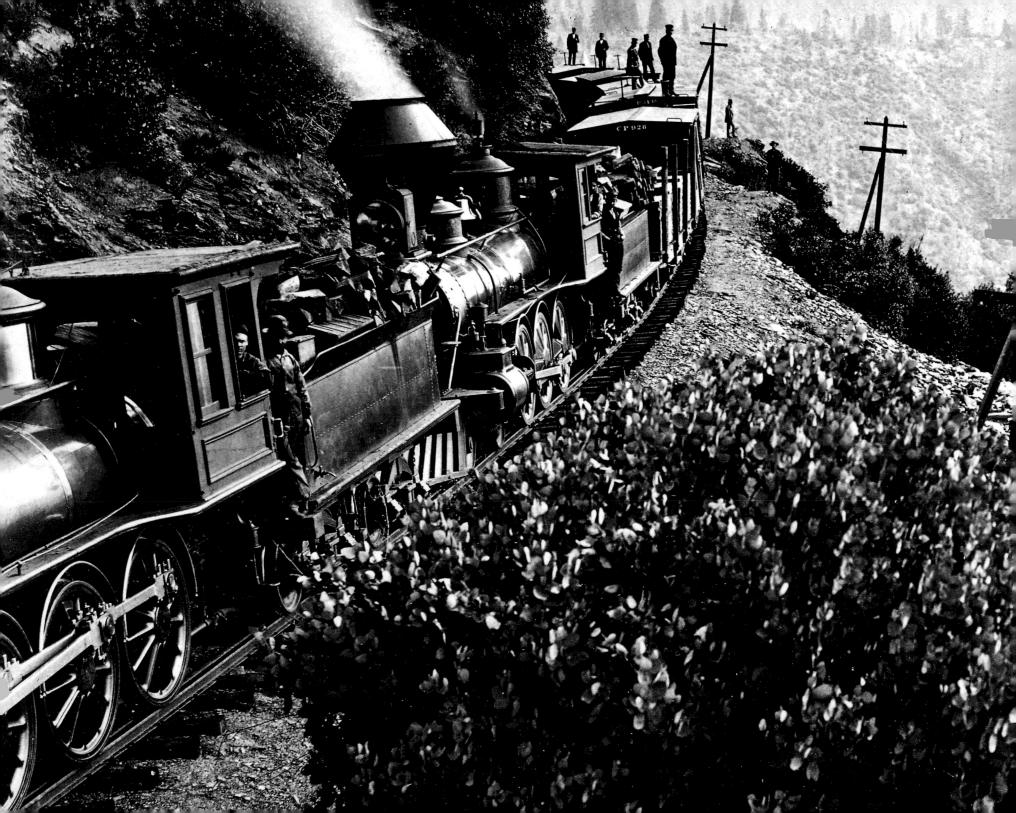

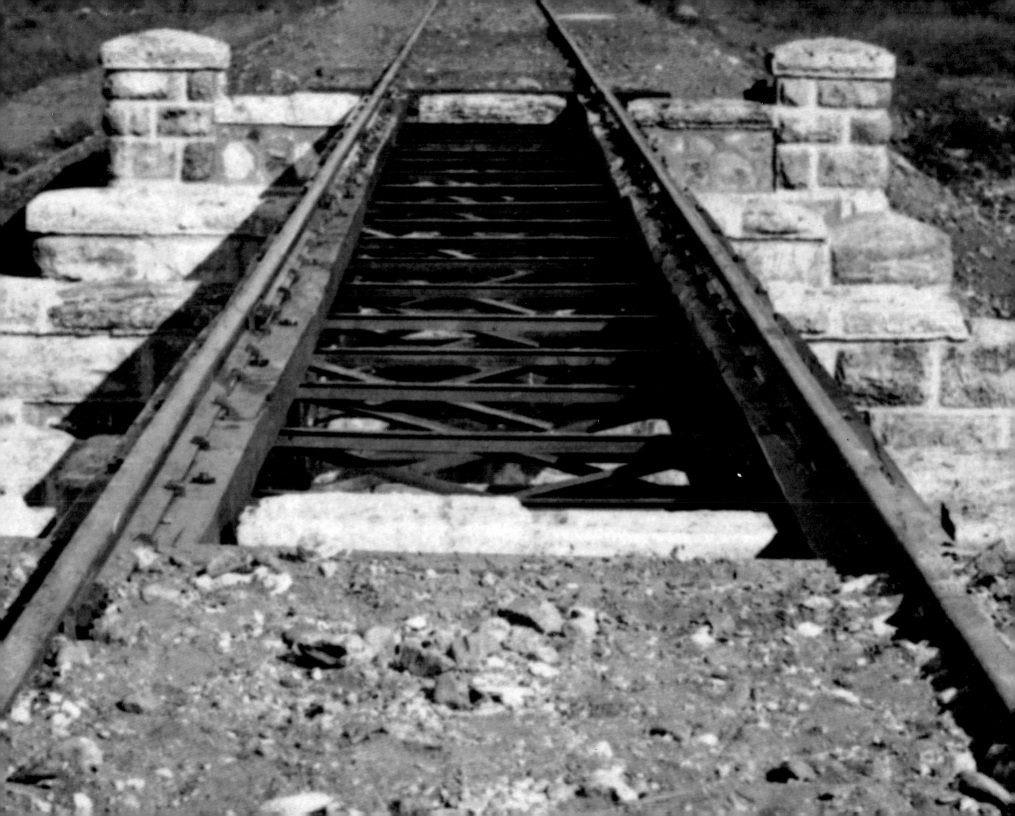

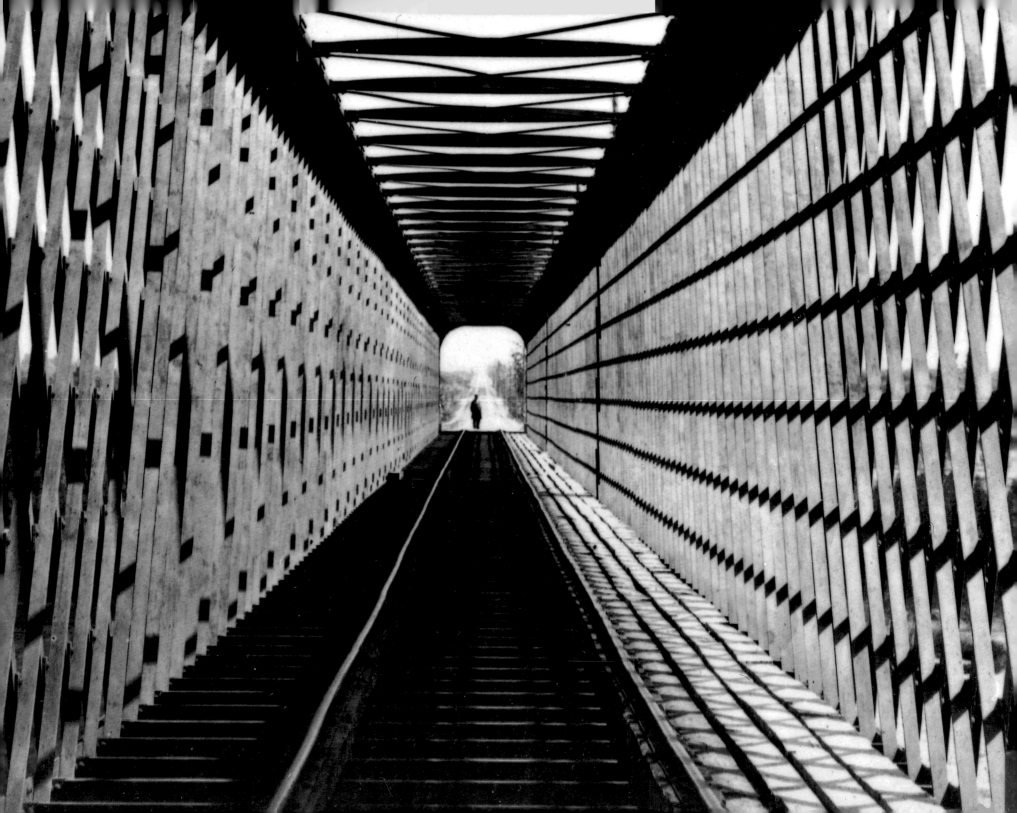

Railroad Vision

Photography, Travel, and Perception

ANNE M. LYDEN

The J. Paul Getty Museum
Los Angeles

© 2003 J. Paul Getty Trust

Getty Publications
1200 Getty Center Drive
Suite 500
Los Angeles, California 90049-1682
www.getty.edu

Christopher Hudson, Publisher
Mark Greenberg, Editor in Chief
Ann Lucke, Managing Editor

PROJECT STAFF
John Harris, Editor
Jim Drobka, Designer
Stacy Miyagawa, Production Coordinator
Christopher Allen Foster, Photographer

Typography by Diane Franco
Printed by Arti Grafiche Amilcare Pizzi, S.p.A., Milan, Italy

Unless otherwise specified, all photographs are courtesy
of the institution owning the work illustrated.

FRONT COVER
William and Frederick Langenheim. *Niagara Falls, Summer View: Suspension Bridge
and Falls in the Distance*, ca. 1855–56. See PLATE 2.

BACK COVER
Willy Zielke. *Untitled (Railroad Tracks)*, ca. 1933–35. See PLATE 79.

DETAILS
p. i: A. J. Russell. *Wyoming Station, Engine 23 on Main Track*, May 1868. See PLATE 12.
p. ii: Alfred A. Hart. *View of the Forks of the American River, 3 miles above Alta*. Negative:
 after August 1867–1869; printed by Carleton Watkins after 1870. See PLATE 20.
p. iii: William Henry Jackson. *Cameron's Cone from "Tunnel 4,"* 1887–89. See PLATE 56.
p. iv: Carleton Watkins. *Trestle on the Central Pacific Railroad*. Negative: ca. 1877;
 print: ca. 1880. See PLATE 33.
p. v: Carleton Watkins. *Cape Horn, C.P.R.R.*, ca. 1878–85. See PLATE 69.
p. vi: Carleton Watkins. *View on Lake Tahoe*, 1877. See PLATE 35.
p. vii: Unknown photographer. *View of Railroad, Turkey*, 1880s. See PLATE 77.
p. viii: Juan Laurent. *The Zuera Bridge*, ca. 1867. See PLATE 45.
p. xvi: Unknown photographer. *"Locomotion,"* ca. 1870. See PLATE 1.
p. 6: John Stuart. *Nielson Locomotive Engine (Caledonian Railway)*, 1870. See PLATE 5.
p. 36: A. J. Russell. *Trestle Work, Promontory Point*, 1869–70. See PLATE 34.
p. 78: William Henry Jackson. *Dale Creek Bridge, U.P.R.R.*, 1887–93. See PLATE 55.
p. 114: Willy Zielke. *Untitled (Railroad Tracks)*, ca. 1933–35. See PLATE 79.

LIBRARY OF CONGRESS CATALOGING-IN-PUBLICATION DATA

Lyden, Anne M.
 Railroad vision : photography, travel, and perception / Anne M. Lyden.

 p. cm.
 ISBN 0-89236-726-1 (hardcover)
 1. Photography of railroads. I. Title.
 TR715.L93 2003
 779'.9385--dc21

 2003005580

Contents

Foreword

"WITH LESS THAN ONE-TWELFTH of the world's population and little more than one-third of its area, North America has nearly one-half of the world's railway mileage and far more than one-half of the aggregate railway capacity to move passengers and freight." So we are informed by W. J. Cunningham, who was Professor of Transportation at Harvard University. It may be noteworthy that Harvard's Governing Boards considered the field of transportation as being worthy of a named professorship in 1942, when Professor Cunningham occupied his position. The century leading up to 1942 had seen the rise of the United States as an industrial force and tourist destination. Nowhere else on earth did railroads and photography advance so completely side by side, mutually reinforcing each other. It is no surprise to learn that, of the photographs of railroads in the Getty's collection, images of the American railroad system constitute the single largest holding, and many of them are published for the first time in this book.

John Plumbe, who later became an accomplished photographer, first publicly articulated the idea of a continuous line of steel track over which a locomotive pulling railway cars could travel from the Atlantic to the Pacific coast. Publishing this bold proposal in 1836, when photography was still a dream in the minds of its European inventors, Plumbe spent enormous time and money aggressively promoting the notion of a coast-to-coast rail route, an idea that was ahead of its time and that would ultimately drive him to suicide.

In large part due to Plumbe's photographic activity, the United States Congress in March 1853 appropriated funds specifically to explore the western states to locate "the most economical and practical route for a railroad to the Pacific from the Mississippi." General John C. Fremont, who was already famous for his 1844 expedition across the continent, was assigned to this task in 1853. Informed by the work of Plumbe, Fremont engaged the photographer S. N. Carvalho to make daguerreotypes along the route of the expedition. These pioneering photographs do not survive today. We know of their existence only through written documents, and it is left to our imaginations to picture how the earliest photographers recorded the "blankness of desolation [and] the majesty of loneliness" that were the most compelling emotions recorded by overland voyagers after the transcontinental railroad became reality.

The mutually reinforcing relationship between railroads and photography in America coincides with the completion of the 1,848 miles of track that were laid between Omaha, Nebraska, and Sacramento, California, between 1863 and 1869. On May 10, 1869, a golden spike was hammered in at Promontory Summit, Utah, thus completing the first transcontinental railroad and marking the beginning of a new era in American history. The Manifest Destiny of this country—what was perceived as an ordained right to settle and populate the west—was a driving force behind the growth

and development of the American railroads. The photographs that proliferated were intended to promote the landscape and entice prospective settlers.

Although the Getty Museum's collection of railroad photographs is abundant in American prints, it also includes images from countries as diverse as Austria, Brazil, and France. Some of these railroad regions of the world are represented in this book, and it is interesting to note the similarities and unifying elements of these photographs that constitute "railroad vision."

The Getty's collection of photographs was acquired over the years from various collectors, donors, and dealers, who themselves possessed vision when it came to recognizing and celebrating the historical and aesthetic importance of railroad photographs. Perhaps the earliest collectors to fully grasp the connection between the two subjects were André and Marie-Thérèse Jammes, who provided many of the rare French railroad prints by Édouard Baldus and Hippolyte-Auguste Collard. Samuel Wagstaff of New York became the first American to aggressively collect the work of Baldus after being introduced to it by Mr. and Mrs. Jammes in the 1970s. In addition to the French work, Wagstaff enjoyed an interest in American history, and to him we owe the presence in the collection of prints by A. J. Russell, Alfred A. Hart, Carleton Watkins, C. R. Savage, William Henry Jackson, William H. Rau, and Alfred Stieglitz. Another astute collector to whom we owe much is Arnold Crane, from whom we acquired historically important photographs by A. J. Russell, Alexander Gardner, and Walker Evans. Daniel Wolf, in his capacity as a collector, dealer, and agent for other collectors, was the source for twenty-two photographs reproduced here, including seven William Henry Jackson images and three by William H. Rau, and individual works by Gustave Le Gray, A. J. Russell, and Carleton Watkins. Through Wolf we acquired the Larry Gottheim collection of the work of Frederick and William Langenheim, including the dazzling hand-colored glass stereograph that is reproduced on the cover of this book. To all of these, as well as to the many unsung heroes in the field of collecting and dealing in rare photographs, we express our continued appreciation and respect.

Weston Naef
Curator of Photographs

Acknowledgments

In the spring of 2000 I began working on the idea of exploring the relationship between photography and the railroads—two nineteenth-century innovations with a tremendous impact on today's society. This small idea grew into a large exhibition entitled *Railroad Vision*, which featured ninety works of art drawn mainly from the J. Paul Getty Museum's fine holdings of nineteenth- and twentieth-century photographs. The majority of the prints reproduced in this publication were in the original display at the Museum from March 5 through June 22, 2002. I hope that in the following pages the images will be enjoyed once more.

I would like to begin by thanking Deborah Gribbon, Director of the J. Paul Getty Museum, for her support of both projects. Many thanks are due to Weston Naef, Curator of Photographs, whose initial enthusiasm encouraged me to research the subject and ultimately led to the development of the exhibition and book. His knowledge and input throughout both projects were extremely helpful. My colleagues in the Department of Photographs proved invaluable in assisting me with the innumerable tasks, and their support, not to mention their sense of humor, kept me going time and time again. I extend my grateful thanks to Judith Keller, Gordon Baldwin, Julian Cox, Mikka Gee Conway, Michael Hargraves, Marisa Nuccio, Valerie Graham, Brett Abbott, Paul Martineau, Tami Simonian, and volunteer LeeAnn Brown. Beyond my immediate office environs, special recognition is due to the Department of Paper Conservation: Marc Harnly, Ernie Mack, Lynne Kaneshiro, Teruko Burrell, and Erin Murphy, all of whom worked diligently in preparing the prints for both the exhibition and publication. They are an amazing team. I would also like to express my appreciation to Ann Marshall, Michael Lira, Jack Ross, Christopher Allen Foster, Rebecca Vera-Martinez, Susan Logareci, Susanne Winterhawk, Amelia Wong, Irene Lotspeich Phillips, Fran Terpak, and the staff of the Special Collections at the Getty Research Institute. This book was made possible by the diligent efforts of several members of the staff from Getty Publications: Jim Drobka, John Harris, Andrea Mackenzie, Stacy Miyagawa, and Mark Greenberg. I offer my appreciation to them all.

In the course of researching the exhibition and book I was helped by many individuals from institutions around the country and in the United Kingdom. I am extremely grateful to everyone involved: Kyle Williams Wyatt, California State Railroad Museum, Sacramento; Bill Deverell, California Institute of Technology, San Marino; Jennifer Watts, The Huntington Library, San Marino; John Van Horne and Sarah Weatherwax, The Library Company, Philadelphia; Malcolm Daniel, The Metropolitan Museum of Art, New York; Peter Galassi, Susan Kismaric, and Sarah Hermanson Meister, Museum of Modern Art, New York; Brian Liddy and Russell Roberts, National Museum of Photography, Film, and Television, Bradford, England; Ed Bartholomew and Dieter Hopkins, National Railway Museum, York, England; Kate Ware, Philadelphia Museum of Art; Karen Sinsheimer and Marshall Price, Santa Barbara

Museum of Art; Amanda Barth, TravelTown, Los Angeles; and Violet Hamilton, Wilson Center for Photography, London, England. Thanks are due to the many individuals, private collectors, and artists who shared time, energy, and information and made invaluable contributions to the project: Val Bass, Mr. and Mrs. Michael Blasgen, Ron Hollander, Jim Hsieh, Janet Lehr, Nick Lera, Theresa Luisotti, Mark Ruwedel, Roger Taylor, Steve VanDenburgh, Mr. and Mrs. Stephen White, and Mr. and Mrs. Michael Wilson.

Special thanks are also due to Douglas Nickel, Director, Center for Creative Photography, Arizona, and John Gruber, President, Center for Railroad Photography and Art, Madison, Wisconsin, both of whom carefully read over my manuscript, offering insightful comments and suggestions. I would like to express my sincerest gratitude to Jim Wilke for his extensive knowledge and excellent research on railroad history and design. His generous sharing of information provided important and vital contributions to this book.

I would like to thank the many friends who offered inspiration and support, in spite of my constant (and no doubt annoying!) railroad puns. I am grateful to them all, especially Ewan Clow, Elizabeth Escamilla, Carl Lawton, Beth Morrison, and Julie Rosenberg. Finally, some personal and heartfelt thanks to my family, especially Mum, Dad, Claire, and last, but by no means least, Christopher. Thank you.

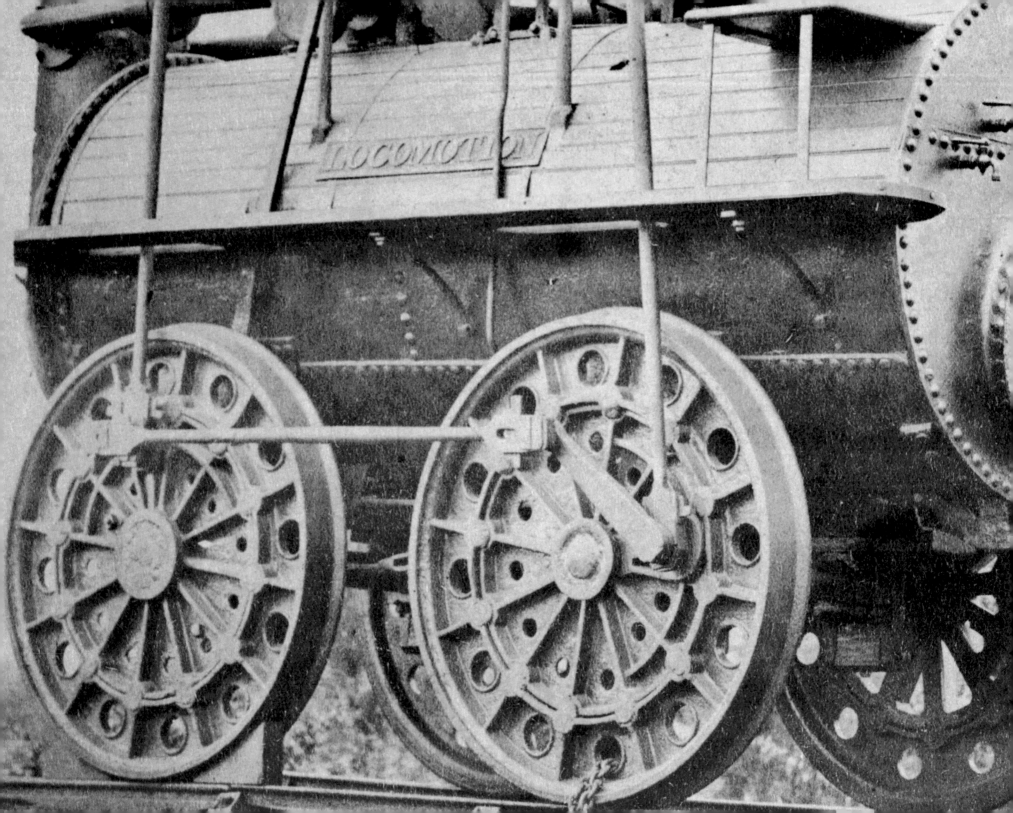

"Railroad Vision"

ROM ITS BIRTHPLACE IN ENGLAND, the railroad quickly spread around the world as a revolutionary form of transportation. By 1839, fourteen years after the appearance of the first public passenger train, another significant technical innovation had appeared: photography. These two phenomena redefined the relations between space, time, and distance; in so doing, the railroad and photography created a cultural phenomenon that may be called "railroad vision."

The notion of "vision ferroviaire," or railroad vision, was first discussed by the French scholar Clément Chéroux in 1996 as an instantaneous perception that is simultaneously fragmented and focused.[1] The idea of railroad vision came up again in the writing of Douglas R. Nickel in his publication on nineteenth-century photographer Carleton Watkins. Nickel describes railroad vision as "the semicontinuous, flattened, enframed but open-ended treatment of landscape."[2] One cannot focus on the immediate foreground, which rushes by as a blur; instead, one looks beyond to a great panoramic distance. As Nickel explains, railroad vision is essentially photography's

capacity to replicate and simulate the view of the world from the window of a train. But arguably it is much more than that. Railroad vision is the social history of the railroad as documented through photography; it also offers a unique visual perspective. It is a distinct way of looking at the world. Over the years the railroad has been a vehicle for social and political change in modern society, and photography, as a visual medium that defines the physical world, has had an important bearing on how we see ourselves in this society and how our perceptions continue to evolve. In short, this mutually beneficial relationship has shaped our experience of the modern world.

To fully appreciate how revolutionary the two technologies were, one need only consult writings from the period. In March 1825 the British journal the *Quarterly Review* thought it "palpably absurd and ridiculous" that locomotives would ever travel twice as fast as stagecoaches and commented: "As to those persons who speculate on making railways general throughout the kingdom, and superseding all the canals, all the waggons, mail, and stage-coaches, post-chaises, and, in short, every other mode of conveyance by land and by water, we deem them and their visionary schemes unworthy of notice."[3]

FIGURE 1 Follower of Jan Siberechts (Flemish, 1627–1703). *River Landscape with Carriage Drawn by Six Horses*, ca. 1674. Oil on canvas, 81 × 95 cm (31⅞ × 37⅜ in.). Los Angeles, J. Paul Getty Museum, 78.PA.224.

Before long it would become impossible for people *not* to notice the growing presence of the railroad in their lives. The same year this passage appeared in the *Quarterly Review*, George Stephenson's steam engine Locomotion (PLATE 1) first journeyed from Stockton to Darlington in the north of England, traveling at the speed of fifteen miles per hour, which observers considered amazingly fast by comparison to travel by foot or by horse and wagon. For the passengers aboard this vehicle, the experience was unlike any other. The event marked the beginning of the railroad age. In a letter dated August 26, 1830, the actress Fanny Kemble wrote about traveling by train: "You cannot conceive what that sensation of cutting the air was; the motion is as smooth as possible too.... When I closed my eyes this sensation of flying was quite delightful, and strange beyond description."[4] In the twenty-first century it is hard to imagine the revolutionary nature of this new mode of transportation and the impact it had on the physical landscape, politics, and culture of the time.

Prior to the advent of the railroad, few people were able to travel great distances. Those who did venture far generally measured the journey in days rather than hours. The traditional modes of transportation—walking, riding, traveling by boat or barge—were very much connected to the flow of nature (FIGURE 1). The pace of a journey was dictated by the strength of man or beast or the physical characteristics of the natural environment, such as wind or tide. This "organic" pace was completely shattered with the introduction of the steam locomotive, which was faster, mechanized, and detached

from nature.[5] With this detachment came a completely different understanding of space, time, and distance, to the point where people were utterly amazed at the prospect of traveling by steam engine. The physical momentum of man or beast was intuitively understood, but steam locomotion was a new phenomenon, its exact mechanical workings largely unknown, even invisible. In a bid to understand steam power, people often made an analogy between the new form of transportation and the old: many initial accounts refer to the steam engine as a living beast, an "iron horse."[6]

Traveling at up to three times the speed of a stagecoach, the early locomotives were able to cover greater distances in much less time. In discussing the completion of the Liverpool and Manchester Railway in 1830 (FIGURE 2), company secretary Henry Booth remarked on "the sudden and marvellous change which has been effected in our ideas of time and space.... Speed—dispatch—distance—are still relative terms, but their meaning has been totally changed within a few months: what was quick is now slow; what was distant is now near, and this change in our ideas will not be limited to the environs of Liverpool and Manchester—it will pervade society at large."[7]

When the invention of photography was announced to the world in 1839, some fourteen years after the first passenger train, it too was hailed as an innovation that would revolutionize the world.[8] In March 1839 the British periodical *The Spectator* declared: "An invention has recently been made public in France that seems more like some marvel of a fairy tale or delusion of necromancy than a

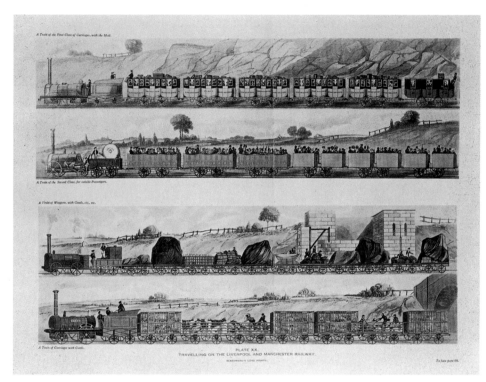

FIGURE 2 Unknown artist. *Traveling on the Liverpool and Manchester Railway.* Lithographic print. London, Private Collection/Bridgeman Art Library.

practical reality: it amounts to nothing less than making light produce permanent pictures, and engrave them at the same time, in the course of a few minutes. The thing seems incredible, and, but for indisputable evidence, we should not at first hearing believe it; it is, however, a fact."[9] Again there is the sense of the fantastic, this time in reference to photography and the workings of the camera. Most people were unaware of the technology that allowed steam engines to run; they were equally ignorant of the technical processes that made possible the creation of photographic pictures through the agency of light. The new invention offered the public a means of recording the physical world with remarkable clarity and truth and, in turn, marked a definitive shift in all previously held notions of perception, simultaneously providing "evidence" and a subjective interpretation of that evidence. While the birth of photography may have been seen as some kind of magic that was capable of sounding a death knoll to painting, the truth was less dramatic but just as profound.

Some writers made explicit the analogy between photography and railroads, acknowledging that both provided exciting new views of the world and both had the capacity to transport people: one by means of the iron rail, the other by the photographic prints. In 1866, the *Philadelphia Photographer* noted: "Nothing seems beyond the reach of photography. It is the railway and the telegraph of art.... The railways carry us to points afar, and so does photography—and it does more."[10] Earlier, in 1842, novelist Paul de Kock, writing about the French railroads, had stated: "Traveling by train isn't tiring, it's

a pleasure, a delight.... you sense yourself so smoothly moving along as to not be moving. You see trees, houses, villages, all passing before you, passing by more quickly than a magic lantern show—and that's all real, not an optical illusion!... The railroad is nature's own magic lantern."[11]

A population accustomed to travel by foot or horse and carriage initially responded to the railroad with reactions ranging from genuine curiosity to suspicion and fear. In response, pictures designed to simultaneously reassure and tempt the audience of potential passengers began to proliferate. The new medium of photography was employed to faithfully portray the steam locomotives, trains, wagons, tracks, bridges, tunnels, and stations. In a bid to increase ridership, railroad companies commissioned photographers to document scenic attractions and entice new settlers to the towns and dwellings springing up along the new routes. Photographers benefited from repeat sales of prints to the passengers who traveled the routes, and they developed an audience of armchair travelers who pored over the prints brought back by family and friends. All of this created a body of work that espoused certain ideals, followed particular patterns of composition, and created images that spoke of a railroad vision.

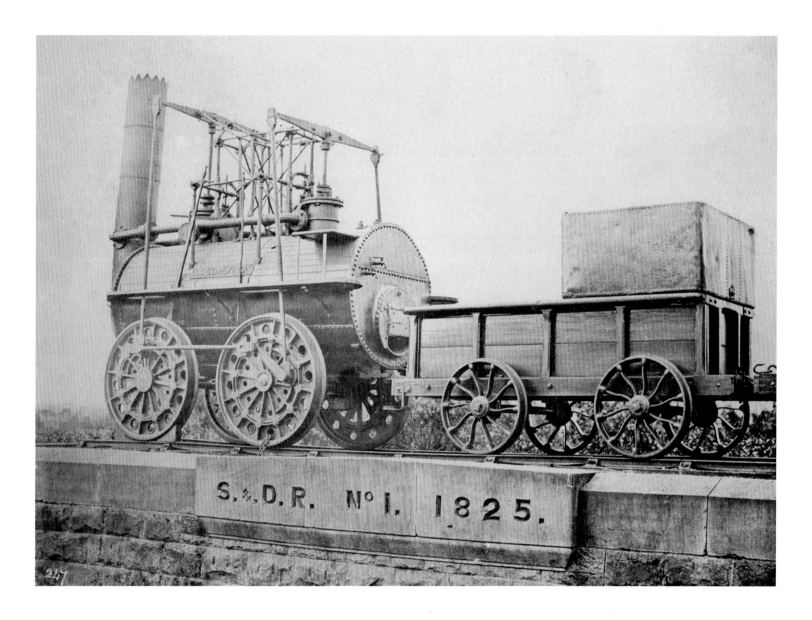

PLATE 1 Unknown photographer. *"Locomotion" Displayed on a Plinth at North Road Station, Darlington*, ca. 1870. Albumen silver print, 20.5 × 15.5 cm (8 × 6 in.). York, England, National Railway Museum/Science and Society Picture Library, 666/56.

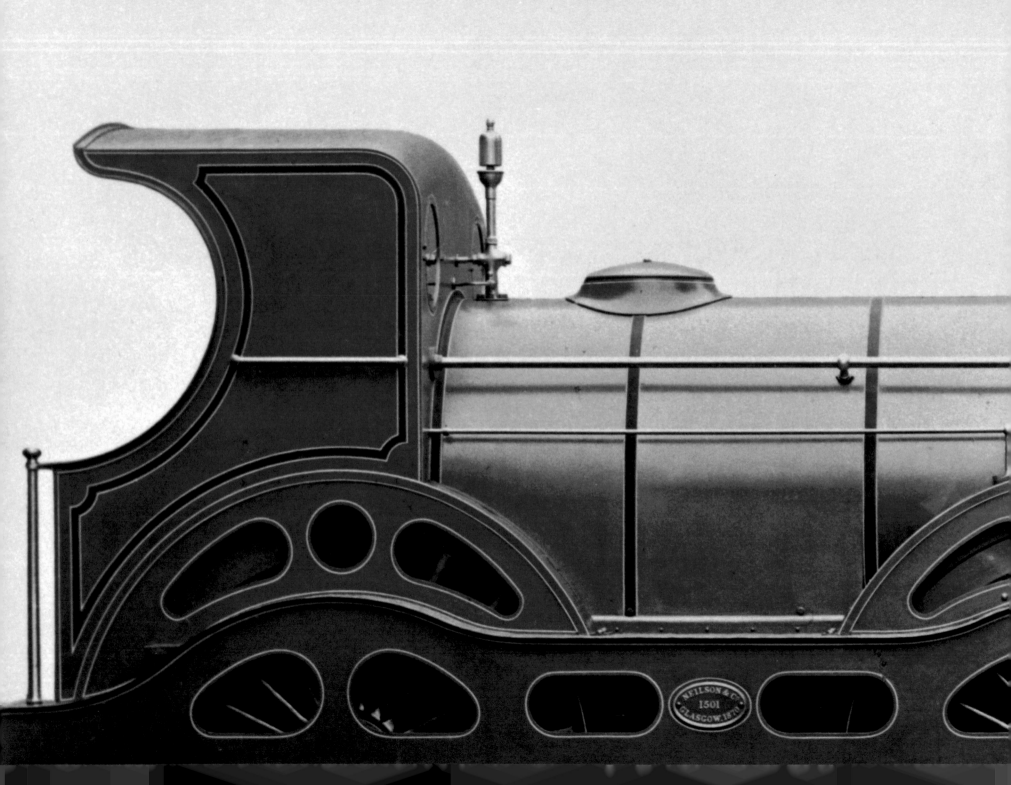

The Dawn of a New Age: Railroads and Photography

PHOTOGRAPHY UNIQUELY CAPTURED the spirit of this new railroad age, creating a reciprocal relationship that served many purposes, from business to pleasure. As visual documents of the successful growth and expansion of the railroad routes, photographs were used to attract financial backing and government support while tempting paying passengers to travel to the destinations—urban and rural—that were now accessible by train. Photography was particularly instrumental in developing the tourism industry, which emerged after the Englishman Thomas Cook organized his first excursion tour via railroad in 1841.[12] From then on, train travel was synonymous with tourism, and photography made possible visual records that served as works of art, promotions, and mementos.

An early example of photography inspired by rail travel is a series of stereographs made in America by the Langenheim brothers, William and Frederick. As the first commercial practitioners of the stereographic process in the United States, the Langenheims produced by hand more than eight hundred glass views, in addition to hundreds

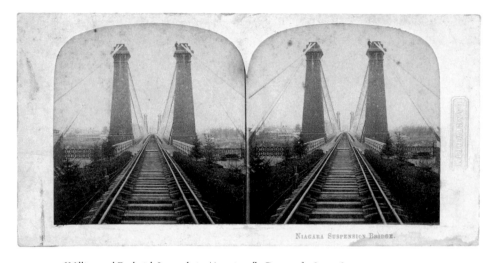

FIGURE 3 William and Frederick Langenheim (American [b. Germany], 1807–1874 and 1809–1879). *Niagara Suspension Bridge*, ca. 1856. Albumen silver print stereograph, 7.9 × 17.1 cm (3⅛ × 6¾ in.). Los Angeles, J. Paul Getty Museum, 2000.10.76.

of paper prints (FIGURE 3). The stereograph consists of two photographs mounted onto a support of either glass or cardboard. When viewed together in a stereoscopic device they produce a seemingly three-dimensional image, re-creating human binocular vision. In spite of the labor-intensive process, which required coating the glass plates and applying delicate touches of color by hand, the Langenheims were extremely prolific in producing fine-quality stereographs. Their

stereograph of the Niagara Suspension Bridge (PLATE 2) dates from 1855–56 and shows the newly built bridge with a locomotive crossing the Niagara River Gorge; in the background, just faintly visible, are the Niagara Falls. The small, hand-colored glass plate, an almost jewel-like object, was dependent upon transmitted light to illuminate the scene. When viewed in the stereoscope the small image became a three-dimensional panorama, fully encompassing the viewer's range of vision. In a sense, the viewer was transported into the actual scene, complete with its breathtaking view of the bridge suspended high above the river.

Designed by the engineer John A. Roebling (a pioneer in the development of suspension technology who also designed the Brooklyn Bridge), the Niagara bridge had two tiers, clearly visible in the Langenheim image; the lower level was for foot and vehicular traffic, while the upper level was for the railroad. On March 8, 1855, a large locomotive weighing twenty-three tons and bearing the name London became the first engine to cross the bridge, traveling at a speed of eight miles per hour.

By the mid-1800s Niagara Falls was a popular tourist destination, largely because of the expansion of the New York Central and Great Western railways. Although working independently of the railroad companies, the Langenheim Brothers traveled the various routes systematically, documenting the sights encountered along the way, with each picture intended to inform, delight, and satisfy a growing population of travelers and photography enthusiasts. Indeed,

a few years later, a photographer, most likely William England working under the auspices of the London Stereoscopic Society, made a larger print of the Niagara Suspension Bridge, adopting a viewpoint similar to the Langenheims' (see PLATE 3 and FIGURE 3). In both cases the photographers focused their attention on the large masonry towers, built in the style of the Egyptian Revival, to which the cables were tethered some 245 feet above the water. The viewer is able to get a sense of these monumental structures by the placement of the figures and the locomotive in the England print. The men are dwarfed by the steam engine in the center of the image, and yet the engine itself is lost amidst the immense structures. It is a deliberate composition, designed to convey the grandiose features and engineering design of the bridge and to emphasize the power of man over nature; even the impressive Niagara River Gorge and its mighty falls are no match for the path of the railroad.

Just as the American photographs by the Langenheim Brothers and William England celebrate the railroad and its achievements, so too do the prints made by James Mudd and John Stuart in Great Britain (PLATES 4-6). These photographs proudly portray the locomotives in their newly manufactured glory, fresh out of the workshop. In one (PLATE 4), Mudd shows an engine beneath the water tower of the Beyer Peacock and Company locomotive works based in Manchester. Established in 1854, the company manufactured many of the world's locomotives over many decades; more than eight thousand locomotives were built at the Gorton Foundry (FIGURE 4).

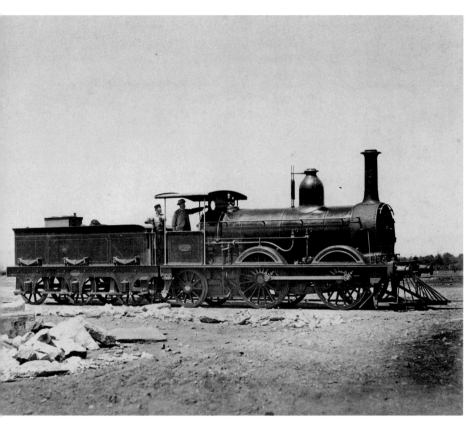

FIGURE 4 Unknown photographer. *Beyer and Peacock Railway Engine, Turkey,* 1880s. From the album "Alaschier chemin de fer de Asie Minor." Albumen silver print, 24.2 × 19.2 cm (9½ × 7½ in.). Los Angeles, Research Library, The Getty Research Institute, 96.R.14, pl. 25.

Setting his camera far enough back to accommodate the large engine and its tender, Mudd created a worthy portrait. The even rows of the brick buildings on either side and the towering legs of the water tower create a strange, almost abstract backdrop, which is in contrast to the two prints by Stuart (PLATES 5–6). Stuart was similarly working for a locomotive works, Nielson and Company based in Glasgow, and like James Mudd he made his photographs on the grounds of the workshops; unlike Mudd, he chose to focus exclusively on the engines. He would do this in one of two ways: by hanging a large tarpaulin behind the engine, so as to hide the structures and buildings of the foundry, or by retouching the negative and painting out the backdrop (as he did for the two plates reproduced here). In order to achieve maximum detail in the photograph he had the engines painted in shades of gray and black, and very likely only on one side—the camera side. These grayish tones registered more faithfully on the negative. This was a practice he employed only in documenting the engines at the workshops. Although it increased the work by requiring that the engine be painted twice over, it was obviously considered a worthwhile endeavor, yielding the desired clarity and detail in the finished print.

The locomotive companies used the photographs as a means of recording their designs and technical achievements, but they also used the prints as promotional materials for prospective buyers, that is, railroad companies around the world. Stuart produced an image of an engine on the Caledonian Railway—Scotland's finest line

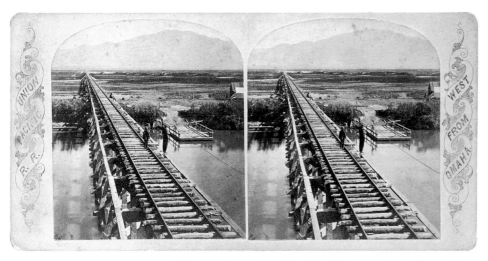

FIGURE 5 Unknown photographer. *Weber River, Bridge 32*, ca. 1870. Albumen silver print stereograph, 8.7 × 17.6 cm (3⅜ × 6⅞ in.). Los Angeles, J. Paul Getty Museum, 84.XC.979.7407. Gift of Weston and Mary Naef.

(PLATE 5) — for the home market and another for the Cape Government Railway in South Africa (PLATE 6). The key characteristics of each engine are easily visible to a discerning eye. The Caledonian Railway engine has a rigid wheel arrangement and is specifically designed to run on the type of track laid in Great Britain. The South African model has a very different configuration, where the flexibility of the lead truck accommodates curves and prevents derailments. This design was essential for the primitive conditions of the South African railroad. Stuart was able to capture the key design elements of the massive engines in these striking documentary photographs.

In Gustave Le Gray's 1859 photograph *Pope Pius IX's Railroad Car* (PLATE 7), the subject is not the locomotive but the luxuriously opulent carriage specially made for Pius IX, head of the Roman Catholic Church from 1846 to 1878. The car employed the latest technology, for example, the plate glass in the windows and the four-wheel bogies, or trucks upon which the car rode. The ornate carving and the finials are completely decorative and not at all practical, intended to set the papal car apart from any other carriage and in so doing reinforce its importance as the vehicle for spreading the word of God. Le Gray's interest in the railroad appears to have been minimal; few of his prints of the subject exist.[13] It is likely that the making of this particular image was inspired by the importance of the passenger, not the historical significance of the car.

While few people traveled in the luxury afforded the pontiff, the introduction of the Pullman Palace Sleeping Car in 1865 certainly

elevated the degree of comfort for many paying passengers on America's railroads. In Carleton Watkins's cabinet card of 1869–70 (PLATE 8), the interior of the car is shown with a made-up berth visible in the center of the composition. (Watkins's camera is visible in the mirror on the back wall of the car.) Designed by George Pullman and Ben Field, the cars contained regular seats for day travel that could easily be transformed into sleeping berths. The beds were very much welcomed for the long journey across the continent, which took several days, made possible by the completion of the transcontinental railroad in 1869. The first Pullman-equipped train arrived in Sacramento, California, in June 1869, but an overestimation of the number of passengers meant trains were only half full; by July 1870 the Central Pacific Railroad had canceled the Pullman contract in favor of its own Silver Palace Sleeping Cars. Given these dates, Watkins probably photographed this interior of a Pullman car within the first year of operation, before the contract was canceled. (Not until the late nineteenth century did Pullman service resume on the Central Pacific line.)

As a young man in his hometown of Oneonta, New York, Watkins befriended Collis P. Huntington, who became a railroad magnate in California and would be heavily involved with the Central and Southern Pacific Railroads. The friendship stood Watkins in good stead: throughout his photographic career he traveled and worked extensively on the railroads, often equipped with a special flatbed car provided by Huntington for his photographic wagon and free passage up and down the line (see PLATE 66).

The energetic westward expansion of the American railroads had to wait until the end of the Civil War, when there was more money and labor available for the construction. President Abraham Lincoln, intent on fortifying the union of the country, had endorsed a transcontinental railroad with the Pacific Railroad Act of 1862. One year later, ground was broken at Omaha, Nebraska, but it was not until 1865 that construction began on the Union Pacific Railroad. Lincoln had championed the progress of the railroad as a means of securing more territories for the Union, but his support stemmed all the way back to the 1850s and was further strengthened by the strategic success of the military railroads during the Civil War.

Andrew Joseph Russell worked as a war photographer for the United States Military Railroads (U.S.M.R.R.). The line, run by civilian railroaders, had its own inventory of engines as well as equipment captured from the Southern lines. An important means of transporting soldiers, munitions, and supplies, the railroad was frequently under attack. Railroad wrecks were common at this time. In a portrayal of one, *Railroad Accident Caused by Rebels* (PLATE 9), Russell shows the wrecked locomotive Charles Minot, with a second, unidentified engine lying behind it. The men in the photograph are the salvage crew who are in the process of dismantling smaller parts before hauling the engines back onto the track. More railroad carnage appears in another Russell print, *Remains of Wreck on the Track* (PLATE 10), where the scene captures two wrecked engines in the process of being taken back to the U.S. Military Railroads' shops in

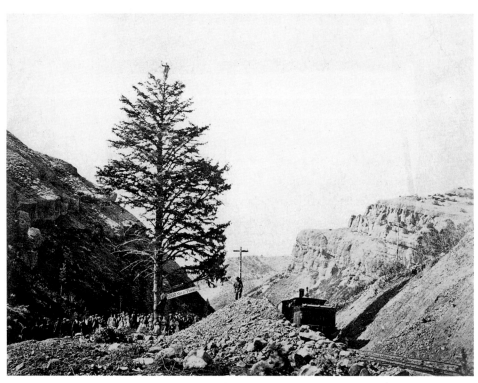

FIGURE 6 A. J. Russell (American, 1830–1902). *Thousand Mile Tree*, 1869–70.
From the book *Sun Pictures of Rocky Mountain Scenery* (New York: Julius Bien, 1870).
Albumen silver print, 15.4 × 20.5 cm (6 1/16 × 8 1/16 in.). Los Angeles, J. Paul Getty
Museum, 84.XB.1339.19.

Alexandria, Virginia. On the far left is the Union, built by the
Baldwin Locomotive Works of Philadelphia in June 1862. The mid-
dle engine is the Commodore, built by the New Jersey Locomotive
and Machine Works of Paterson, New Jersey, in May 1863. Pulling
the two wrecks is the ornate Rapidan, built by Smith and Perkins of
Alexandria, Virginia, in 1856 for the Orange and Alexandria
Railroad and later confiscated by the U.S.M.R.R. There appear to be
mourning ribbons of black and white silk attached to the Rapidan's
handrail, suggesting that the wrecks caused fatalities.

The U.S.M.R.R. confiscated not only the locomotives and their
tenders but the actual iron rails. In Russell's *Rails of the Manassas Gap*
from about January 1865 (PLATE 11), the scene shows the thirty-five
miles of rails taken from the Manassas Gap Railroad of Virginia. By
seizing this "metal treasure," Union forces depleted Southern sup-
plies and added to their own for future use; meanwhile, Union block-
ades prevented imported iron rails from reaching the South.

Russell left the military in 1865 and began working as the offi-
cial photographer for the Union Pacific Railroad, documenting the
construction of the line as it made its way westward (FIGURE 6). The
photographs served as visual proof to the company owners back east
and the financial backers in Congress that the railroad was indeed
moving forward and making progress.[14] Russell made the photograph
Wyoming Station, Engine 23 (PLATE 12) in May 1868, one year before
the historic union of the rails at Promontory Summit, Utah. Russell
arranged everyone into a static position (with the exception of the dog

on the tender), stopping time with his camera. The engine's crew stand proudly to attention; the engineer at front with his oilcan, the fireman smoking his pipe, the conductor standing between the cab and tender, and the brakemen by the tracks, one of whom holds a rifle (and is perhaps responsible for the antlers above the cowcatcher)—all stare intently at the camera. Russell's print is an important portrait, not just of the railroad and its engine but of the dedicated crew who kept everything running. The image has a "pioneer" quality to it; the set of antlers adorning the locomotive seems to symbolize the unbeatable power of the railroad over the land. The Union Pacific was a frontier railroad, but, as historian Jim Wilke has pointed out, "the 'frontier railroad' was ephemeral, only lasting a few years—until towns grew up along the line, eastern standards of good track and facilities were installed, and the line no longer blocked by herds of bison."[15]

Much of American railroad photography at this time was taken up with documenting the westward expansion of the rails, and people became more and more interested in photographs of the subject. Stereographs became very popular during the mid–nineteenth century as the relatively new viewing technology of the stereoscope was used to "experience," so to speak, the development of the railroads. The dramatic views of large steam engines, railroad cuts, and grades made for exciting and lively subjects when viewed in three dimensions. One of the most productive photographers was Alfred A. Hart, who, in his capacity as official photographer for the Central Pacific Railroad, produced more than thirty thousand stereographs from three hundred negatives between 1866 and 1869.[16] These stereographic photographs (PLATES 13, 15–21) capture something of the excitement and innovation associated with the building of the railroad. His bold viewpoints and oblique angles create a sense of dynamism; showing engines rounding sharp bends or passing through deep cuts, Hart experimented with perspectives that he knew would be exaggerated even more by the three-dimensionality of the images.

In his stereograph *Last Rail Laid at Promontory Point, May 10th 1869* (PLATE 21), Hart again employs a striking composition, in contrast to the views made by Charles Savage and A. J. Russell (FIGURES 7–8). Hart captures the historic moment when the Central Pacific and Union Pacific Railroads met at Promontory Summit, Utah (not at Promontory Point, as he called it). Unlike the photographs by Russell and Savage—which show side views of the two engines, the Central Pacific's wood-burning Jupiter and the coal-burning Union Pacific No. 119—Hart chooses a vantage point from on top of the Jupiter, looking directly ahead to the Union Pacific locomotive. His audacious composition not only reflects his daring artistic ability—note how he focuses on the newly laid track, which guides the viewer's attention to the recently arrived engine—but reveals his allegiance to the railroad. As official photographer for the Central Pacific Railroad, Hart is espousing the company view *literally*, that is, approaching the Union Pacific engine entirely from the perspective of the Central Pacific Railroad—meeting the rival company head-on.

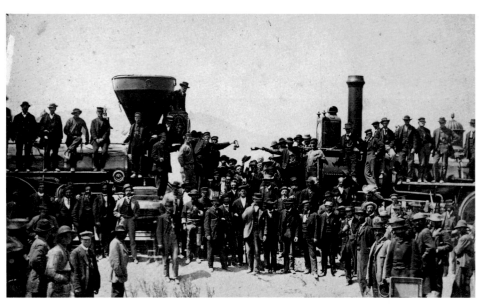

FIGURE 7 Charles Savage (American, 1832–1909). *Ceremony to Join the Rails at Promontory Point*, 1869. Albumen silver print carte-de-visite, 6.1 × 10.1 cm (2⅜ × 4 in.). Carl Mautz Collection.

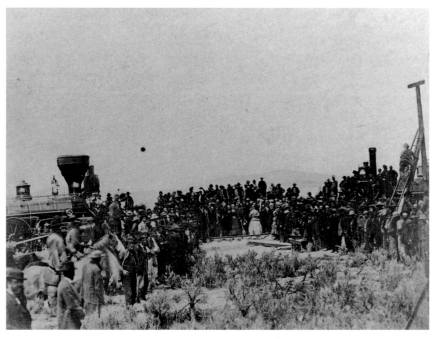

FIGURE 8 A. J. Russell (American, 1830–1902). U.P.R.R. *East and West Shaking Hands at Laying of the Last Rail*, 1869. Albumen silver print, 22 × 29.2 cm (8⅝ × 11½ in.). New Haven, Connecticut, Yale Collection of Western Americana, Beinecke Rare Book and Manuscript Library.

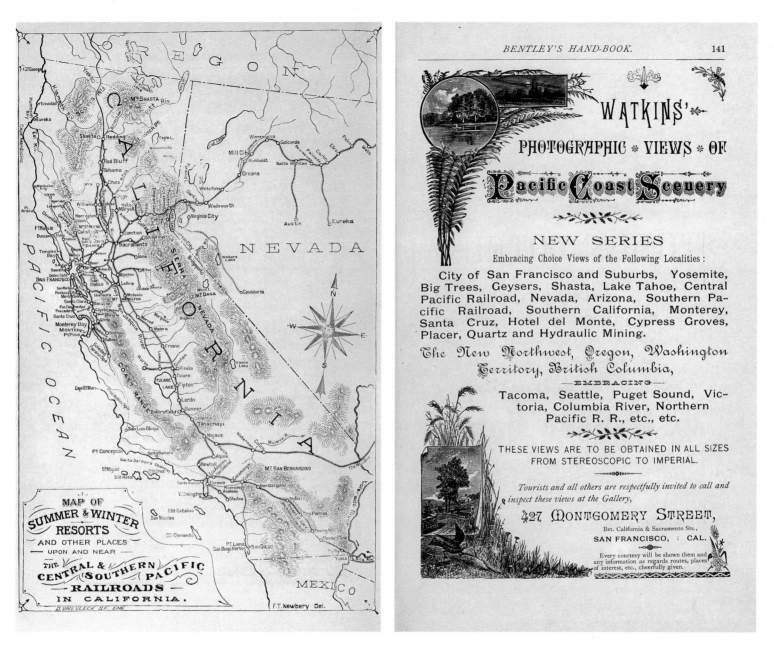

FIGURE 9 Facing pages advertising rail routes in California and photographs by Carleton Watkins, from *Bentley's Handbook of the Pacific Coast*, 1884. Letterpress book with 31 mounted albumen silver prints, 24 × 30.6 cm (9½ × 12¹⁄₁₆ in.). Los Angeles, J. Paul Getty Museum, 88.xb.97, pages 140–41.

The growing network of rails led to what historian John R. Stilgoe has called the "opening" of the landscape.[17] The countryside at large, with its scenic attractions and places of natural beauty, became more accessible to the traveling public. The images recorded by the camera acted not only as souvenirs for the burgeoning tourist industry (FIGURE 9) but as enticements for prospective settlers to the western states. In William Henry Jackson's *Big Tree Station, Santa Cruz* (PLATE 22), the photographer has turned his attention to the large redwood trees that are indigenous to this particular region of California. His small cabinet card is in dramatic contrast to the large plate print made by Alexander Gardner (PLATE 23), yet both images, in their different ways, serve to "open" the landscape. For an audience back east, the giant sequoias of California may have seemed exotic, but the presence of the rails in the center of the composition told the viewer that those trees, however far away and distant, were accessible by train—they were within reach.

Likewise the seemingly unending prairies of the Midwest could be traversed with ease on the iron network of the railroad seen in the print Gardner titled *Across the Continent on the Union Pacific Railway E[astern] D[ivision]* (PLATE 23). Gardner exploits the notion of crossing a vast area of land by composing his photograph in such a way as to capture a sense of movement and recession in what is otherwise a stationary image. The train has obviously stopped long enough to allow a group of passengers to disembark for their photographic portrait. Yet by framing the train so that it boldly emerges from the left of the composition and recedes across the picture plane, Gardner creates a sense of movement where none exists.

The disparity in size between these two prints reflects the different markets for which they were made. One is a cabinet card measuring approximately 7½ × 4½ inches; the other is a large print, 13 × 18¾ inches. Jackson's print was probably intended as a souvenir, small and easily transportable. Gardner's print was commissioned by the railroad company and, given its size, would have likely hung in a station along the route, in the contractor's office, or in one of the railroad-owned hotels. Both photographs were intended as promotional images.

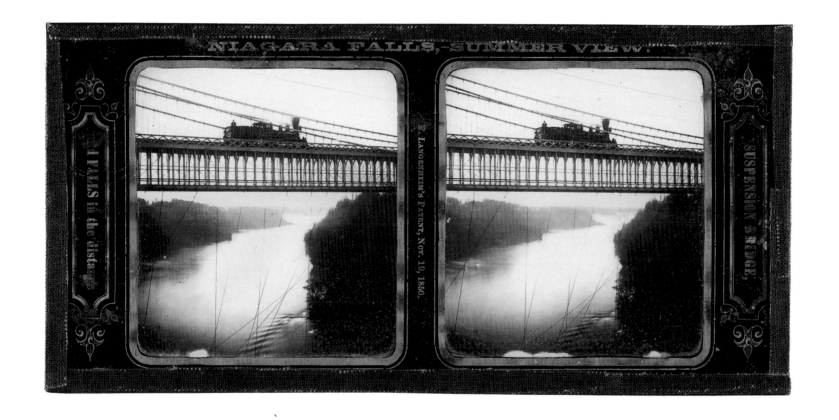

PLATE 2 William and Frederick Langenheim (American [b. Germany], 1807–1874 and 1809–1879). *Niagara Falls, Summer View: Suspension Bridge and Falls in the Distance*, ca. 1855–56. Glass stereograph, 8.3 × 17.1 cm (3¼ × 6¾ in.). Los Angeles, J. Paul Getty Museum, 2000.10.218.

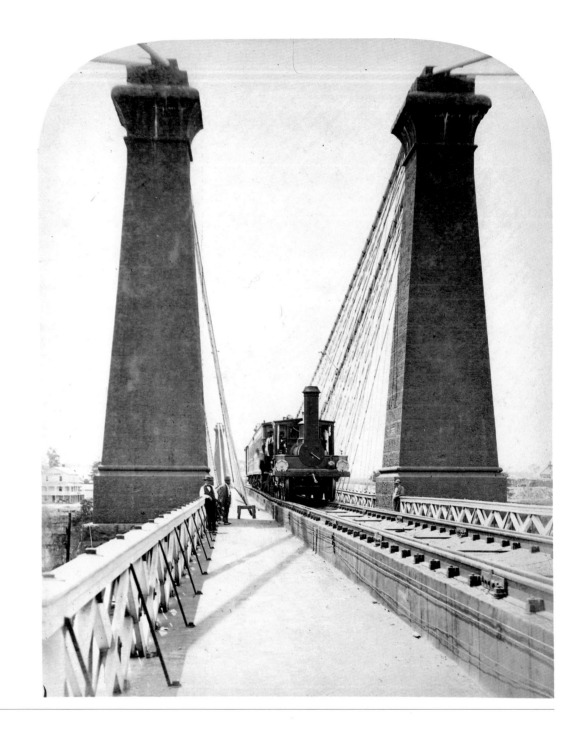

PLATE 3 Attributed to William England
(English, 1816–1896)/London Stereoscopic
Society. *Niagara Suspension Bridge*, 1859.
Albumen silver print, 28.6 × 22.9 cm
(11¼ × 9 in.). Stephen White Collection II.

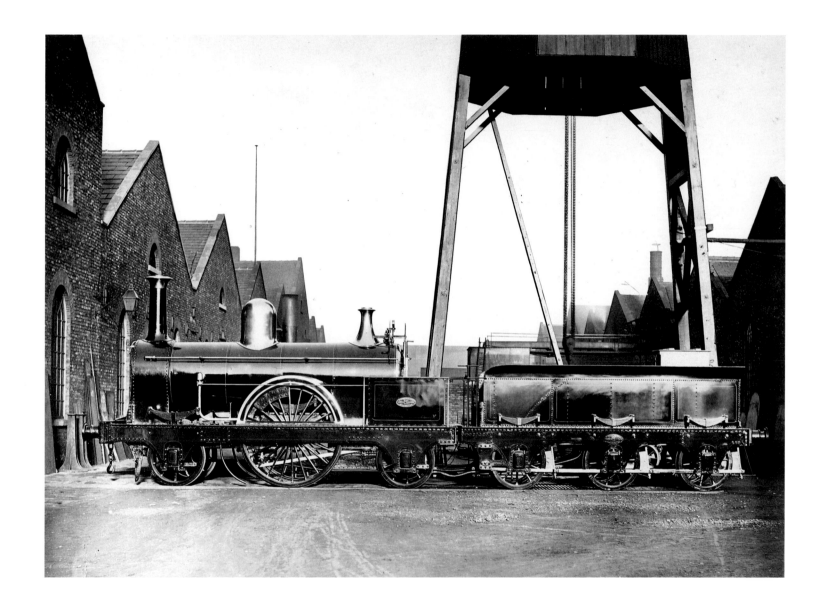

PLATE 4 James Mudd (English, 1821–1906?). *Railway Engine and Foundry*, 1863. Albumen silver print, 30.5 × 45.7 cm (12 × 18 in.). Wilson Center for Photography, LLC.

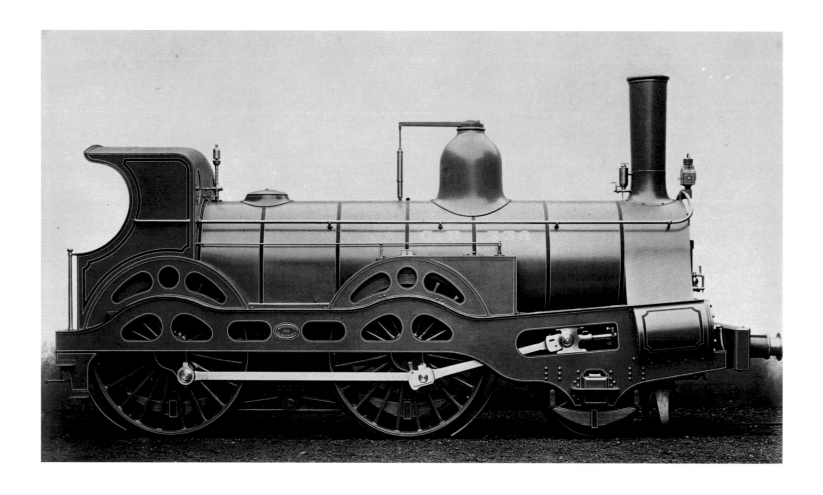

PLATE 5 John Stuart (Scottish, 1831–1907). *Nielson Locomotive Engine (Caledonian Railway)*, 1870. Albumen silver print, 20.3 × 35.6 cm (8 × 14 in.).
Santa Barbara Museum of Art, 2000.30.104. Gift of Jane and Michael G. Wilson.

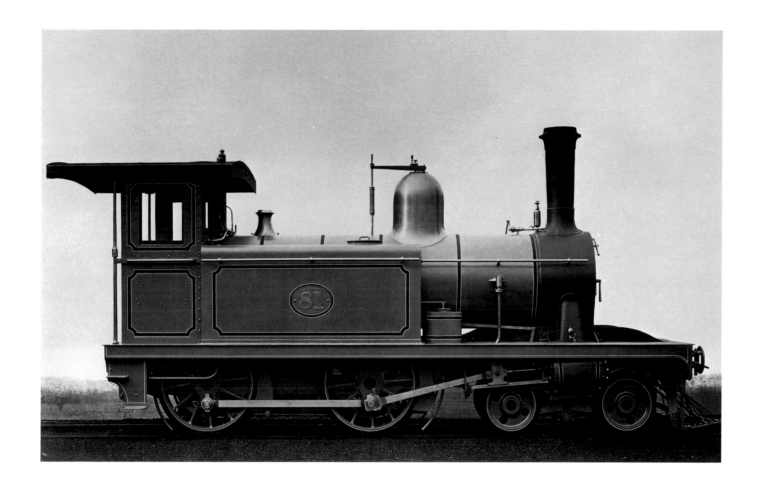

PLATE 6 John Stuart (Scottish, 1831–1907). *Nielson Locomotive Engine (Cape Government Railway, South Africa)*, 1880. Albumen silver print, 21.6 × 34 cm (8½ × 13⅜ in.). Santa Barbara Museum of Art, 2000.30.109. Gift of Jane and Michael G. Wilson.

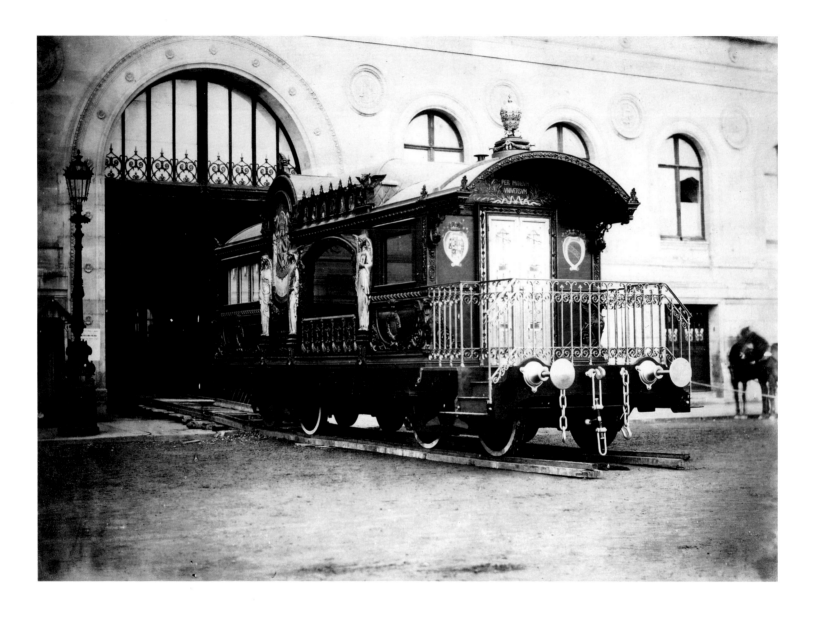

PLATE 7 Gustave Le Gray (French, 1820–1882). *Pope Pius IX's Railroad Car*, 1859. Albumen silver print, 28.9 × 40.6 cm (11⅜ × 16 in.).
Los Angeles, J. Paul Getty Museum, 84.XP.218.40.

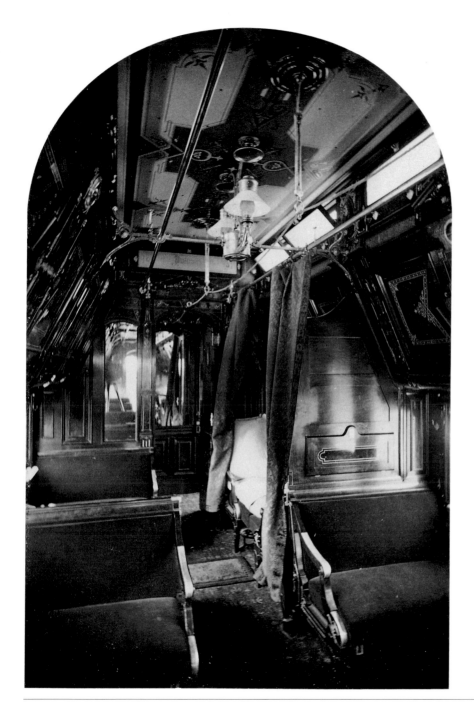

PLATE 8 Carleton Watkins (American, 1829–1916).
Pullman Palace Sleeping Car (Interior), June 1869–July 1870.
Albumen silver print cabinet card, 12.9 × 8.6 cm (5 1/16 × 3 3/8 in.).
Los Angeles, J. Paul Getty Museum, 2000.53.1.

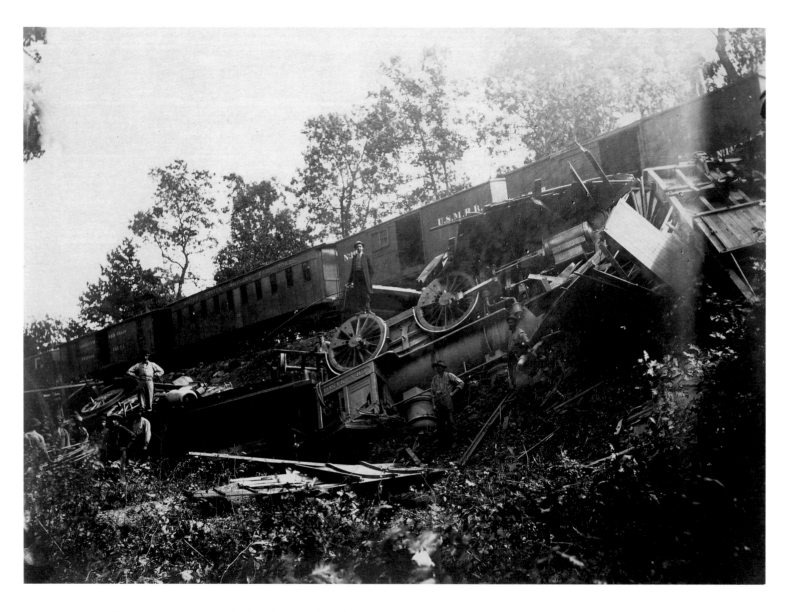

PLATE 9 A. J. Russell (American, 1830–1902). *Railroad Accident Caused by Rebels*, 1863–65. Albumen silver print, 23.5 × 32.6 cm (9¼ × 12¹³⁄₁₆ in.). Los Angeles, J. Paul Getty Museum, 89.XA.77.18.

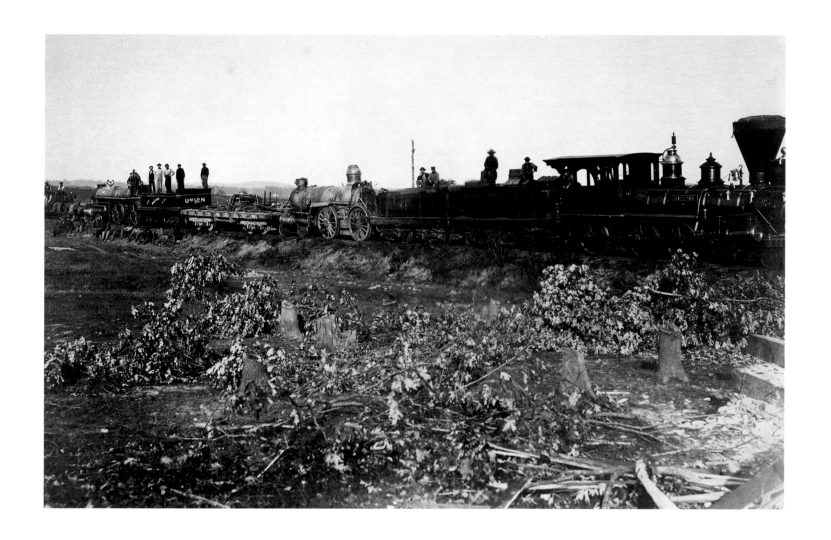

PLATE 10 A. J. Russell (American, 1830–1902). *Remains of Wreck on the Track*, 1863–65. Albumen silver print,
21 × 33.3 cm (8¼ × 13⅛ in.). Los Angeles, J. Paul Getty Museum, 85.XM.6.4.

PLATE 11 A. J. Russell (American, 1830–1902). *Rails of the Manassas Gap Railroad, Alexandria, Virginia,* ca. January 1865.
Albumen silver print, 23.6 × 32.7 cm (9¼ × 12⅞ in.). Los Angeles, J. Paul Getty Museum, 84.xm.481.5.

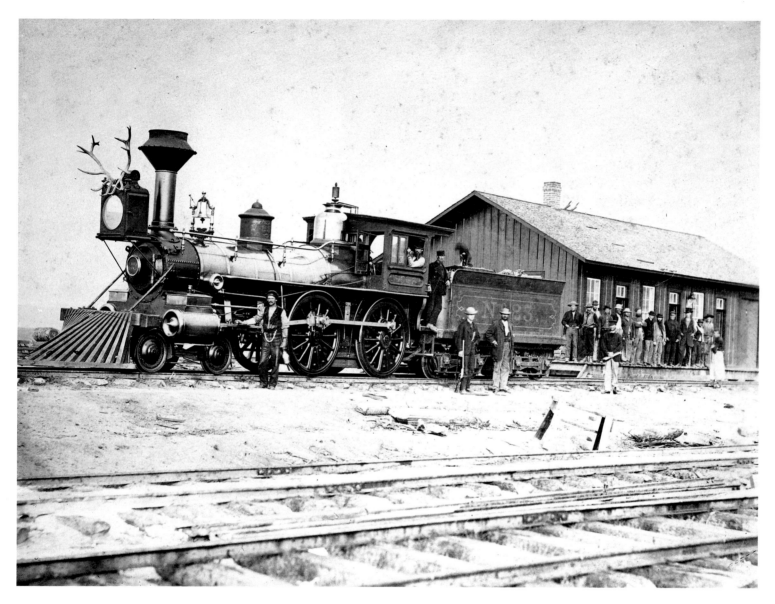

PLATE 12 A. J. Russell (American, 1830–1902). *Wyoming Station, Engine 23 on Main Track,* May 1868. Albumen silver print,
22.4 × 30.6 cm (8¹³⁄₁₆ × 12¹⁄₁₆ in.). Los Angeles, J. Paul Getty Museum, 84. XM.481.8.

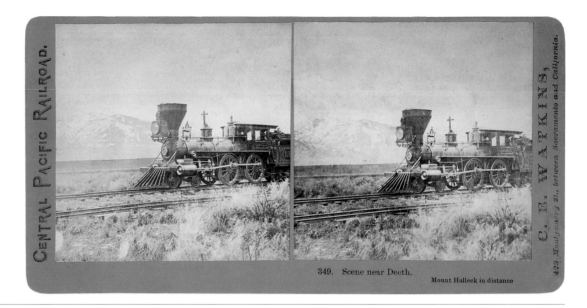

PLATE 13 Alfred A. Hart (American, 1816–1908). *Scene near Deeth — Mount Halleck in Distance*. Negative: April–May 1869; printed by Carleton Watkins after 1870. Albumen silver print stereograph, 8.7 × 17.5 cm (3⁷⁄₁₆ × 6¹³⁄₁₆ in.). Los Angeles, J. Paul Getty Museum, 84.xc.979.4245. Gift of Weston and Mary Naef.

PLATE 14 Unknown photographer. *Midland Railroad*, ca. 1870. Albumen silver print stereograph, 8.7 × 17.6 cm (3⅜ × 6⅞ in.). Los Angeles, J. Paul Getty Museum, 84.xc.1158.299.

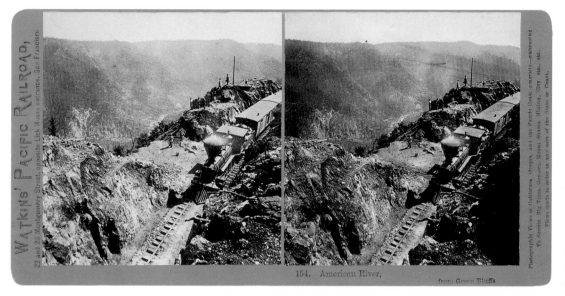

PLATE 15 Alfred A. Hart (American, 1816–1908). *American River, from Green Bluffs*. Negative: ca. 1867; printed by Carleton Watkins after 1870. Albumen silver print stereograph, 8.7 × 17.5 cm (3⁷⁄₁₆ × 6¹³⁄₁₆ in.). Los Angeles, J. Paul Getty Museum, 84.xc.902.72.

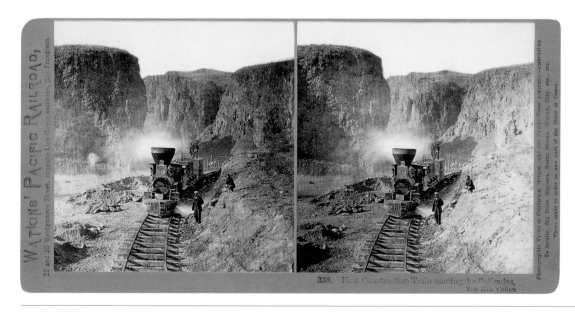

PLATE 16 Alfred A. Hart (American, 1816–1908). *First Construction Train Passing the Palisades, Ten Mile Cañon.* Negative: December 1868–January 1869; printed by Carleton Watkins after 1870. Albumen silver print stereograph, 8.7 × 17.6 cm (3¹³⁄₃₂ × 6¹³⁄₁₆ in.). Los Angeles, J. Paul Getty Museum, 84.xc.902.71.

PLATE 17 Alfred A. Hart (American, 1816–1908). *Bloomer Cut near Auburn, 800 Feet Long and 63 Feet High*. Negative: 1866–69; printed by Carleton Watkins after 1870. Albumen silver print stereograph, 8.6 × 17.6 cm (3⅜ × 6¹⁵⁄₁₆ in.). Los Angeles, J. Paul Getty Museum, 84.xc.873.5532.

PLATE 18 Alfred A. Hart (American, 1816–1908). *Bloomer Cut, 63 Feet High, Looking West*, 1866–69. Albumen silver print stereograph, 8.4 × 17.5 cm (3⁵⁄₁₆ × 6⅞ in.). Los Angeles, J. Paul Getty Museum, 84.xc.979.4216. Gift of Weston and Mary Naef.

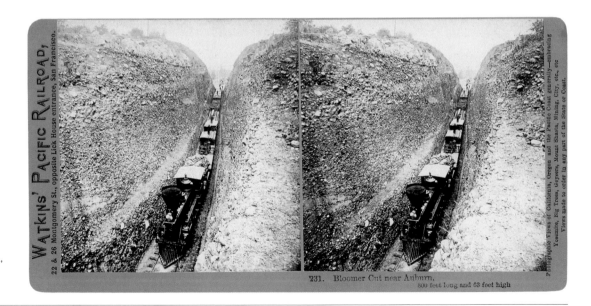

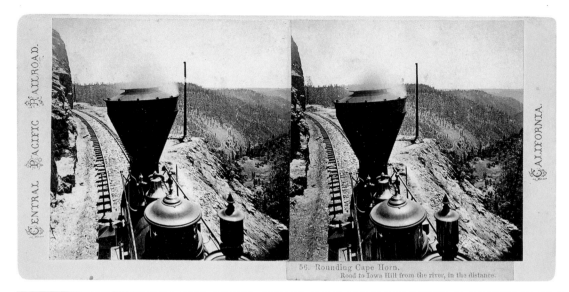

PLATE 19 Alfred A. Hart (American, 1816–1908). *Rounding Cape Horn: Road to Iowa Hill from the River, in the Distance*, 1866–69. Albumen silver print stereograph, 8.3 × 17.5 cm (3¼ × 6⅞ in.). Los Angeles, J. Paul Getty Museum, 84.XC.873.4616.

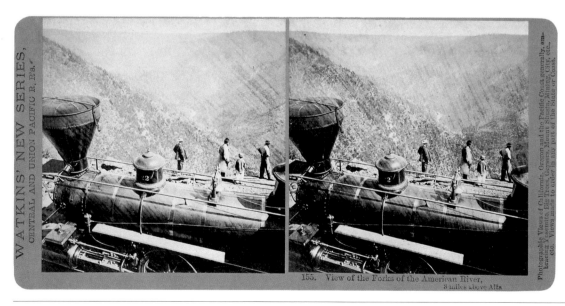

PLATE 20 Alfred A. Hart (American, 1816–1908). *View of the Forks of the American River, Three Miles above Alta*. Negative: between August 1867–1869; printed by Carleton Watkins after 1870. Albumen silver print stereograph, 8.7 × 16.7 cm (3⅜ × 6¹⁵⁄₁₆ in.). Los Angeles, J. Paul Getty Museum, 84.XC.979.4246. Gift of Weston and Mary Naef.

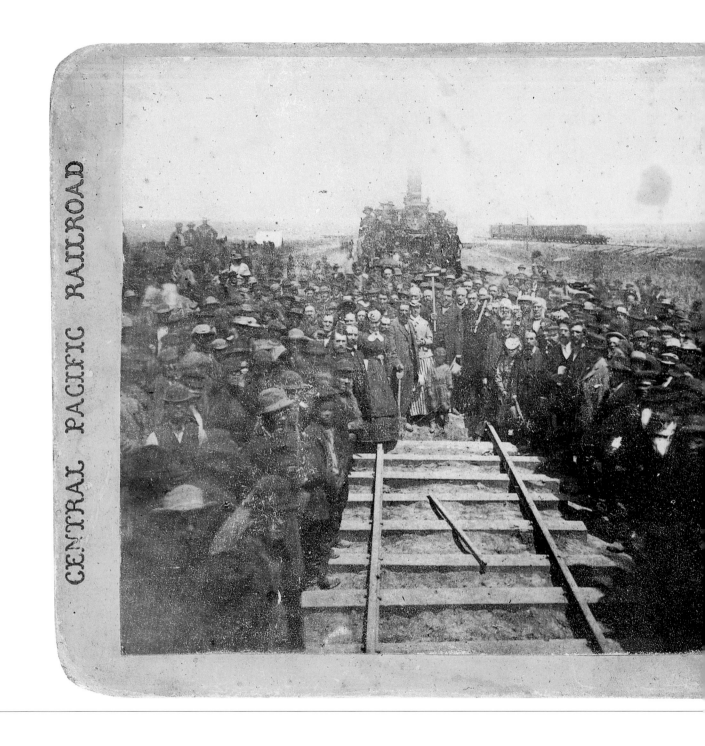

CENTRAL PACIFIC RAILROAD

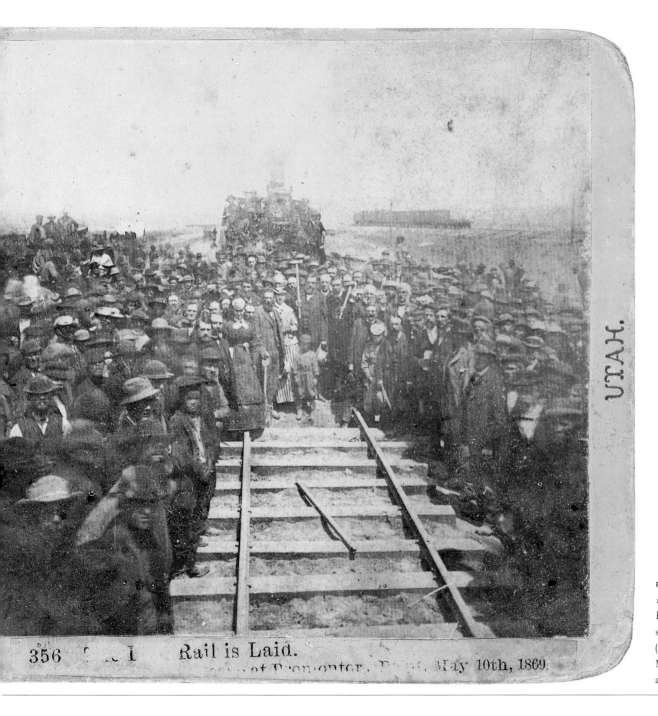

UTAH.

356 [] 1 Rail is Laid.
... at Promontory Point, May 10th, 1869.

PLATE 21 Alfred A. Hart (American, 1816–1908). *Last Rail Laid at Promontory Point, May 10th 1869*, May 10, 1869. Albumen silver print stereograph, 8.3 × 17.1 cm (3¼ × 6¹¹⁄₁₆ in.). Los Angeles, J. Paul Getty Museum, 84.xc.979.4214. Gift of Weston and Mary Naef.

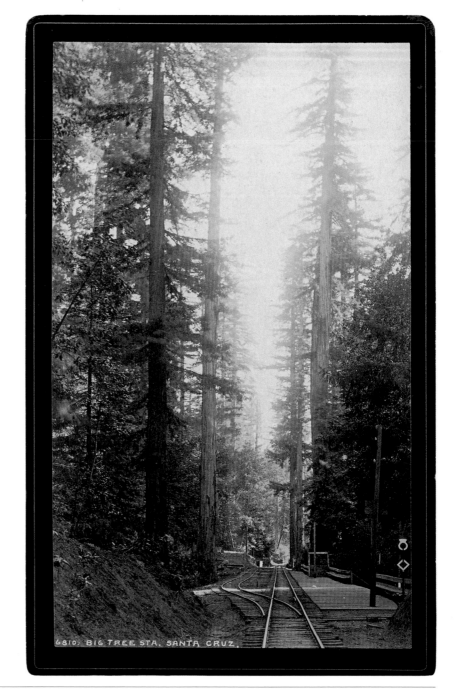

PLATE 22 William Henry Jackson (American, 1843–1942). *Big Tree Station, Santa Cruz*, 1880. Albumen silver print cabinet card, 18.5 × 11.1 cm (7⁵⁄₁₆ × 4³⁄₈ in.). Los Angeles, J. Paul Getty Museum, 85.XM.5.10.

PLATE 23 Alexander Gardner (American [b. Scotland], 1821–1882). *Across the Continent on the Union Pacific Railway E[astern] D[ivision]*, 1867. Albumen silver print, 33 × 47.5 cm (13 × 18¾ in.). Los Angeles, J. Paul Getty Museum, 84.XM.1027.14.

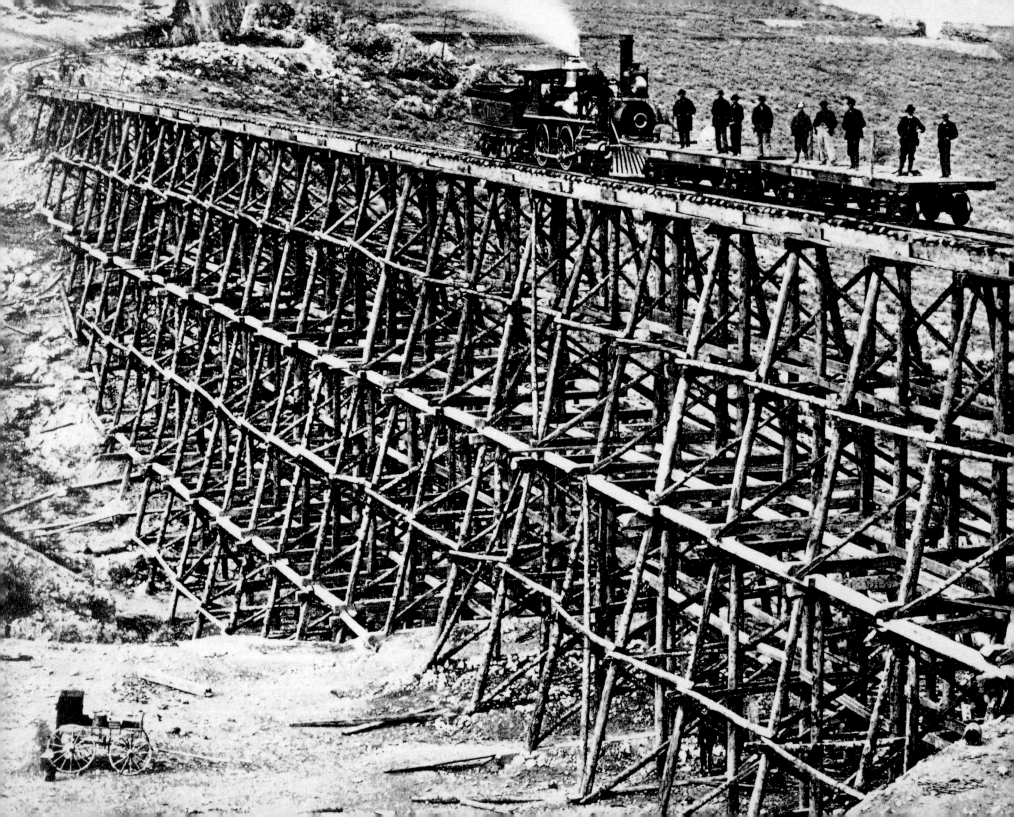

Bridges, Trestles, and Viaducts

HE RAILROAD REQUIRED a straight, level, and direct route in order to be efficient and cost-effective. A series of engineering feats—bridges and tunnels, cuts and gradings—emerged on the landscape to minimize the changes in elevation and make possible an even rate of speed. These impressive, often awe-inspiring, structures were unfamiliar sights to the general public. The steam-producing locomotives passing swiftly across the landscape, on, over, and under various structures, were viewed with some degree of suspicion and fear. To familiarize the public—potential train passengers—with the railroad, companies commissioned photographers to document the new bridges and newly built iron networks. Photographers experimented with bold and innovative viewpoints that emphasized the inherent dynamism of the railroad, producing sumptuous albums and large-format prints that defied the rules of landscape composition by adopting plunging orthogonals and deep recessions. Railroad vision was becoming more complex, imbued with subtle nuances that went beyond simple documentation to reveal cultural differences from country to country.

The railroad functioned as an important device in the "opening up" and settling of the American West, while it helped to strengthen national identities in an already settled Europe.

From the late 1850s onward, railroad companies began to commission photographers to document tracks, tunnels, trestles, and stations. In France the photographer Hippolyte-Auguste Collard produced a series of images made specifically for the Bourbonnais Railway Company. In a sequential set of photographs (PLATES 24–26), Collard systematically charted the building of a viaduct over the river near Montargis, southeast of Paris. The first photograph (PLATE 24), made in the summer of 1865, shows the bridge under construction, the unfinished arches being built with large stone blocks. In the winter of 1866 Collard recorded the bridge, now completed and in use (PLATES 25–26). He carefully assumed the same vantage point in order to document the contrasts between the bridge in its unfinished and finished states. (The winter rains caused the water levels of the river to rise, which is why there appears to be less foreground in the later image.)

Prints of this kind, often mounted and bound into albums, provided virtual tours of these newly built railroads. The images not

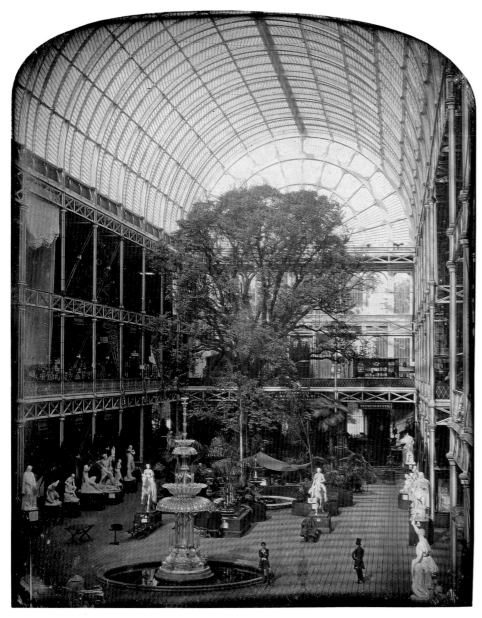

FIGURE 10 John Jabez Edwin Mayall (English, 1810–1901). *The Crystal Palace at Hyde Park, London*, 1851. Mammoth-plate (reduced) daguerreotype, 30.5 × 24.6 cm (12 × 9¹¹⁄₁₆ in.). Los Angeles, J. Paul Getty Museum, 84.XT.955.

only documented the construction, celebrating spectacular engineering achievements; they also charted the physical progression of the tracks as they mapped their way across the country. For example, in the large photographic album compiled by Édouard Baldus for the Chemins de fer de Paris à Lyon et à La Méditerranée (PLATES 29–31), the sixty-nine images begin in Lyon and end with the station at Toulon—the terminus of the line itself and the final plate of the album. This album marked the second time Baldus had been commissioned by the French railroads, the first being in 1855, when he made a series of images for the Chemin de fer du Nord. These prints were mounted into albums, one of which was specially made for Queen Victoria and presented to her during a royal visit to France. For the later project Baldus expanded greatly upon his work of 1855, celebrating the railroad within the context of the French countryside.[18]

As the railroad moved across France, new forms of architecture such as stations and roundhouses began to proliferate. With these new structures came a whole new design aesthetic. Utilizing the relatively new architectural materials of iron and glass, these buildings represented strength, power, and innovation. The sensation produced by the Crystal Palace in London in 1851 (FIGURE 10) led to this growing trend for glass and iron structures. Newly constructed railroad stations (PLATES 28–29) embodied the modernity of Napoléon III's Second Empire; the visual art of the period also embraced that modernity.

In the architecture of railroad stations, iron seemed an extension—an *elevation*—of the iron tracks and even of the locomotives

themselves. In these buildings glass helped provide light and air. These contrasting properties attracted Claude Monet when he painted his *Gare St.-Lazare in Paris* in 1877 (FIGURE 11). Monet framed his composition between the apex of the glass roof and the receding tracks. Considered "an unorthodox view with few precedents in the history of painting,"[19] this visual strategy had already been employed by photographers such as Baldus and Collard. While Monet was more concerned with the evanescent qualities of light and smoke, the photographs and the painting are alike in their embrace of a modernity that was fast becoming a part of daily life. As one commentator reported upon visiting Édouard Manet's studio, close to the Gare St.-Lazare: "The trains pass close by, sending up their agitated clouds of white steam. The ground, constantly agitated, trembles under our feet and shakes like a fast-moving boat."[20] Collard's *Roundhouse for Thirty-two Locomotives* (PLATE 27) is another such celebration of the new technology. The glass oculus is skillfully placed within the frame, while the iron girders direct one's attention to the sentry of locomotives below.

Napoléon III actively encouraged new forms of industry, and by 1880 the railroads were bringing significant profits to the state, earning 243,383,313 francs in that year alone.[21] The railroad was emerging as a powerful agent for social and political change. A distinct unifying force, the railroad in France was connecting the disparate regions and cultures of the country. In 1863, Eugène Flachat—the engineer who designed the Gare St.-Lazare—declared:

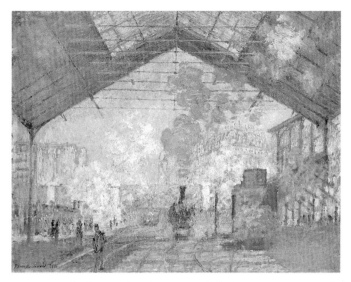

FIGURE 11 Claude Monet (French, 1840–1926). *The Gare St.-Lazare*, 1877. Oil on canvas. Paris, Musée d'Orsay. Photo: Hérve Lewandowski. Copyright Réunion des Musées Nationaux/Art Resource, N.Y.

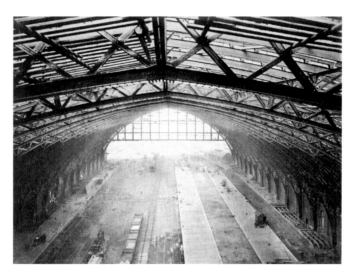

FIGURE 12 Unknown photographer, possibly J. Ward or J. B. Pyne. *St. Pancras Station, View from the Roof towards the Platforms*, 1868. Albumen silver print made from glass-plate negative, 31.7 × 21.7 cm (12½ × 8½ in.). York, England, The National Railway Museum/Science and Society Picture Library, 1988.8759.3.23.

"The railroads have everywhere spread a more equal political life. In the provinces hope is springing up on all sides for the institutions and establishments needed to speed the march of civilization."[22] Even as Napoléon III strove to forge a new national identity for France as a distinctly modern country, he was sponsoring projects and proposals that celebrated the glories of France's cultural history. One no longer needed to make the Grand Tour to study the antique period; the railroad now offered opportunities to appreciate and rediscover ancient sites and medieval monuments in the French countryside. In a way, the railroad became an umbilical cord to Mother France.

This development can be seen in the images of La Voulte (PLATES 30–31), another town photographed by Baldus. In 1790 a paleontological site dating from the Jurassic period had been discovered there. (Interestingly, the discovery resulted from excavations for iron ore.) The railroad provided access to this ancient heritage, making it more reachable by bringing it closer, bringing it home. This fact did not escape Baldus. He framed the old town of La Voulte, with its seventeenth-century castle, within the arch of the modern railroad bridge. The old is juxtaposed with the new, the past with the future. Baldus was not simply documenting what he saw; he was interpreting it with the eye of an artist and cultural commentator. His images of the railroad embody the spirit of the Second Empire—the simultaneous celebration of the *moderne* and the exaltation of France's past.

If the railroad in France linked the past and the future, in America the railroad was all about the future. The desire to reach the

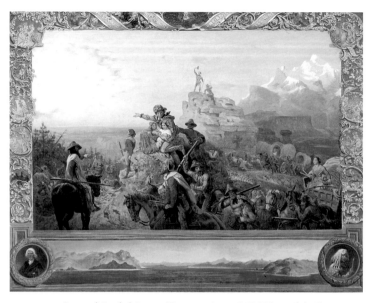

FIGURE 13 Emanuel Gottlieb Leutze (German, 1816–1868). *Westward the Course of Empire Takes Its Way (Westward, Ho!)*, 1861. Oil on canvas, 83.8 × 109.2 cm (33 × 43 in.). Washington, D.C., Smithsonian American Art Museum, 1931.6.1. Bequest of Sara Carr Upton.

FIGURE 14 Fanny Palmer (English, ca. 1812–1876). *Across the Continent Westward the Course of Empire Takes Its Way*, 1868. Colored lithograph, published by Currier and Ives. Museum of the City of New York, Harry T. Peters Collection, 56.300.107.

western states and gain access to Asian markets was a driving force behind the development of the first transcontinental railroad; photographs from the period capture the pioneering spirit and tremendous effort involved. The iron network brought settlers from the east, and soon new cities and towns were springing up. The railroad companies attempted to entice urban dwellers to leave behind their crowded cities for the large open spaces of the west, now made accessible by the railroad. Many of the photographs commissioned by the railroad companies exploited the notion of the empty land, primed for ownership and development. As one historian has written, "The railroad was perceived as—and often in fact was—an implement for the penetration of the wilderness, and for taking dominion over the vast spaces of the continent."[23]

Two photographs—one by Alexander Gardner (PLATE 32) and the other by Carleton Watkins (PLATE 33)—offer rare insight into the actual construction of the railroad. In the Gardner print the workers have stopped laying the track just long enough to allow him to make this image, six hundred miles west of St. Louis. Gardner splits the composition into equal halves of sky and ground; both are empty and desolate. As the vast tract of land spreads out, the only object in the distance is the locomotive and its cars, carrying timber ties and iron rails. Gardner titled his photograph "*Westward the Course of Empire Takes Its Way*," a reference to the famous painting by Emanuel Gottlieb Leutze (FIGURE 13). (The phrase itself, which came from a poem by Bishop George Berkeley, was used as the title for a number of art works around

FIGURE 15　Carleton Watkins (American, 1829–1916). *Trestle on Central Pacific Railroad* (detail of PLATE 33). Negative: ca. 1877; print: ca. 1880. Albumen silver print, 20.5 × 31.3 cm (8¹⁄₁₆ × 12³⁄₈ in.). Los Angeles, J. Paul Getty Museum, 94.XA.113.26. Gift in memory of Leona Naef Merrill and in honor of her sister, Gladys Porterfield.

this time [FIGURE 14].)[24] Where Leutze celebrated the heroic notion of Manifest Destiny, Gardner revealed the more mundane reality of the Kansas landscape. But it was a mundane reality that was making expansionism possible on such a large scale: "If...railways had not been invented, the freedom and natural advantages of our Western States would have beckoned to human immigration and industry in vain."[25]

In contrast to Gardner's spartan scene, the image by Watkins is full of activity against a scenic backdrop, yet it too is unusual in its documentation of the railroad workers. Focusing his attention on a large wooden trestle near Sacramento, Watkins captured an image of the immigrant Chinese workers who were busy moving barrowloads of rubble (FIGURE 15). The Central Pacific Railroad employed over twelve thousand immigrant workers, who were paid as little as twenty-six dollars a month for performing some of the most dangerous jobs involved in the construction of the railroads.

FIGURE 16 Attributed to Henry Flather (English, active 1860s–1890s). *Untitled [Construction Site of the Metropolitan Railway]*, 1862–63. Albumen silver print on card stock, 21.8 × 17.6 cm (8½ × 6⅞ in.). York, England, The National Railway Museum/Science and Society Picture Library, 1478/21/63.

These photographers, working under the auspices of the railroad companies, extolled engineering achievements and spectacular views but rarely focused their lenses on the toil of the laborers—the men who built the trestles and bridges that afforded such amazing vantage points. Images such as Jackson's *"Loop" near Georgetown, Colorado* (PLATE 37) are more typical. Positioning his camera high up on a hillside, Jackson captured the magnitude of the track ascending the hill and the spectacular vista of the Colorado countryside. Watkins adopted a similar strategy in California when he documented the Tehachapi Loop (PLATE 38) of the Southern Pacific Railroad, owned by his friend Collis P. Huntington and other

investors. While recognizing the dominance of the railroad over the landscape, the images also celebrated that same landscape.

In John Wheeley Gough Gutch's early panorama of the South Devon Railway at Dawlish in England (PLATE 39), the tracks follow the coastline, becoming a boundary separating land from sea. Gutch, unlike his American counterparts, was not working on commission; his choices were based on aesthetics alone. Traveling in Cornwall during 1858, Gutch made a series of photographs that invariably contained views of the very railroad transporting him around the country. These views are among the earliest in British railroad photography. In the picture of Dawlish, Gutch created a panoramic view of the small beach town. Unable to make a single print large enough to encompass the entire view, he mounted two salted-paper prints together to form a panorama. In so doing he provided an accurate account of the relation of town to railroad to beach to sea. It becomes clear in reading the image just how important the railway was in creating and defining a new sense of space.

Unlike France and America, Britain—birthplace of the railroad and photography—did not yield any large-scale commissions for railroad photographs. From the very beginning the British had tended to view the railways with a certain degree of suspicion and even trepidation. Writing in 1829, the very year that George Stephenson's Rocket traveled at record speeds at the Rainhill trials,[26] Thomas Carlyle had stated that the present era was not a "Heroical, Devotional, Philosophical, or Moral Age, but above all others, the

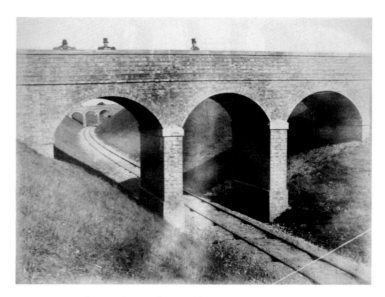

FIGURE 17 Unknown photographer, possibly Richard Keene (English, active ca. 1860s–1890s). *Coalville Branch*, ca. 1873. Albumen silver print, 21 × 15.5 cm (8¼ × 6⅛ in.). York, England, The National Railway Museum/Science and Society Picture Library, 1998.11843.31.

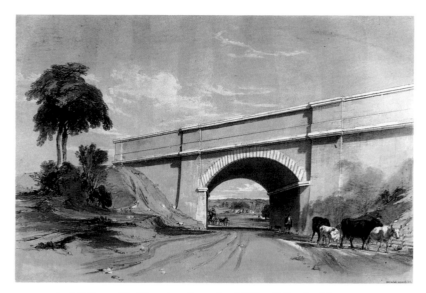

FIGURE 18 J. C. Bourne (English, active 1830s–1850s). *Oblique Bridge, Box Moor*, 1838. Lithograph, 22.7 × 39.7 cm (9 × 15⅝ in.). New Haven, Connecticut, Yale Center for British Art, Paul Mellon Collection.

Mechanical Age. It is the Age of Machinery, in every outward and inward sense of that word." Carlyle, like many of his contemporaries, did not wholly reject machinery but thought that progress brought with it a moral loss; he feared that man would become "mechanical in head and heart."[27] John Ruskin likened traveling by rail to the experience of being a posted parcel. What both Carlyle and Ruskin were referring to, in their different ways, is what scholar Leo Marx has identified as "alienation."[28]

With the introduction of the numerous railways around Britain there was a growing sense that nothing could stop the path of the iron road. While some welcomed the network of rails connecting the country, others felt it was violating the landscape with its amaz-

ing power over Nature itself. As Charles Dickens wrote in *Dombey and Son*, the railroad was "defiant of all paths and roads, piercing through the heart of every obstacle...through the fields, through the woods, through the corn, through the hay, through the mould, through the clay, through the rock."[29] The fact that many of these new and extremely profitable roads traveled through the heart of villages and low-income dwellings and city slums (FIGURE 16) led to contentious and highly political debates.[30]

Controversial or not, the railroads continued to fascinate artists. It is estimated that approximately two thousand lithographic prints of railroad subjects were published in Britain between 1830 and 1850 (FIGURE 18).[31] And yet very few photographs exist from the same

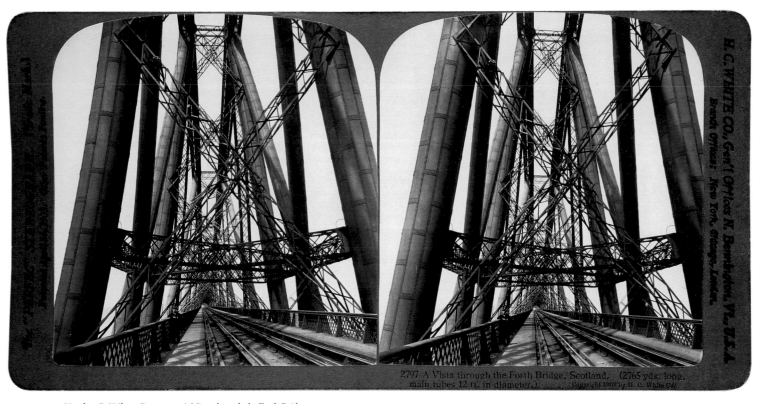

FIGURE 19 Hawley C. White Company. *A Vista through the Forth Bridge,*
Scotland, 1903. Gelatin silver print stereograph, 8.8 × 17.8 cm (3½ × 7 in.).
Los Angeles, J. Paul Getty Museum, 84.xc.870.692.

The following text is printed on the back of the stereograph:
"Our view is taken near the junction of two of these cantilevers, and suggests at first an
unhappy passenger's nightmare of a steamer's masts and funnels dancing in wild confusion.
But besides these immense tubes (12 feet in diameter) there is the network of cross-braces
endlessly repeated. The roadway provided for the two tracks, with high guardrails, and a
footway on either side. The length is the most impressive, as the eye follows the rails to a
distant vanishing-point, or loses itself in the thicket of overhead braces."

period. Railroads in Britain did not inspire any grand commissions; photographers in Britain were not promoting some high ideal of expansionism or destiny. Their legacy consists of photographs detailing some of the most spectacular and noteworthy engineering achievements of the age.

One such example is Henry Flather's *Inspection on the Metropolitan Railway* (PLATE 40). In May 1862 the Metropolitan Railway conducted a trial of its newly built London line, which would mark the beginning of London's Underground. Attended by prominent parliamentary figures, including William Ewart Gladstone (who happened to be a shareholder in the Metropolitan and District Railway) and gentry such as the duke of Sutherland, the inspection marked the beginning of rail travel within the city. It is strange to see such dignitaries sitting in coal cars, but the line would not open until January 1863 and was still under construction. The need for this urban railway was pressing. With the increased network of railroads around the country the cities were now becoming more accessible; as England continued to move from an agrarian to an industrial society, more and more people were flocking to the urban centers. Up until this point most stations had been located on the outskirts of the larger cities, but as the population grew so did the demand for public transit. Such was the demand that on the first day of service for the Metropolitan Railway almost forty thousand people turned out, and by the end of 1863 the company had carried nearly nine and a half million passengers.[32]

Of the many engineering achievements of the age, the Royal Albert Bridge at Saltash and the Forth Bridge in Scotland were two of the most notable, and there exist a considerable number of photographs of both (PLATES 41–44). Designed by the renowned English engineer Isambard Kingdom Brunel, the Royal Albert Bridge used a combination of tubular arch and chain cable, with two main spans of 455 feet. The spans were constructed separately, floated into the River Tamar, and raised hydraulically. The stone pier was then built up to the girder about three feet at a time. One of the first cantilever bridges in the world, the Forth Bridge in Scotland was designed and built by Benjamin Baker and John Fowler in the late 1880s. An engineering marvel, the bridge consisted of three cantilevers with two suspended spans employing fifty-eight tons of steel. There was controversy surrounding the structure. Some critics found it ugly and oversized; admirers thought it was ahead of its time. Given the considerable interest in the structure, it was frequently photographed (PLATE 43). The formidable network of iron girders was often portrayed as an abstract arrangement, dizzying in its visual effect (PLATE 44 and FIGURE 19). The camera was able to show perspective dazzlingly—it conveyed recession in such a way as to exploit the linear nature of the railroad yet retain the reality of the scene. These photographs defied the traditional rules of landscape composition, by which the eye is gently led into the distance by means of an intricate balance of fore-, middle-, and background. Like the railroad itself, these prints plunge the viewer directly into the scene.

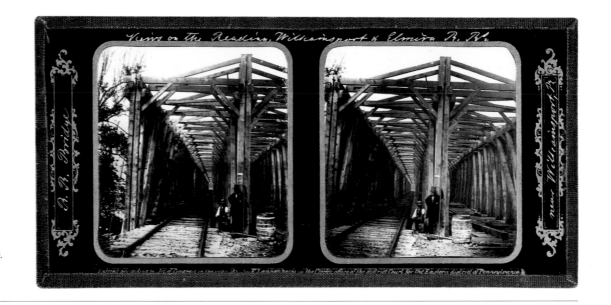

FIGURE 20 William and Frederick Langenheim (American [b. Germany], 1807–1874 and 1809–1879). *Views on the Reading, Williamsport, and Elmira Railroad/Railroad Bridge/Near Williamsport, Pennsylvania,* 1854. Glass stereograph, 8.3 × 17.1 cm (3¼ × 6¾ in.). Los Angeles, J. Paul Getty Museum, 2000.10.185.

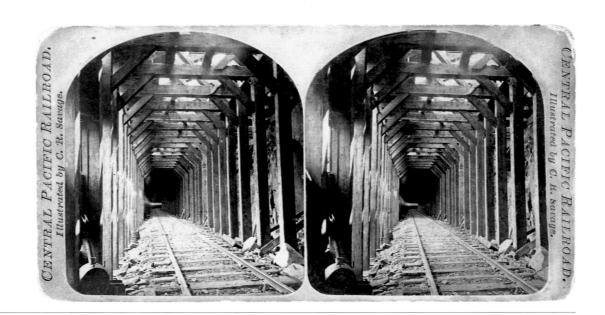

FIGURE 21 Charles Savage (American, 1832–1909). *Interior of Snow Sheds over the Sierra Mountains, California,* ca. 1870. Albumen silver print stereograph, 8.7 × 17.5 cm (3⁷⁄₁₆ × 6⅞ in.). Los Angeles, J. Paul Getty Museum, 84.xc.873.6509.

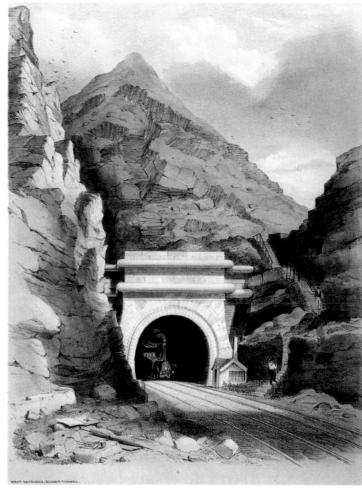

FIGURE 22 Arthur Fitzwilliam Tait (English, 1819–1905). *West Entrance, Summit Tunnel,* 1845. Lithograph; image: 33.7 × 25.7 cm (13¼ × 10⅛ in.). New Haven, Connecticut, Yale Center for British Art, Paul Mellon Collection.

Such compositions were popular in railroad photography. From the early glass stereograph by the Langenheim Brothers (FIGURE 20) to the prints by Juan Laurent in Spain (PLATE 45) and Louis-Émile Durandelle in France (PLATE 46), photographers were responding to this new subject in a remarkably similar fashion. In these instances the structure of the bridge fills the picture plane, only to recede into the distance, while the camera occupies the ground immediately over or adjacent to the tracks—a compositional technique that was first explored in the series of stereographs by the Langenheim Brothers. The sense of recession is enhanced by the strong geometric pattern of the wooden trusses and iron girders that leads the viewer's eye to a distant vanishing point. The dynamic perspective underlines the intrinsic power and excitement associated with the railroad itself. To prevent the image from becoming too abstract there is usually the addition of a human figure to provide an important sense of scale. A similar viewpoint was often used to depict tunnels (PLATES 47–49 and FIGURE 22), whether in France or Peru. As one writer notes: "Since straightness was of great importance on a railway, it frequently became necessary when bisecting other roads or ways to adopt such skew forms. The idiosyncrasy of this kind of construction made it a favorite subject of artists and engravers, many of whom also made use of the straight line of the railway track itself, employing a recessional perspective and often adding an approaching train."[33]

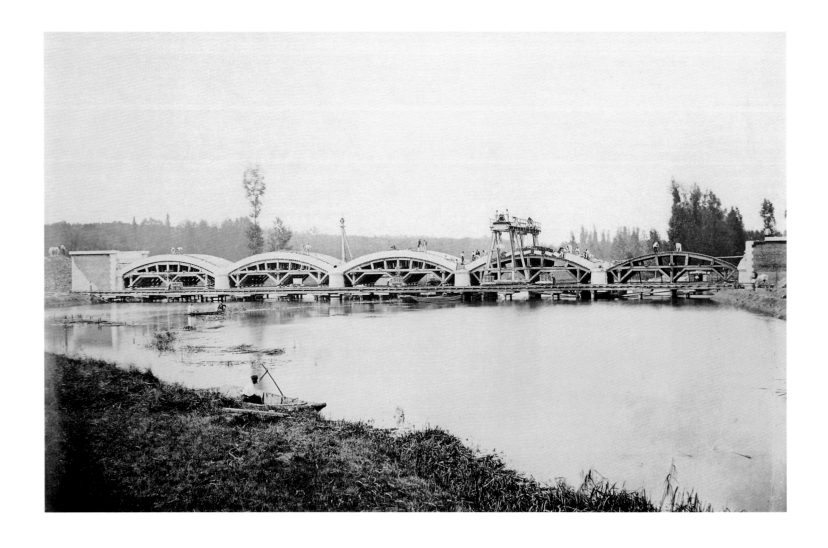

PLATE 24 Hippolyte-Auguste Collard (French, 1812–1897). *Line from Villeneuve-Saint-Georges to Montargis/Viaduct on the Loing (near Montargis)*, July 1865. From the album "Chemin de fer du Bourbonnais. Moret-Nevers-Vichy." Albumen silver print, 22.9 × 36.5 cm (9 × 14⅜ in.). Los Angeles, J. Paul Getty Museum, 84.XM.407.17.

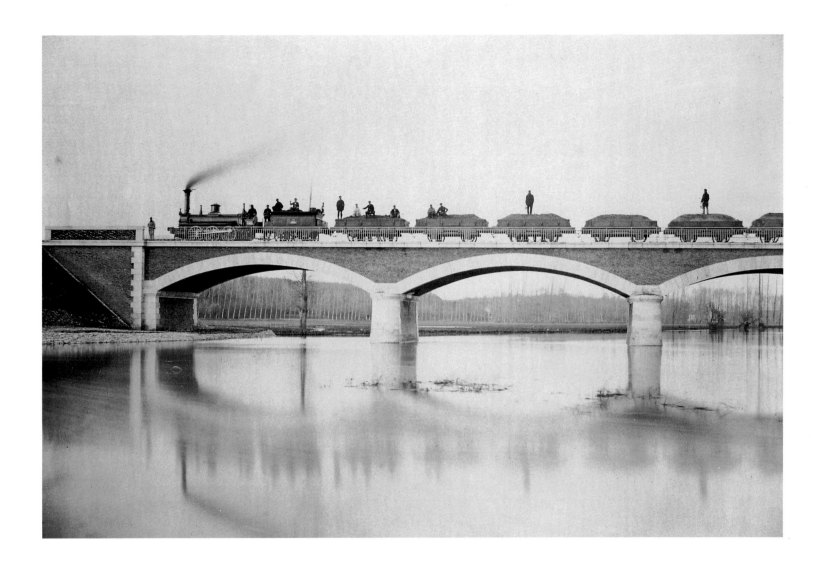

PLATE 25 Hippolyte-Auguste Collard (French, 1812–1897). *Line from Villeneuve-Saint-Georges to Montargis / Viaduct on the Loing (near Montargis),*
December 1866. From the album "Chemin de fer du Bourbonnais. Moret-Nevers-Vichy." Albumen silver print, 22.5 × 34.3 cm (8²⁷⁄₃₂ × 13½ in.).
Los Angeles, J. Paul Getty Museum, 84.XM.407.18.

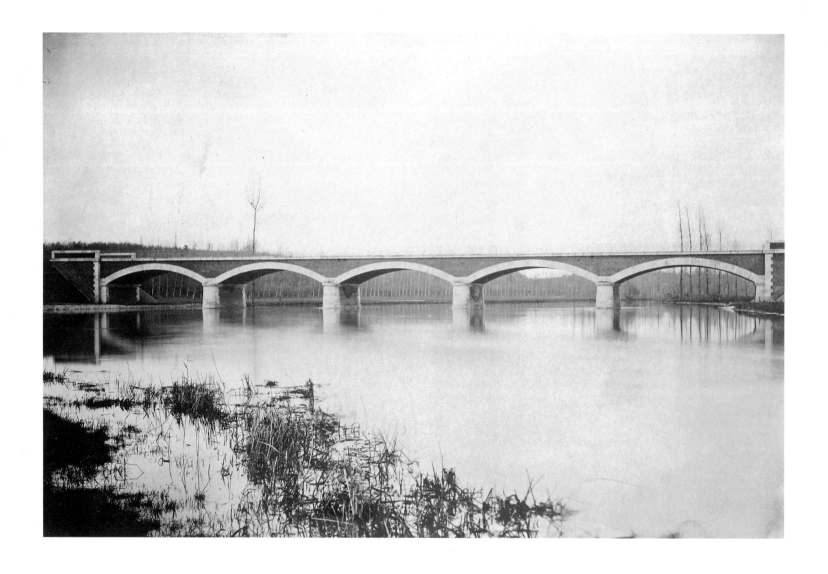

PLATE 26 Hippolyte-Auguste Collard (French, 1812–1897). *Line from Villeneuve-Saint-Georges to Montargis / Viaduct on the Loing (near Montargis)*, December 1866. From the album "Chemin de fer du Bourbonnais. Moret-Nevers-Vichy." Albumen silver print, 22.5 × 34.9 cm (8⅞ × 13¾ in.). Los Angeles, J. Paul Getty Museum, 84.XM.407.19.

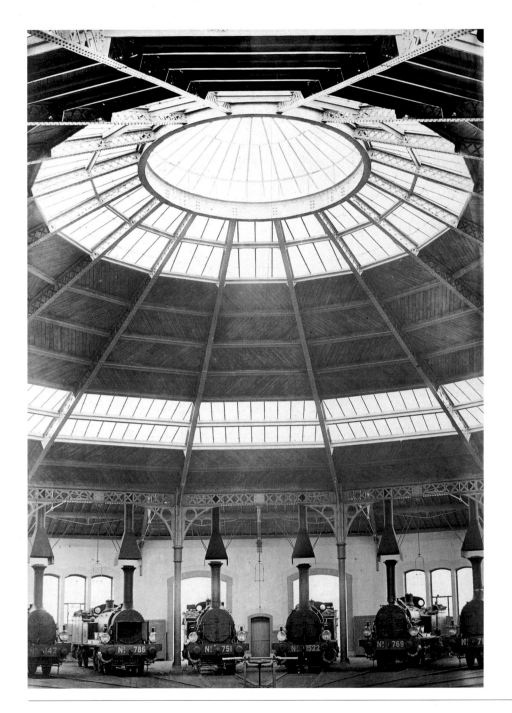

PLATE 27 Hippolyte-Auguste Collard (French, 1812–1897). *Roundhouse for Thirty-two Locomotives at Nevers on the Bourbonnais Railway*, ca. 1860–63. From the album "Chemin de fer du Bourbonnais. Moret-Nevers-Vichy." Albumen silver print, 31 × 22.4 cm (12¼ × 8¹³⁄₁₆ in.). Los Angeles, J. Paul Getty Museum, 84.XO.393.28.

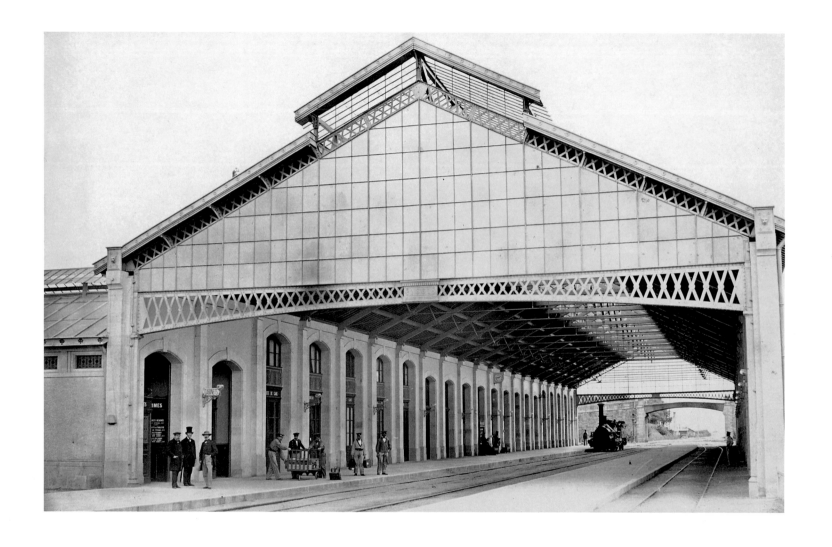

PLATE 28 Hippolyte-Auguste Collard (French, 1812–1897). *Nevers Station*, 1860–63. From the album "Chemin de fer du Bourbonnais.
Moret-Nevers-Vichy." Albumen silver print, 19.8 × 31.6 cm (6¾ × 12½ in.). Los Angeles, J. Paul Getty Museum, 84.xo.393.26.

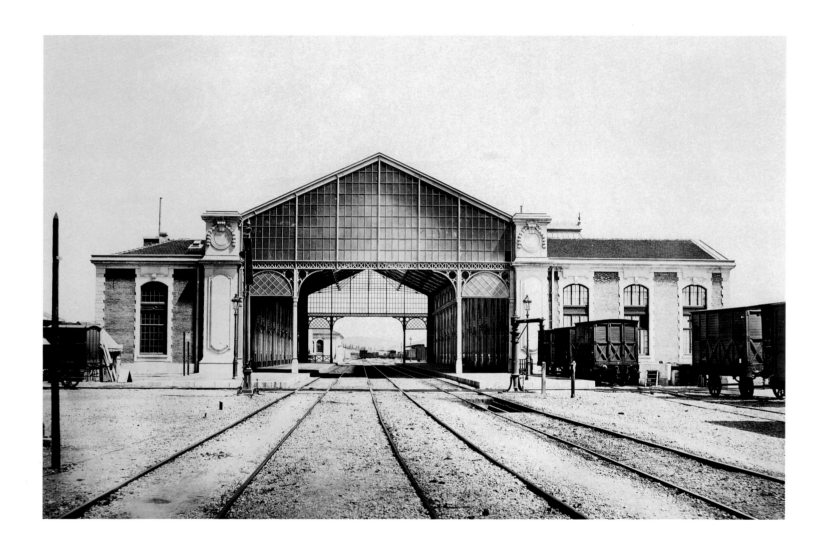

PLATE 29 Édouard Baldus (French, 1813–1889). *Toulon*, ca. 1861. From the album "Chemins de fer de Paris à Lyon et à La Méditerranée."
Albumen silver print, 32.9 × 43.3 cm (12 15/$_{16}$ × 17 1/$_{32}$ in.). Los Angeles, J. Paul Getty Museum, 84.xo.734.1.69.

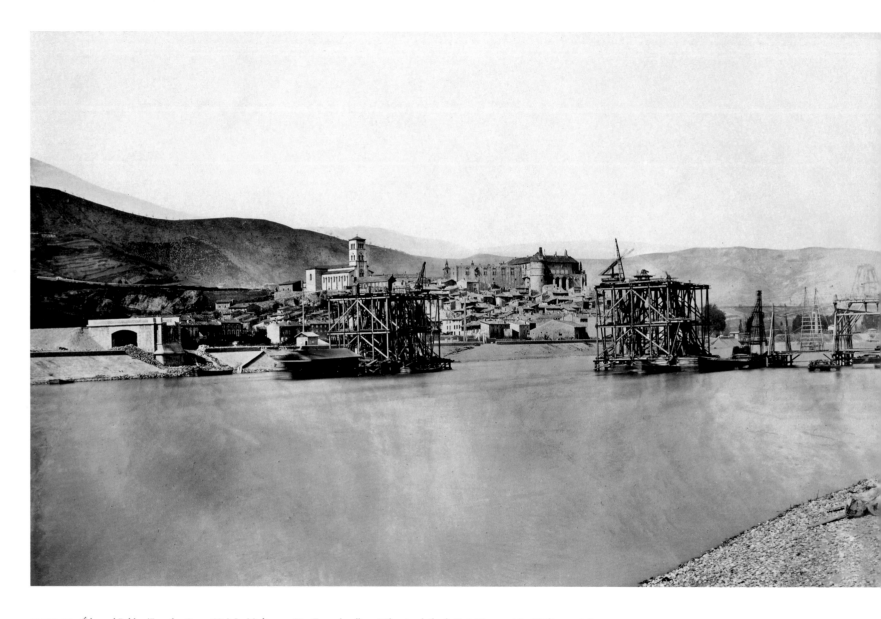

PLATE 30 Édouard Baldus (French, 1813–1889). *La Voulte*, ca. 1861. From the album "Chemins de fer de Paris à Lyon et à La Méditerranée."
Albumen silver print, 26.3 × 83.2 cm (10¹¹⁄₃₂ × 32¾ in.). Los Angeles, J. Paul Getty Museum, 84.xo.401.16.

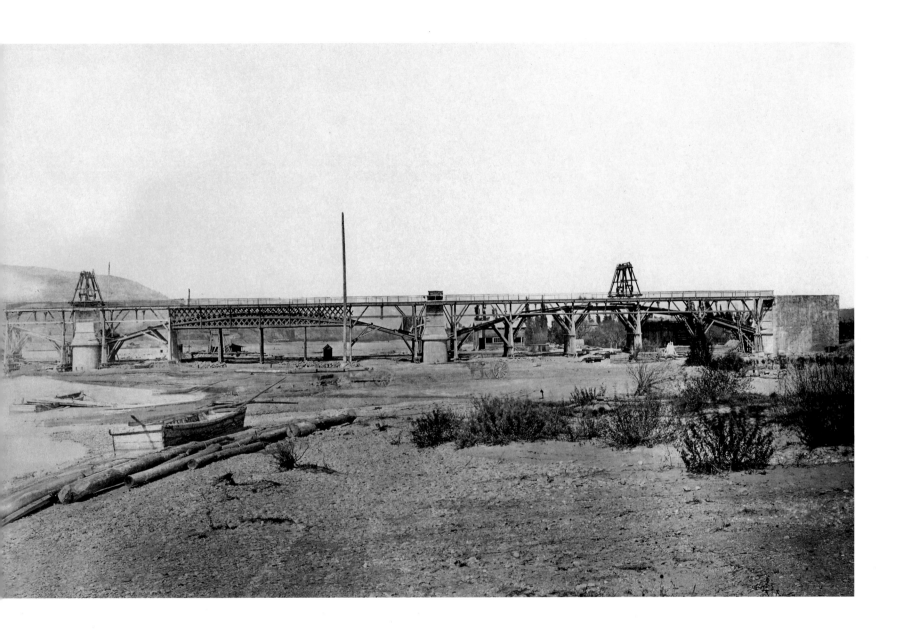

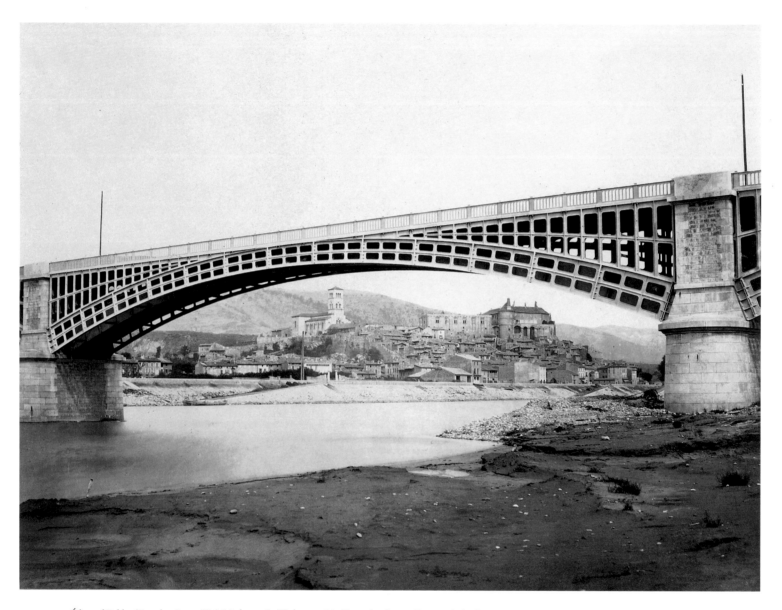

PLATE 31 Édouard Baldus (French, 1813–1889). *Viaduct at La Voulte*, ca. 1861. From the album "Chemins de fer de Paris à Lyon et à La Méditerranée." Albumen silver print, 29.8 × 40.8 cm (11¾ × 16⅟₁₆ in.). Los Angeles, J. Paul Getty Museum, 84.x0.734.1.18.

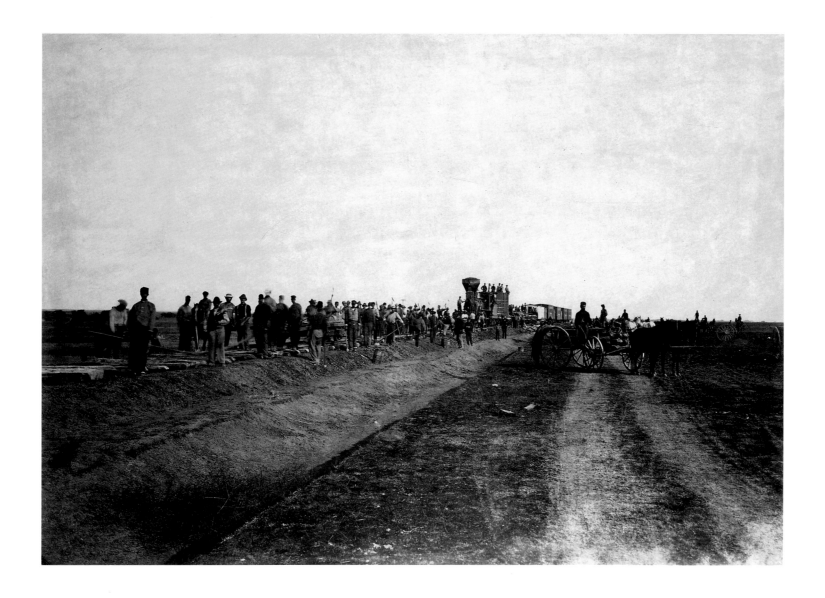

PLATE 32 Alexander Gardner (American [b. Scotland], ca. 1821–1882). *"Westward the Course of Empire Takes Its Way,"* October 19, 1867.
Albumen silver print, 32.9 × 47.5 cm (13 × 18¹¹⁄₁₆ in.). Los Angeles, J. Paul Getty Museum, 84.xm.1027.37.

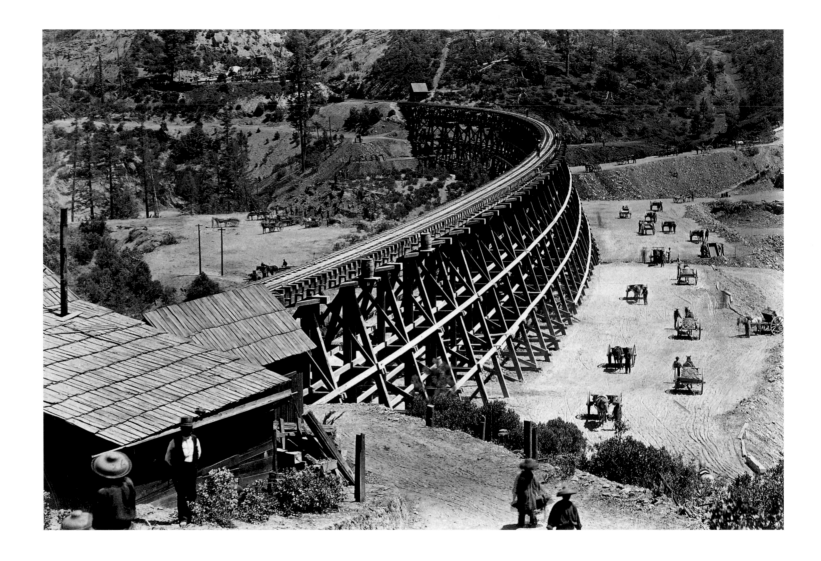

PLATE 33 Carleton Watkins (American, 1829–1916). *Trestle on Central Pacific Railroad.* Negative: ca. 1877; print: ca. 1880.
From the album "California Tourists Association, San Francisco." Albumen silver print, 20.5 × 31.3 cm (8 1/16 × 12 3/8 in.). Los Angeles,
J. Paul Getty Museum, 94.XA.113.26. Gift in memory of Leona Naef Merrill and in honor of her sister, Gladys Porterfield.

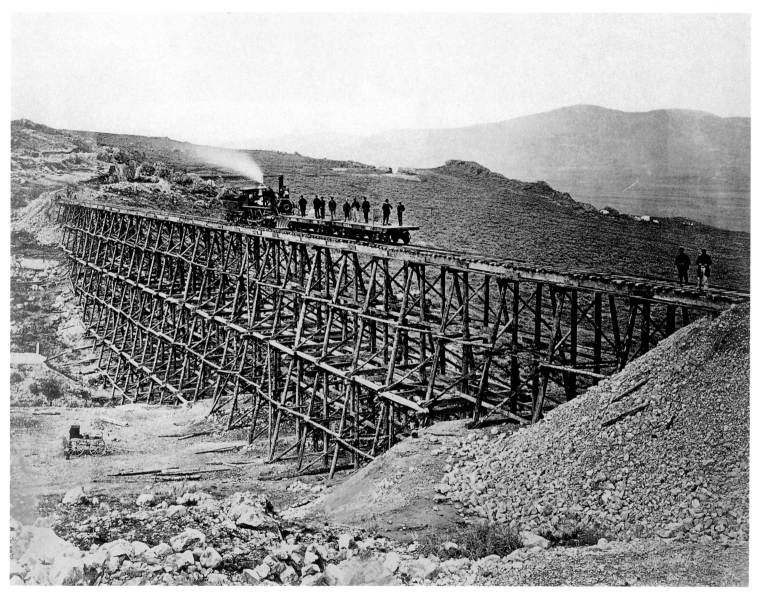

PLATE 34 A. J. Russell (American, 1830–1902). *Trestle Work, Promontory Point*, 1869–70. From the book *Sun Pictures of Rocky Mountain Scenery*
(New York: Julius Bien, 1870). Albumen silver print, 15.5 × 20.4 cm (6⅛ × 8¹⁄₁₆ in.). Los Angeles, J. Paul Getty Museum, 84.XB.1339.28.

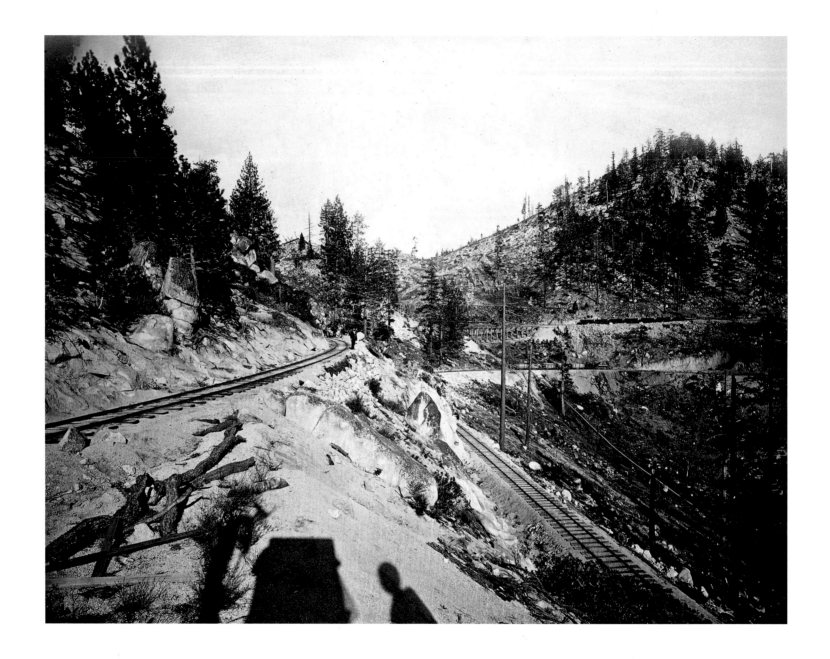

PLATE 35 Carleton Watkins (American, 1829–1916). *View on Lake Tahoe*, 1877. Albumen silver print, 40.3 × 52.7 cm (15⅞ × 20¾ in.). Los Angeles, J. Paul Getty Museum, 87.XM.72.4.

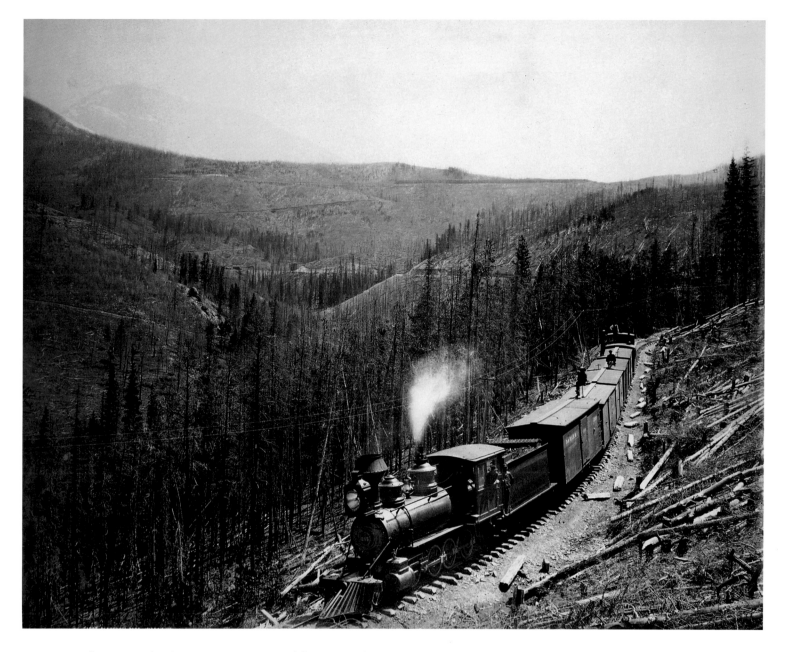

PLATE 36 William Henry Jackson (American, 1843–1942). *Marshall Pass—Westside*, 1882–96. Albumen silver print, 43.2 × 49.2 cm (17 × 19⅜ in.). Los Angeles, J. Paul Getty Museum, 84.xm.494.9.

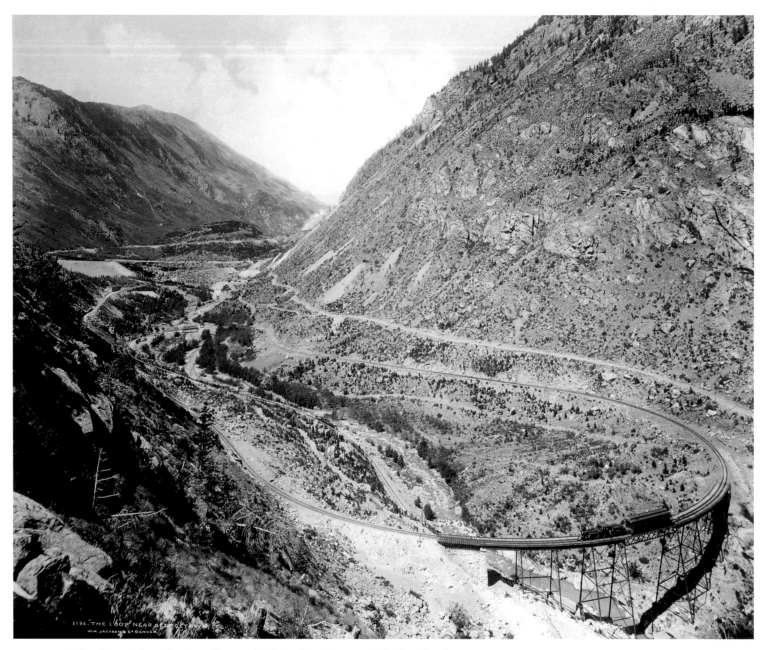

PLATE 37 William Henry Jackson (American, 1843–1942). *"The Loop" near Georgetown, Colorado,* 1884–96.
Albumen silver print, 44.5 × 48.6 cm (17½ × 19⅛ in.). Los Angeles, J. Paul Getty Museum, 85.XM.5.35.

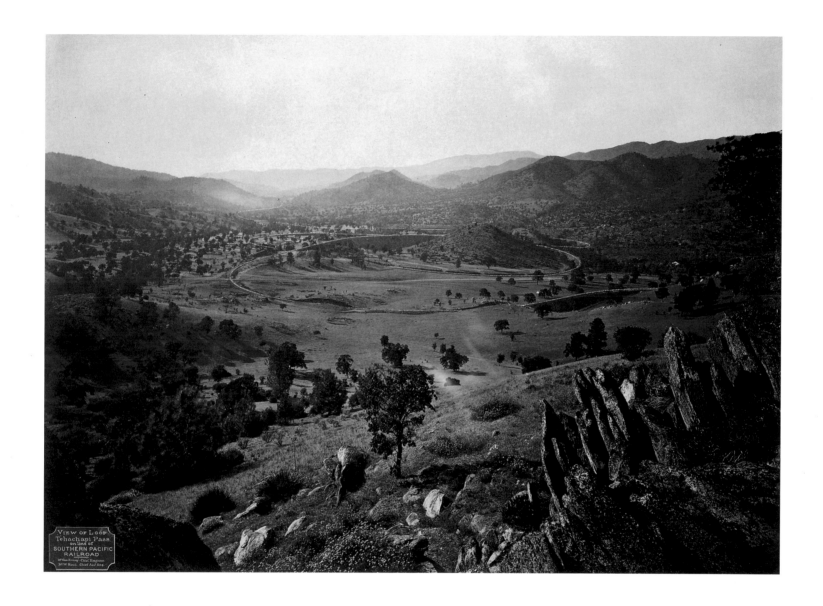

PLATE 38 Carleton Watkins (American, 1829–1916). *View of "Loop," Tehachapi Pass on Line of Southern Pacific Railroad,* ca. 1876.
Albumen silver print, 36.8 × 53.3 cm (14½ × 21 in.). Los Angeles, J. Paul Getty Museum, 2001.94.2. Gift of the Wilson Center for Photography.

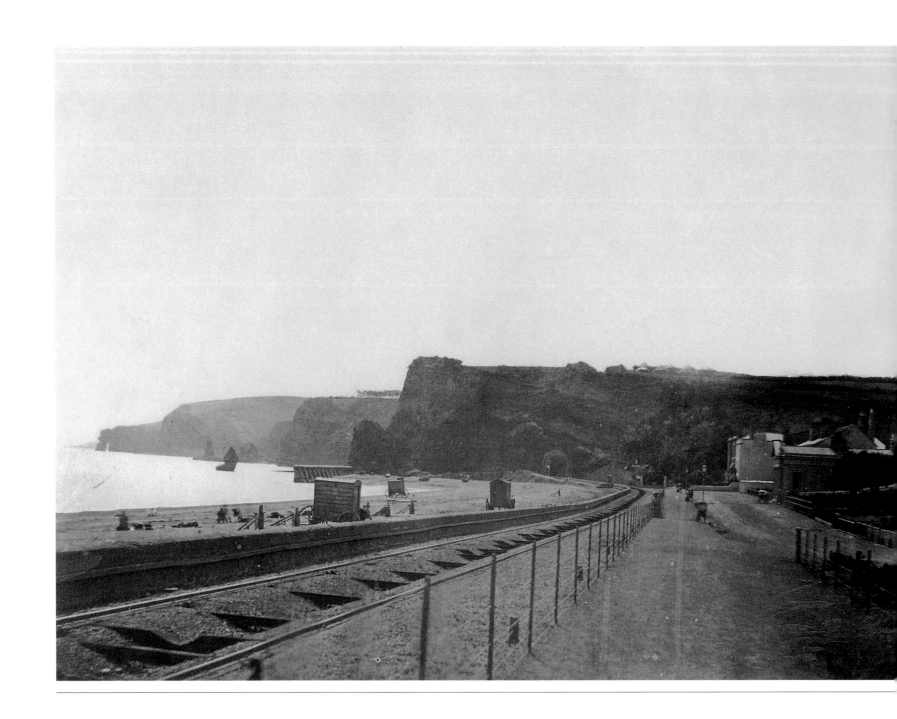

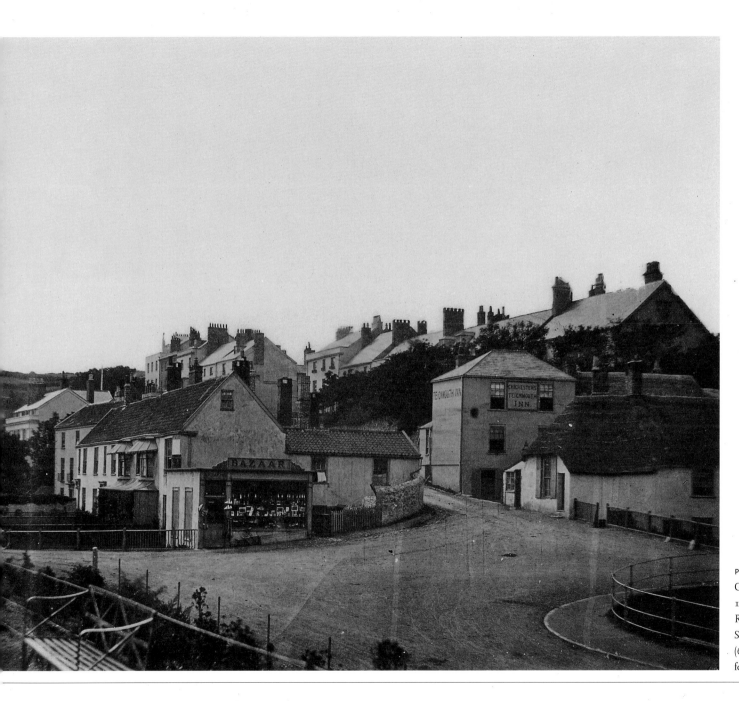

PLATE 39 John Wheeley
Gough Gutch (English,
1809–1862). *South Devon
Railway, Dawlish*, 1856–57.
Salt print, 15.2 × 45.7 cm
(6 × 18 in.). Wilson Center
for Photography, LLC.

PLATE 40 Henry Flather (English, active 1860s–1890s). *Inspection on the Metropolitan Railway*, 1862.
Albumen silver print, 25.4 × 39.4 cm (10 × 15½ in.). Stephen White Collection II.

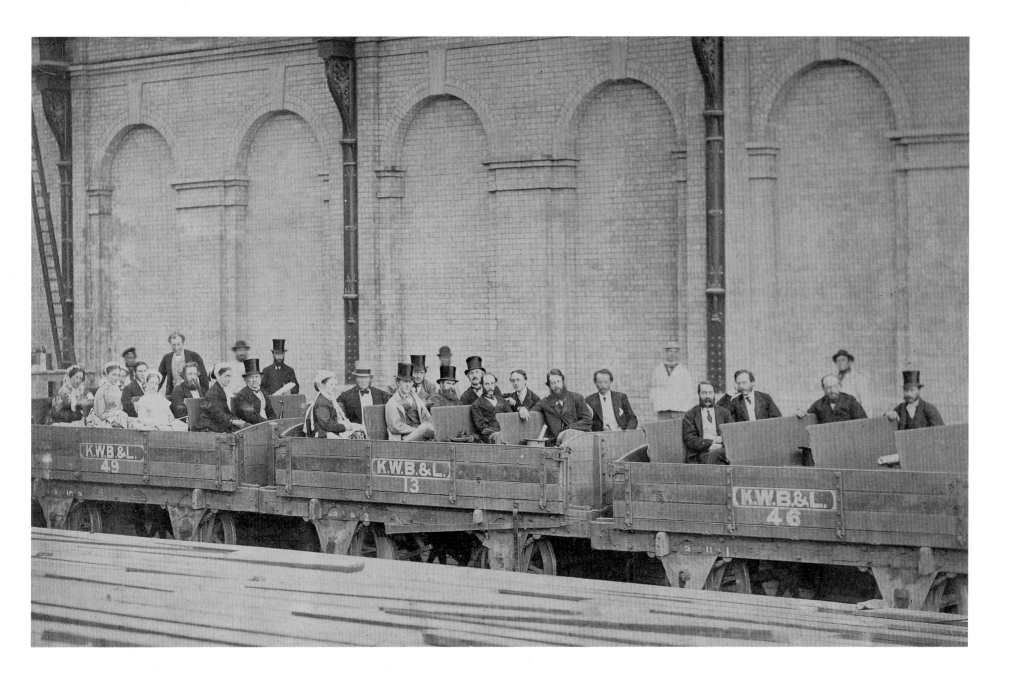

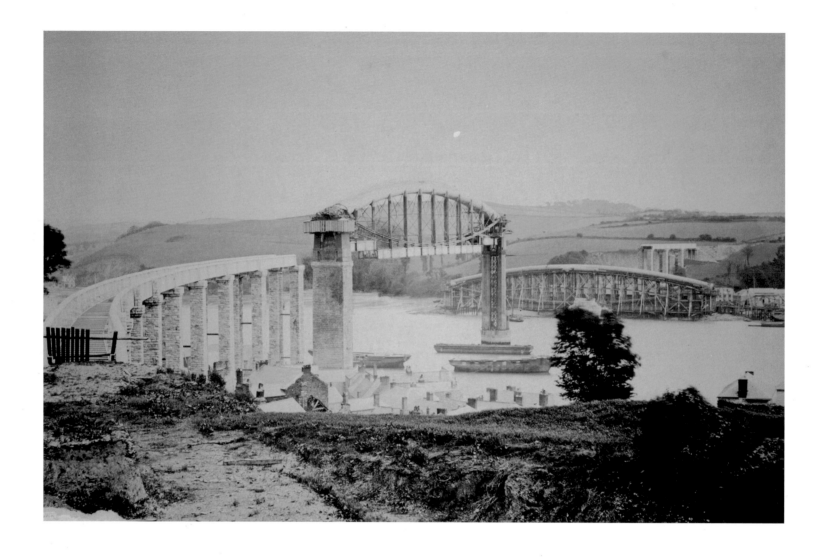

PLATE 41 Unknown photographer. *Royal Albert Bridge at Saltash, under Construction in Spring 1858*, 1858. Albumen silver print, 32.1 × 20.7 cm (12⅜ × 8⅛ in.). York, England, National Railway Museum/Science and Society Picture Library, 945/51.

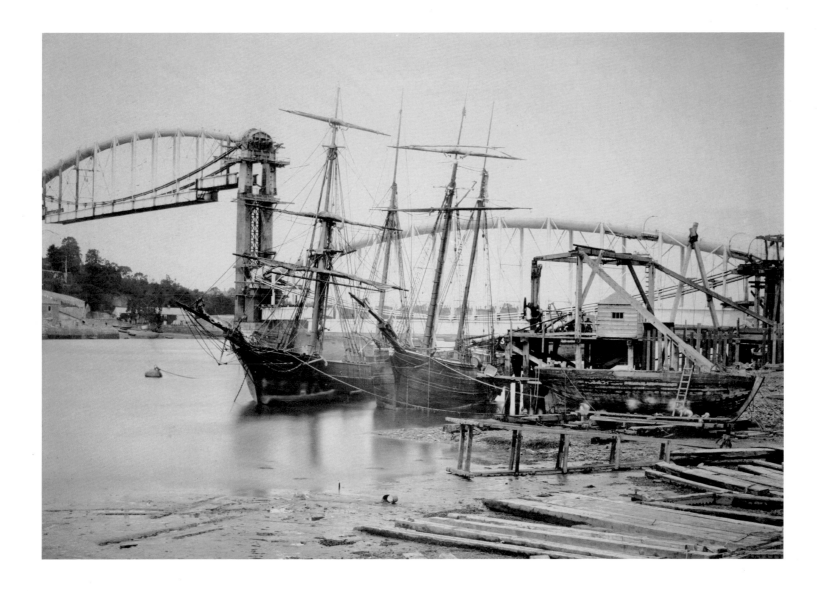

PLATE 42 Unknown photographer. *Royal Albert Bridge at Saltash, under Construction in August 1858.* Negative: August 1858; print: 1880s.
Gelatin silver printing-out paper, 32 × 22 cm (12⅝ × 8⅝ in.). York, England, National Railway Museum/Science and Society Picture Library, 946/1-3/51.

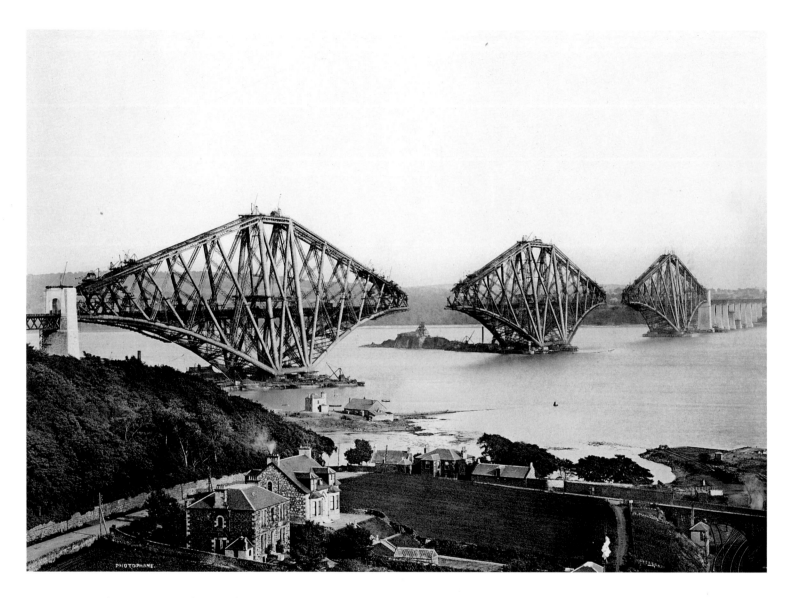

PLATE 43 Photophane Company. *Cantilevers Complete, July 9, 1889. From The Forth Bridge in Its Various Stages of Construction and Compared with the Most Notable Bridges of the World* (Edinburgh: R. Grant and Son, ca. 1890). Photogravure, 23.4 × 28.5 cm (9¼ × 11³⁄₁₆ in.). Los Angeles, J. Paul Getty Museum, 84.XB.874.3.1.34.

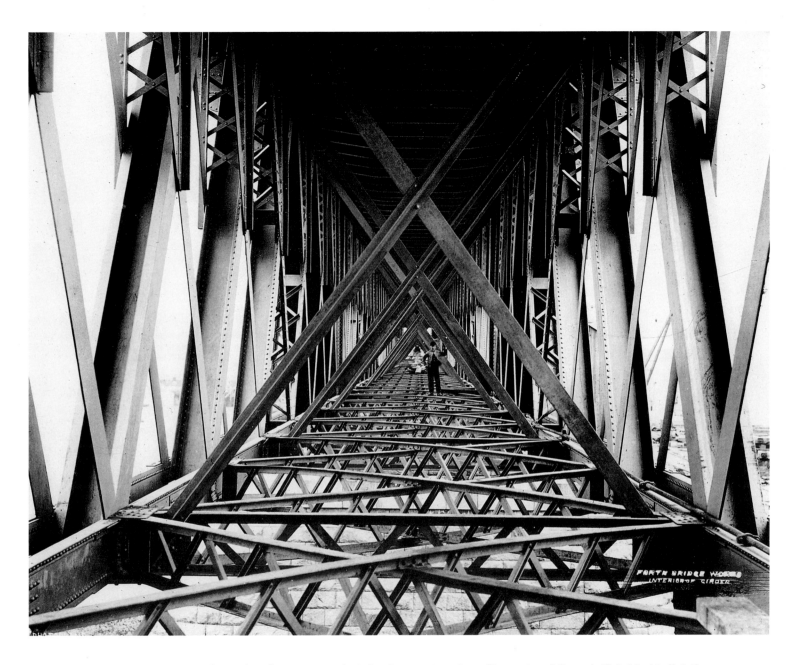

PLATE 44 Photophane Company. *Interior of Approach Viaduct*, 1889. From *The Forth Bridge in Its Various Stages of Construction and Compared with the Most Notable Bridges of the World* (Edinburgh: R. Grant and Son, ca. 1890). Photogravure, 18.1 × 22.8 cm (7⅛ × 9 in.). Los Angeles, J. Paul Getty Museum, 84.XB.874.3.1.30.

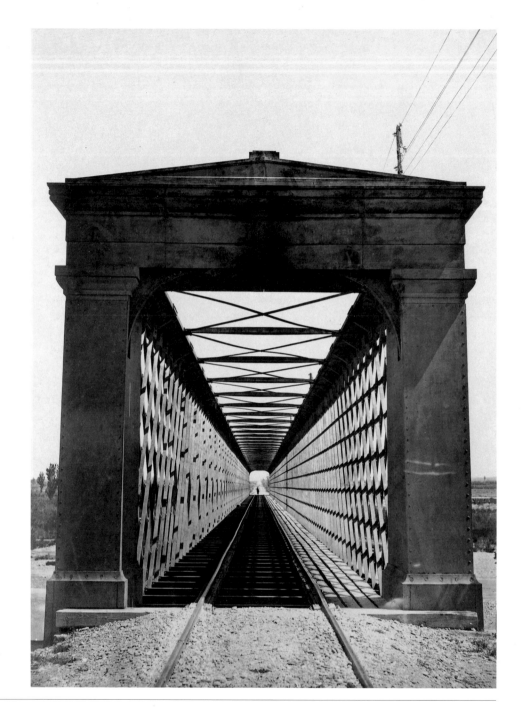

PLATE 45 Juan Laurent (French, 1816–1892). *The Zuera Bridge*, ca. 1867. Albumen silver print from glass negative, 33.9 × 24.8 cm (13⅜ × 9¾ in.). New York, The Metropolitan Museum of Art, 1999.138. Purchase, The Horace W. Goldsmith Foundation Gift, by exchange, 1999.

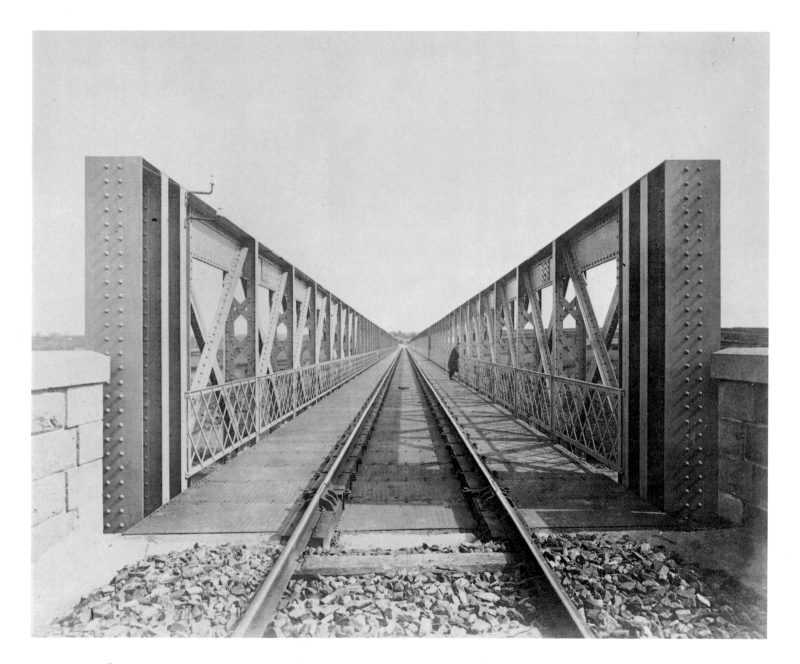

PLATE 46 Louis-Émile Durandelle (French, 1839–1917). *Pont de la Penzé*, 1882. Albumen silver print, 21.4 × 26.4 cm (8⅜ × 10⅜ in.). Los Angeles, Research Library, The Getty Research Institute, 93.R.22.

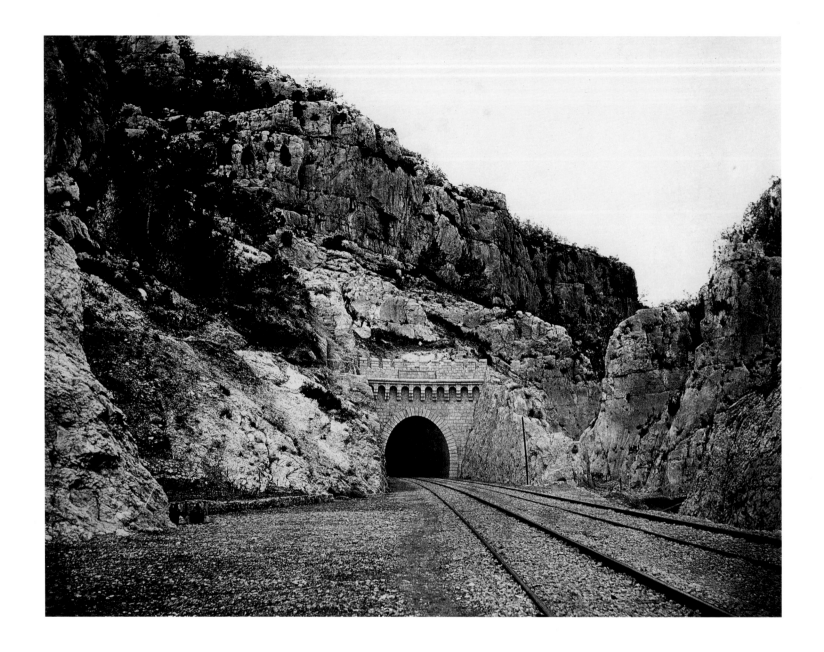

PLATE 47 Édouard Baldus (French, 1813–1889). *Tunnel at Nerthe*, 1860s. From the album "Chemins de fer de Paris à Lyon et à La Méditerranée."
Albumen silver print, 32.9 × 43.4 cm (13 × 17 1/16 in.). Los Angeles, J. Paul Getty Museum, 84.xo.401.54.

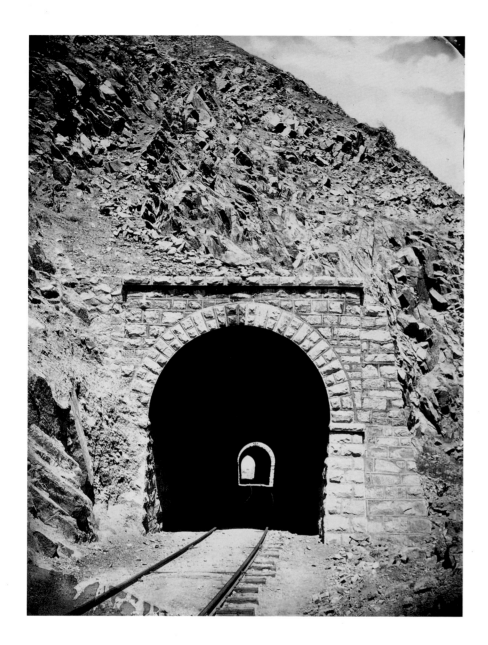

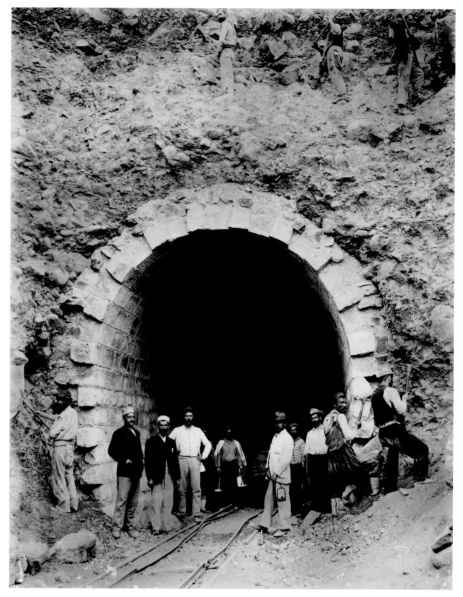

PLATE 48 Unknown photographer. *Railroad Tunnel in Peru*, late 1860s. Albumen silver print, 25.4 × 19.7 cm (10 × 7¾ in.). Stephen White Collection II.

PLATE 49 Unknown photographer. *View of Tunnel*. From the series "Construction de chemin de fer en Anatolie," 1880–85. Albumen silver print, 24.2 × 19.2 cm (9½ × 7½ in.). Los Angeles, Research Library, The Getty Research Institute, 96.R.14.

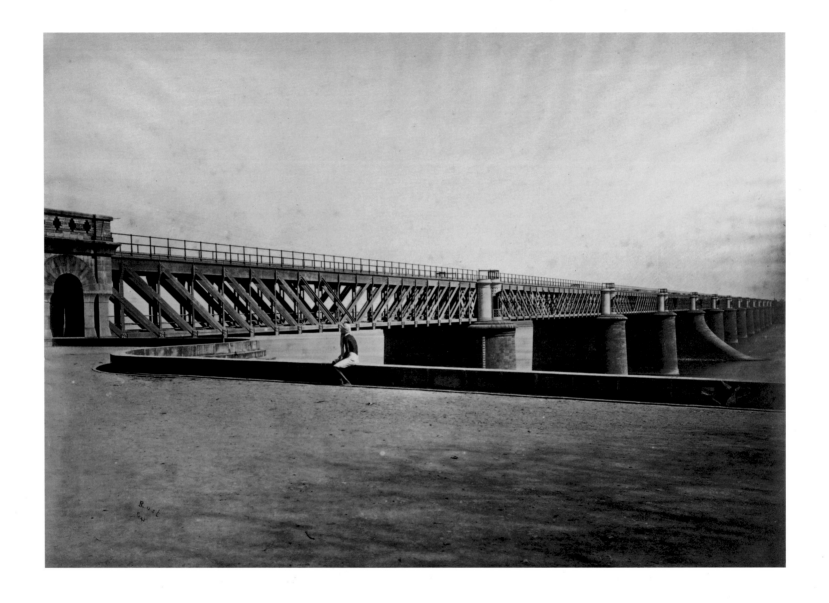

PLATE 50 Unknown photographer. *View of a Bridge in India*, ca. 1880s. Albumen silver print, 20.4 × 29.2 cm (8 × 11⁷⁄₁₆ in.).
Los Angeles, Research Library, The Getty Research Institute, 93.R.22.

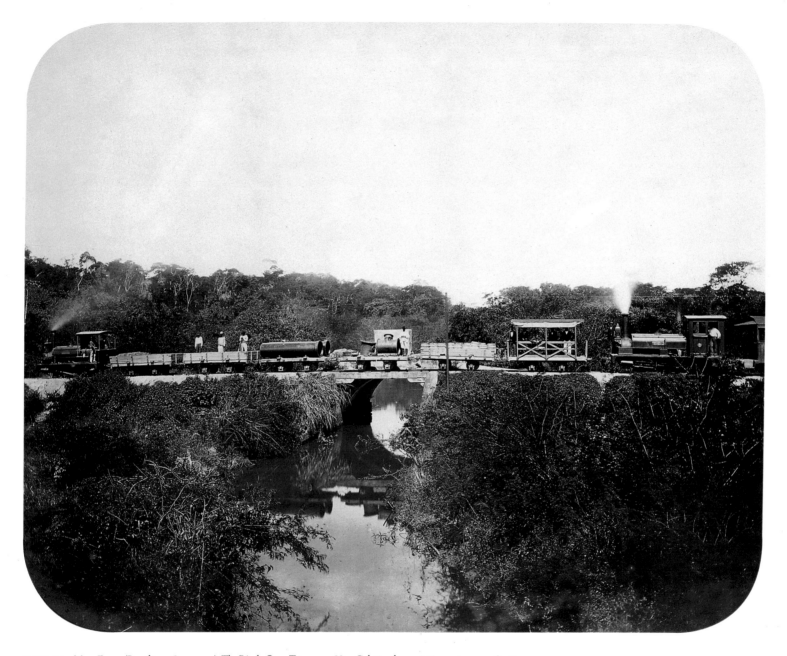

PLATE 51 Marc Ferrez (Brazilian, 1843–1923). *The Rio do Ouro Tramway*, 1880s. Gelatin silver printing-out paper, 26.5 × 39.4 cm (10⁷⁄₁₆ × 15½ in.). Los Angeles, J. Paul Getty Museum, 85.xm.322.1.

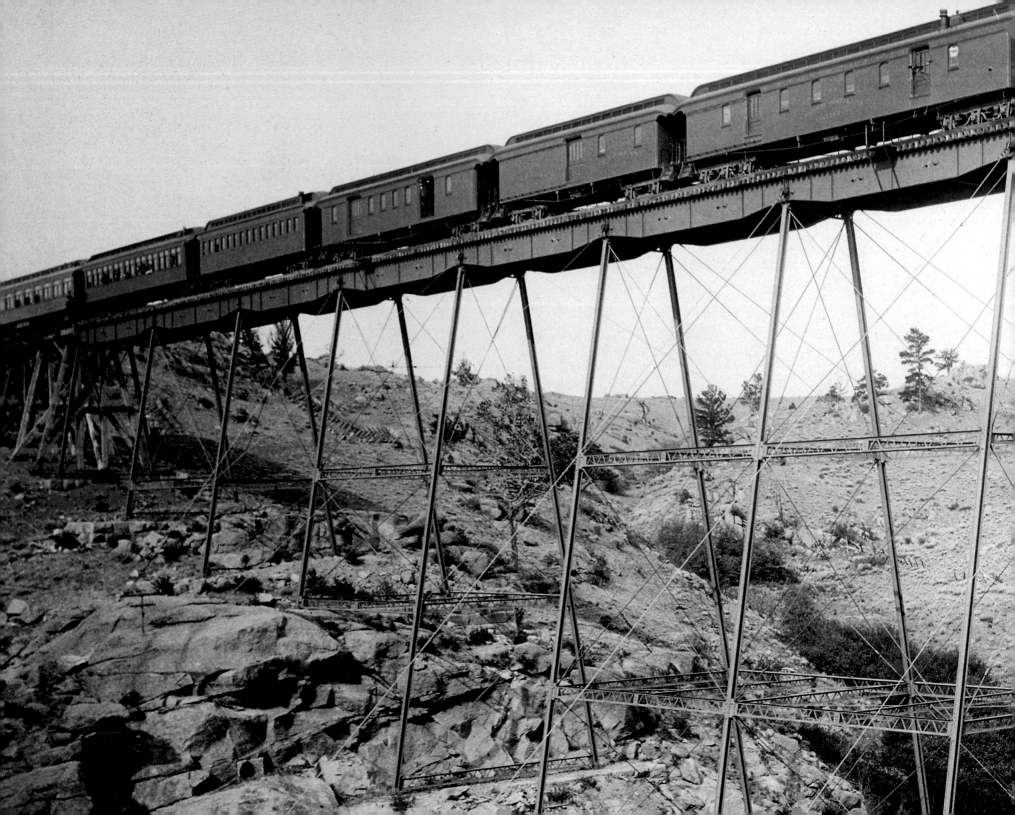

The Moving Landscape

FIGURE 23 William H. Rau (American, 1855–1920). *Interior of Photographic Car,* ca. 1891. Lantern slide. Courtesy of the Library Company of Philadelphia, p9474, #83b.

HILE THE RAILROAD opened up geographic areas that were previously inaccessible, it simultaneously "destroyed" space by reducing the distance between two points.[34] The average speed of the early trains in the 1840s was twenty miles per hour, approximately three times the speed of a stagecoach. In 1839, the year photography was announced, the *Quarterly Review* described the railroad as "the gradual annihilation, approaching almost to the final extinction, of that space and of those distances which have hitherto been supposed unalterably to separate the various nations of the globe."[35] The sense is one of sublime technology; what was previously considered only within the province of divine power was now achievable by man.[36] With the introduction of the locomotive, travel had become mechanized. This changed the traveler's experience of the landscape; in effect, the traveler became a slightly distanced observer of nature, looking out from the confines of an elevated rail carriage.

The railroad offered a new way of experiencing the world, and images that reflected this experience were relayed to the ever-increasing passenger population. The photographer, following the route of the railroad, recorded idyllic landscapes, dramatic viewpoints, and scenic attractions. Recognizing the persuasive power of photographs, railroad companies began to commission work. As officially appointed artists, photographers were given free passage on designated routes and, in many cases, a specially equipped car, complete with darkroom and storage facilities (FIGURE 23).[37]

William Henry Jackson was such a photographer. During the 1880s and '90s he worked for the Denver and Rio Grande Railroad and Colorado Midland Railroad, among others, documenting their

routes through Colorado. Jackson had a keen eye for composition and would scale cliff faces and hillsides with his bulky camera equipment in tow, intent on capturing a spectacular scene. His *Cañon of the Rio Las Animas* (PLATE 53), made between 1882 and 1886, is a breathtaking example of his skill and ingenuity. Upon first glance it is somewhat difficult to distinguish the locomotive from the craggy rock face, which seems to swallow up the engine and train—but this is where the mastery lies; Jackson is inducing a degree of awe by adopting such an oblique angle. The steep and inhospitable terrain is further exaggerated by the low viewpoint of the camera, causing the image to read as a celebration of man's power over nature. The same is true of the *Royal Gorge* (PLATE 54), also made around the early 1880s. Jackson exploits the natural geological properties of the gorge to create an image that possesses strong graphic qualities; the bold masses of dark rock that impose on either side of the frame and the sliver of sky in between reinforce the centrality and importance of the railroad by framing and directing one's attention to the track in the immediate foreground.

Whereas many photographers preferred a horizontal format to a vertical one, Jackson alternated between the two. He would choose a vertical arrangement (PLATE 54) in order to exploit the view and emphasize the dramatic height of the rocky terrain. The choice was deliberate, in the same way that he chose a horizontal format to document the Dale Creek Bridge (located near the summit of Sherman Hill in Wyoming) (PLATE 55). Here, Jackson is intent on creating an image that shows the full expanse of the bridge, the longest trestle on the Union Pacific line—some seven hundred feet long, with the train of cars and locomotives progressing from left to right across the composition. Jackson takes the exciting, perhaps terrifying, characteristics of the spindly structure and incorporates them into his photograph. From his low viewpoint he frames the locomotives against the backdrop of the sky and in so doing acknowledges the commonly held notion that traveling by train was akin to flying through the air. Indeed, any passenger looking out the window at this particular crossing would have seen nothing underfoot but a terrific drop down to the canyon below. One passenger who crossed the earlier wooden version of the bridge (FIGURE 24) gave the following account: "Dale Creek Bridge comes into sight. There is a rush to the platform [of the coaches] to enjoy the sensation of crossing the abyss. Seen from a distance, this marvel of wood spanning the deep rocky bed of the stream has the airiest and most gossamer-like effect, but it is a substantial structure over which our long train goes roaring into safety, although not without a few shrieks from those on platforms who are averse to seeing 130 feet of space yawning below them."[38]

Jackson's railroad career had begun earlier, in the late 1860s, when he received an order for ten thousand stereographs of the route along the Union Pacific Railroad. In those days Jackson relied on the benevolence of the railroad employees, as he recalled in his autobiography, *Time Exposure*: "The trainmen were, on the whole, very obliging about letting us off between stops, and equally so about picking

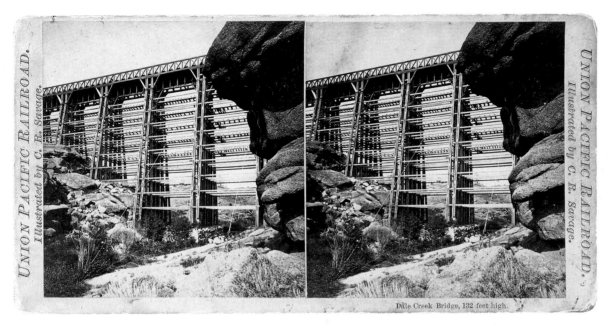

FIGURE 24 Charles Savage (American, 1832–1909). *Dale Creek Bridge,*
ca. 1868–76. Albumen silver print stereograph, 8.7 × 17.5 cm (3¹³⁄₃₂ × 6⅞ in.).
Los Angeles, J. Paul Getty Museum, 84.xc.873.599.

us up when we flagged them."[39] By the 1880s, when Jackson made
the image entitled *Cameron's Cone from "Tunnel 4"* (PLATE 56), he
was traveling in the style and comfort of his own private car. Jackson
has carefully composed the photograph, which shows a traveling
party enjoying a ride on the rails through spectacular scenery. He has
positioned his camera on top of the tracks, which draws the viewer
into the frame and leads one's gaze to the group of passengers at the
center. The figures are dressed stylishly and are no doubt traveling in
a certain degree of comfort. But the passengers are not necessarily the
focus of Jackson's attention. He is intent on showing the scenic back-
drop of the mountainous landscape in relation to this comfortable
journey, framing the image by the lip of a tunnel, which is protrud-
ing out so as to create a vignette. In short, Jackson is providing us
with the entire railroad experience: we admire the amazing view

and appreciate the technical achievement of blasting tunnels
through mountains, all seen from the comfort and security of our
traveling car.

Through the geologist Ferdinand Hayden, Jackson met the
painter Thomas Moran in 1871. Both men traveled on the railroads,
often working alongside each other, with Moran apparently teaching
Jackson some of his compositional skills.[40] Jackson, Moran, and the
writer Ernest Ingersoll journeyed together on the Denver and Rio
Grande Railroad in 1881. Ingersoll was writing about the "scenic line
of America" (the motto of the D&RG) for his book *Crest of the
Continent,* published in 1885. Many of Jackson's photographs were
featured in the book and, together with Ingersoll's text, presented a
view of the west for the eastern tourists, offering verbal and pictorial
portraits of faraway landscapes now accessible by rail.[41]

These photographs served as promotional images and would have hung on the walls of mainline stations, railroad hotels, and company offices. As large-format photographs they were very popular and brought Jackson a certain degree of financial security. In 1892 he was commissioned to make a series of prints for the "Picturesque Baltimore and Ohio," getting paid $10 an image. His work earned him a reputation as a skilled railroad photographer, so much so that when the World's Transportation Commission was set up in 1893, Jackson was appointed the official photographer. Traveling the world for seventeen months, he documented the international railroad systems.[42]

During the 1880s Jackson invited the young photographer William H. Rau to join him in Denver. The two men were friends and shared a love for photography and the railroads. In 1890 the Pennsylvania Railroad employed Rau as its official photographer to document the main line from Pittsburgh to New York. His images celebrate the achievements of the company with large-format albumen and platinum prints (FIGURE 25). For Rau, the photographs "conveyed and revealed, much better than guidebooks or conversation possibly could, the territory of wealth and beauty, the iron bands of the main line and branches, extending in their ramifications and intersecting from the Atlantic Ocean to the far Mississippi, and from the great northern lakes to the crowning line of the Virginias."[43] Many of his photographs were exhibited at the Columbian Exhibition in Chicago in 1893. At this time the Pennsylvania Railroad was one of the most successful companies in America. The panorama

FIGURE 25 William H. Rau (American, 1855–1920). From Rau's article "How I Photograph Railroad-Scenery," *Photo-Era: The American Journal of Photography* 36, no. 6 (June 1916): 266. Courtesy of the Art Department, Free Library of Philadelphia.

entitled *On the Conemaugh near New Florence, Pennsylvania* (PLATE 59) is not an obvious railroad image upon first view; Rau skillfully guides our eye into the composition by means of the meandering river, which gently leads back to the tracks on the horizon. We are presented with an idyllic landscape, a quiet pastoral scene, one in which there are no iron structures or wooden trestles. The image is one of tranquility and reveals nothing of the tragic history surrounding this region of southwestern Pennsylvania. In May 1889, heavy rains and poor design caused a dam to burst, sending a huge wall of water down into the Conemaugh Valley, destroying most of the northern half of the city of Johnstown. More than two thousand people lost their lives. In Rau's photograph, taken several years later, only the title indirectly suggests the demise of one community by the reference to a new one. Rau chose to give prominence to the now tranquil river while almost obscuring the presence of the railroad.

The grand scale of this photograph (which measures 1 × 3 feet when framed) is radically different from the scale, and visual experience, of a stereograph. A stereograph literally posits the viewer within the scene by offering a three-dimensional panorama, while Rau's platinum print remains a flat, two-dimensional image in spite of its commanding presence. Yet the intention behind both is the same. Rau captured the passenger's view from the train, and the panoramic format of the photograph conjures up the notion of an actual window onto the landscape. Receiving specific instructions from the company to "select views as much as possible on the main line of the road, and to illustrate special points of interest," Rau wrote that "the pictures thus produced are usually large, and serve as advertising mediums; the officials realizing the fact that the public is attracted by pictures."[44]

Rau's work for the Pennsylvania Railroad led to his appointment as the official photographer for the Lehigh Valley Railroad in 1895. Rau traveled from New York City through Pennsylvania's Lehigh Valley to upstate New York and Niagara Falls. Founded in 1846, the railroad had grown largely as a result of hauling coal from the anthracite mines of northeastern Pennsylvania. The coal legacy is present in some of Rau's images, such as *Collieries in Manahoy Valley* and *Coal Piers at North Fair Haven* (PLATES 62–63), both dating from about 1895.

RAILROAD COMPANIES ACROSS AMERICA and around the world now began to take great advantage of photography. Whether the subject was a brand new locomotive, fresh out of the shop, or a grand view of a railway within the landscape, the prints provided such clear images that one could study the smallest of details. This was due in part to the medium itself: many of the photographers working in the nineteenth century used glass-plate negatives that recorded minutiae that became clearly visible in albumen prints. Carleton Watkins's *Ferryboat "Solano"* (PLATE 65), made in northern California, is typical. With his camera positioned high up on the hillside, Watkins looks down onto the large boat berthed at the quay, with trains already onboard. Built in West Oakland in 1879, the Solano was the largest

FIGURE 26 Carleton Watkins (American, 1829–1916). *The Ferryboat "Solano,"* after 1879 (detail of PLATE 65). Albumen silver print, 36.8 × 53.3 cm (14½ × 21 in.). Los Angeles, J. Paul Getty Museum, 98.XM.21.2.

ferry in the world, measuring 424 feet long and 64 feet wide and specially adapted to allow freight and passenger trains to load without being uncoupled from the steam engine. If one looks carefully at the center of the composition, there is a locomotive visible beneath the left funnel of the ferry (FIGURE 26). Standing adjacent to the engine is the tiny figure of a man wearing black trousers and a white jacket. The man provides a needed sense of scale next to the engine on the huge sailing vessel and is a necessary part of the overall composition. In the words of one enthusiast: "Although a photographer cannot invent to the same degree as a painter, the detailing within a Watkins photograph . . . is so carefully ordered that it appears to be under the same kind of control."[45]

Photographers working in different countries, on different continents, and at different times often chose similar compositions. For example, the print made by Édouard Baldus in the south of France around 1861 (*Entrance to the Donzère Pass* [PLATE 71]) and the one made by Carleton Watkins in Oregon around 1867 (*Cape Horn, near Celilo* [PLATE 70]) are remarkably similar in their visual structure. (Watkins made both stereographic and mammoth-plate prints of this particular view [FIGURE 27].)[46] In both photographs the tracks emerge in the foreground, only to recede into the middle distance and disappear around the cliff face. Both photographers skillfully control the composition, using a series of bold diagonals to create a visual impetus—the tracks and the crest of the embankment in the Baldus; the broad expanse of sand in the Watkins—thus directing

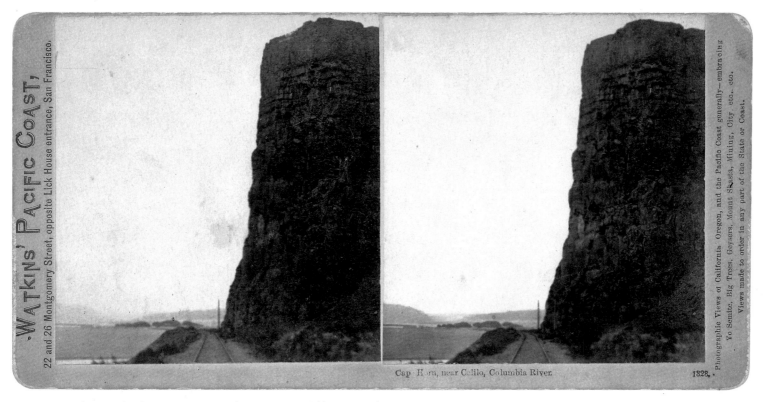

FIGURE 27 Carleton Watkins (American, 1829–1916). *Cape Horn, near Celilo, Columbia River*, ca. 1867. Albumen silver print stereograph, 8.7 × 17.6 cm (3⅜ × 6⅞ in.). Los Angeles, J. Paul Getty Museum, 84.xc.979.7348.

the viewer's attention to the point where the railroad disappears. In both photographs the cliff faces act as grounding devices, anchoring the composition, keeping the visual momentum in check, so to speak.

This was a popular device in railroad photography and seemed to encapsulate the spirit of travel by rail, where the tracks disappear off into a distant landscape. According to Michael Freeman, "In the emerging iconography of railway art, one of the most striking themes was the railway as straight line. It is often viewed in steeply recessional perspective, as if offering a lesson in drawing space."[47] The image of receding tracks recurs throughout the nineteenth century,

as in images by Collard, Czichna, and Rau (PLATES 72–73, 76), working in France, Austria, and America, respectively. Those disappearing tracks seemed to beckon, then as now. This was the lure of railroad vision, with its tempting images of large, open landscapes and awe-inspiring vistas—of escape.

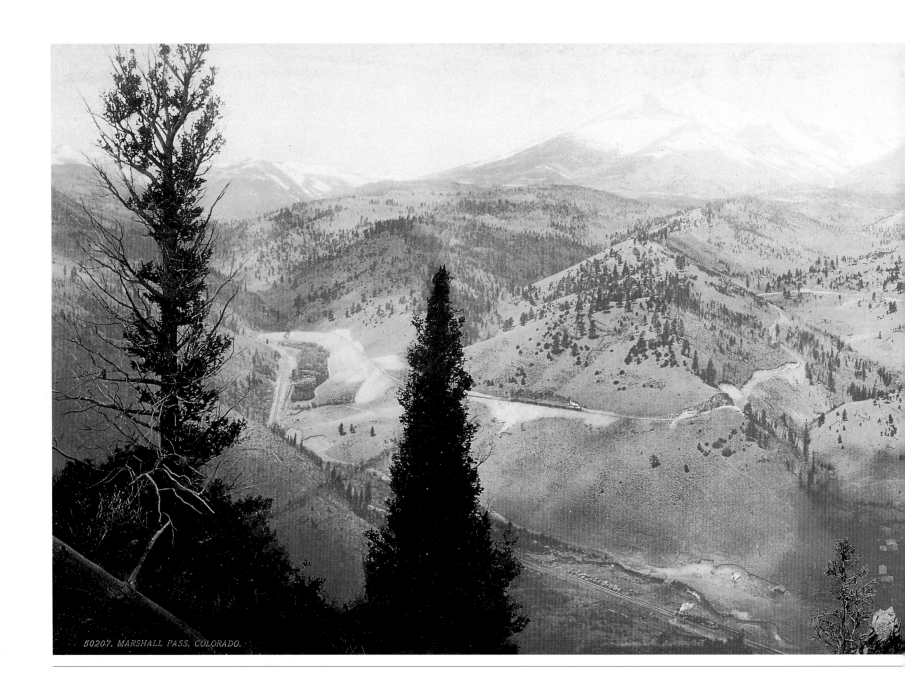

50207. MARSHALL PASS, COLORADO.

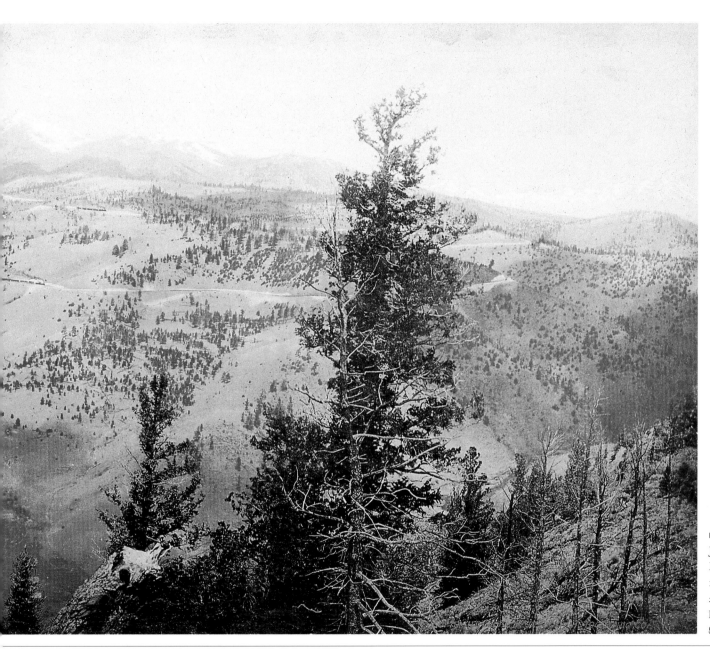

PLATE 52 William Henry
Jackson (American, 1843–1942).
Marshall Pass, Colorado. Negative:
1880s; print: ca. 1914. Photochrom,
20.6 × 54 cm (8⅛ × 21¼ in.).
Los Angeles, J. Paul Getty Museum,
84.XM.494.18.

PLATE 53 William Henry Jackson (American, 1843–1942). *Cañon of the Rio Las Animas*, 1882–86. Albumen silver print, 54 × 42.5 cm (21¼ × 16¾ in.). Los Angeles, J. Paul Getty Museum, 85.XM.5.25.

PLATE 54 William Henry Jackson (American, 1843–1942). *The Royal Gorge. Grand Cañon of the Arkansas*, 1882–86. Albumen silver print, 54.3 × 42.7 cm (21⅜ × 16¹³⁄₁₆ in.). Los Angeles, J. Paul Getty Museum, 85.XM.5.28.

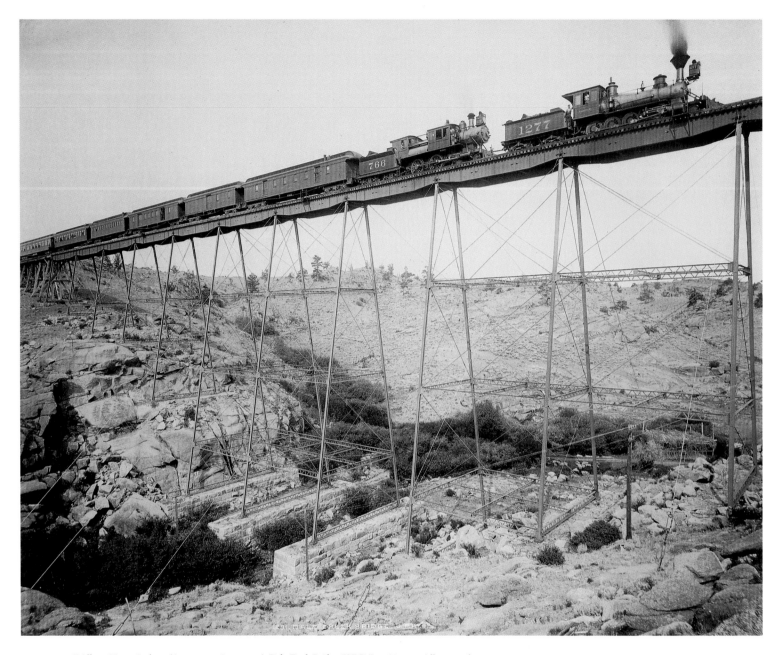

PLATE 55 William Henry Jackson (American, 1843–1942). *Dale Creek Bridge*, U.P.R.R., 1887–93. Albumen silver print, 43.2 × 54 cm (17 × 21¼ in.). Los Angeles, J. Paul Getty Museum, 85.XM.5.34.

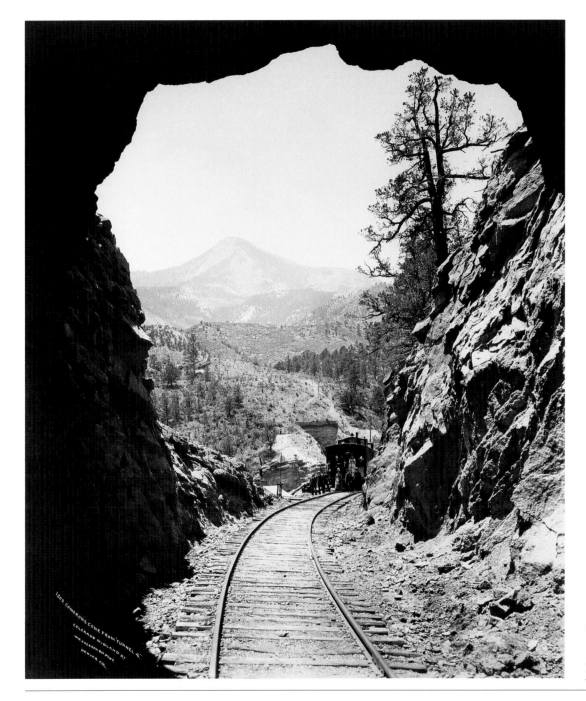

PLATE 56 William Henry Jackson
(American, 1843–1942). *Cameron's Cone from
"Tunnel 4,"* 1887–89. Albumen silver print,
54 × 42.5 cm (21¼ × 16¾ in.). Los Angeles,
J. Paul Getty Museum, 85.XM.5.36.

PLATE 57 William Henry Jackson (American, 1843–1942). *Old Aqueduct at Querétaro, Mexico*, 1886. Albumen silver print,
42.9 × 54.6 cm (16⅞ × 21½ in.). Los Angeles, J. Paul Getty Museum, 85.XM.397.1.

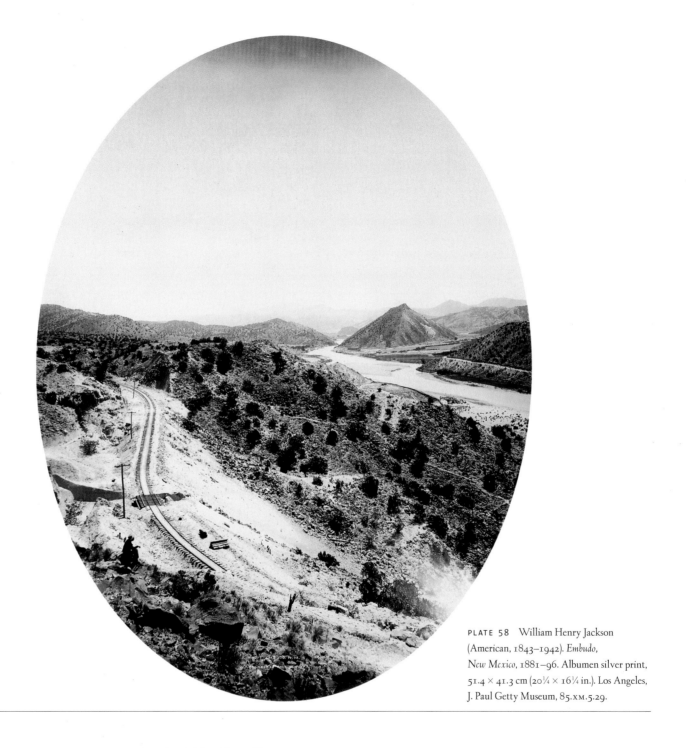

PLATE 58 William Henry Jackson
(American, 1843–1942). *Embudo,*
New Mexico, 1881–96. Albumen silver print,
51.4 × 41.3 cm (20¼ × 16¼ in.). Los Angeles,
J. Paul Getty Museum, 85.xm.5.29.

PLATE 59 William H. Rau
(American, 1855–1920). *On the
Conemaugh near New Florence,
Pennsylvania,* 1891–95.
Platinum print, 41.3 × 111.8 cm
(16¼ × 44 in.). Los Angeles,
J. Paul Getty Museum, 99.XM.22.

PLATE 60 William H. Rau (American, 1855–1920). *Main Line and Low Grade Tracks at Parkesburg,* 1891–95. Gelatin silver print, 44 × 54.6 cm (17⁵⁄₁₆ × 21½ in.). Los Angeles, J. Paul Getty Museum, 84.xo.766.3.1.

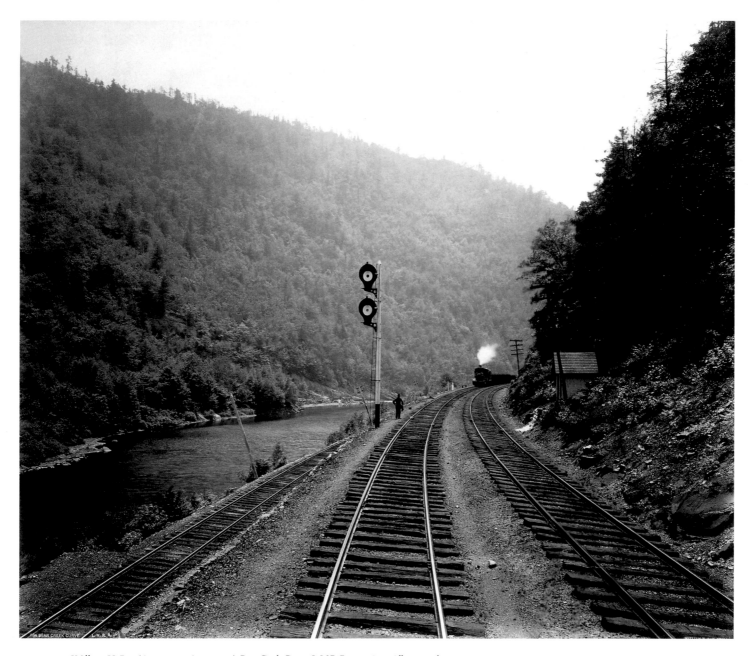

PLATE 61 William H. Rau (American, 1855–1920). *Bear Creek Curve, L.V.R.R.*, ca. 1895. Albumen silver print, 43.5 × 51.8 cm (17⅛ × 20⅜ in.). Los Angeles, J. Paul Getty Museum, 85.XM.12.2.

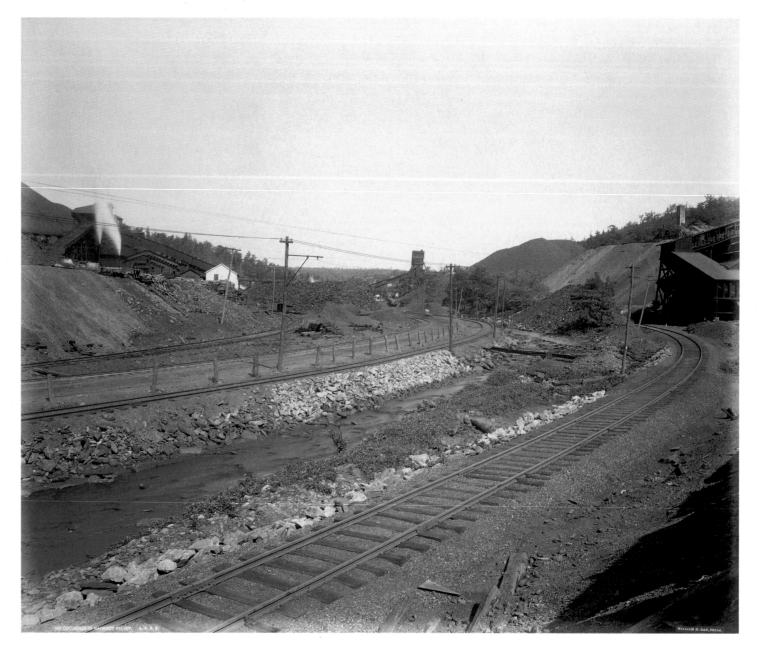

PLATE 62 William H. Rau (American, 1855–1920). *Collieries in Manahoy Valley*, L.V.R.R., ca. 1895. Albumen silver print, 43.5 × 51.8 cm (17 × 20⁷⁄₁₆ in.). Los Angeles, J. Paul Getty Museum, 85.xm.12.14.

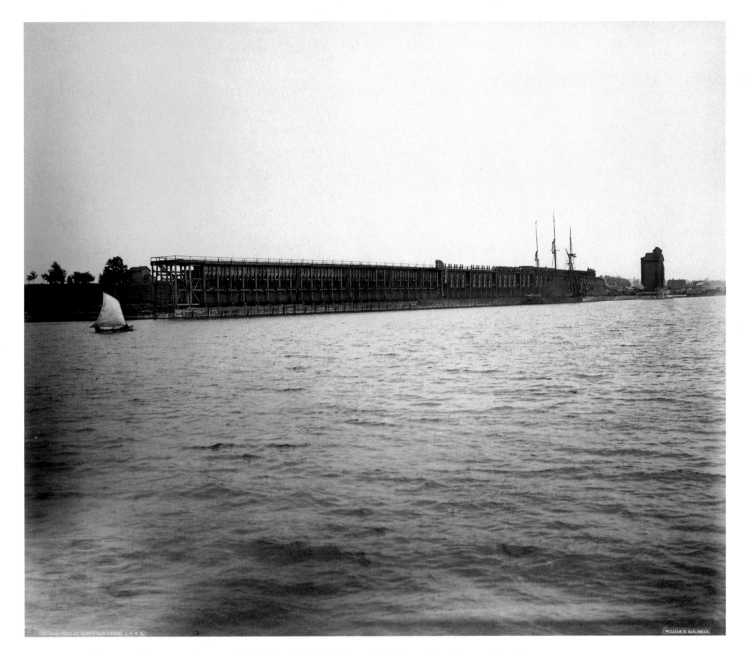

PLATE 63 William H. Rau (American, 1855–1920). *Coal Piers at North Fair Haven, L.V.R.R.*, ca. 1895. Albumen silver print, 44 × 51.9 cm (17⁵⁄₁₆ × 20⁷⁄₁₆ in.). Los Angeles, J. Paul Getty Museum, 84.XP.220.34.

PLATE 64 Alexander Gardner (American, [b. Scotland], 1821–1882). *Railroad Bridge across Grasshopper Creek, Kansas*, 1867.
Albumen silver print, 33 × 47.5 cm (13 × 18¹¹/₁₆ in.). Los Angeles, J. Paul Getty Museum, 84.XM.1027.21.

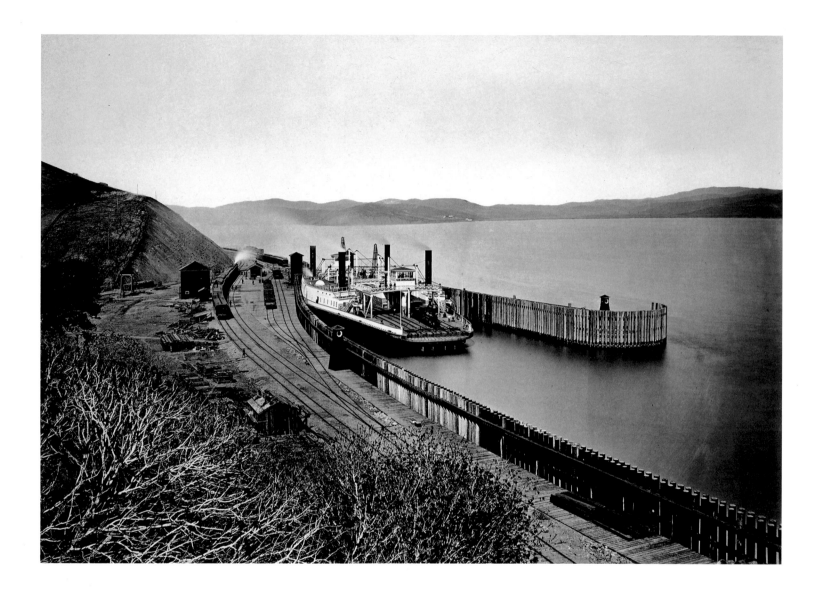

PLATE 65 Carleton Watkins (American, 1829–1916). *The Ferryboat "Solano,"* after 1879. Albumen silver print, 36.8 × 53.3 cm (14½ × 21 in.). Los Angeles, J. Paul Getty Museum, 98.XM.21.2.

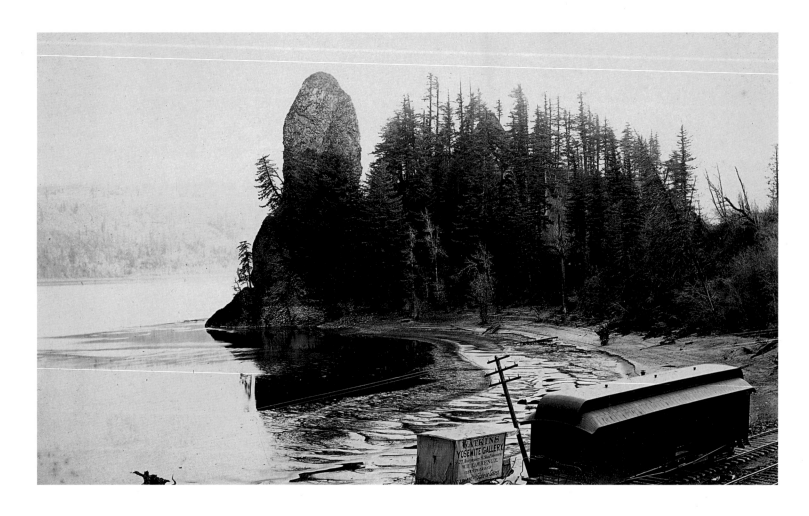

PLATE 66 Carleton Watkins (American, 1829–1916). *Rooster Rock, Columbia River*, ca. 1883. Albumen silver print,
12.1 × 20.5 cm (4¾ × 8⅟₁₆ in.). Los Angeles, J. Paul Getty Museum, 92.XM.99.8.

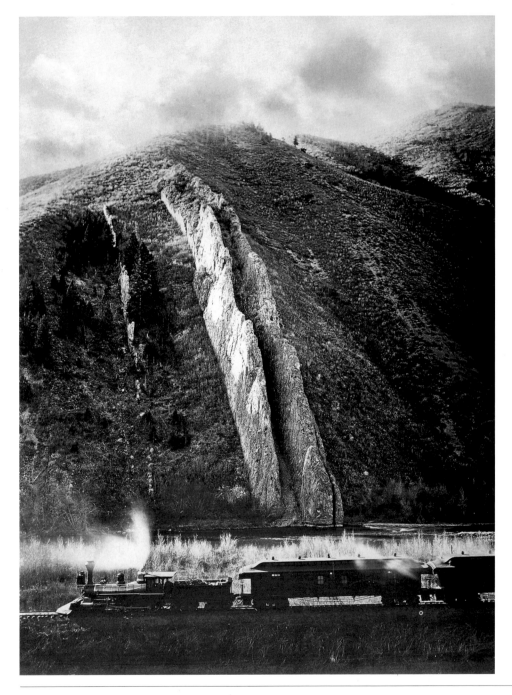

PLATE 67 Carleton Watkins (American, 1829–1916). *The Devil's Slide, Utah,* 1873–74. Albumen silver print, 52.3 × 39 cm (20½ × 15⅜ in.). Los Angeles, J. Paul Getty Museum, 85.XM.11.18.

PLATE 68 Carleton Watkins (American, 1829–1916). *American River from Cape Horn*, ca. 1878–85. From the album "California Tourists Association, San Francisco." Albumen silver print, 20.8 × 30.5 cm (8¼ × 12 in.). Los Angeles, J. Paul Getty Museum, 94.XA.113.22. Gift in memory of Leona Naef Merrill and in honor of her sister, Gladys Porterfield.

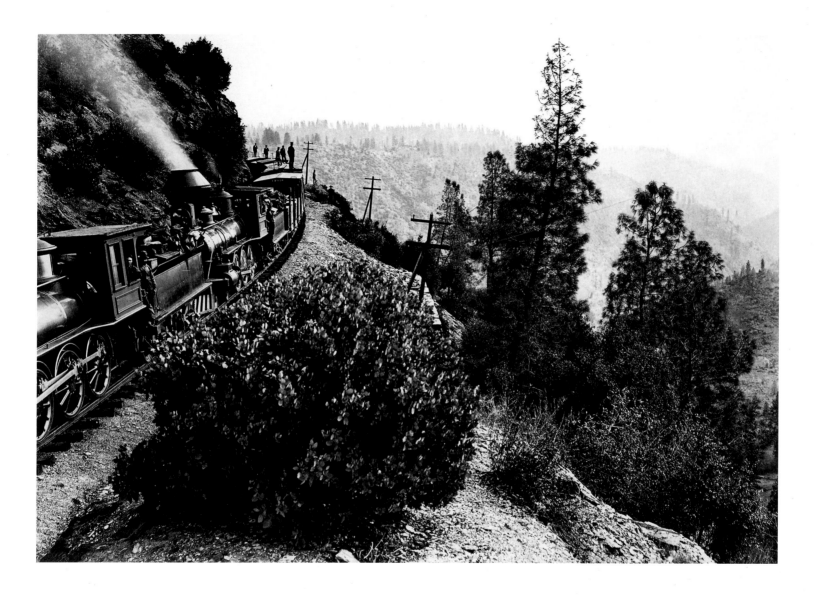

PLATE 69 Carleton Watkins (American, 1829–1916). *Cape Horn*, C.P.R.R., ca. 1878–85. From the album "California Tourists Association, San Francisco." Albumen silver print, 20.8 × 30.5 cm (8¼ × 12 in.). Los Angeles, J. Paul Getty Museum, 94.XA.113.23. Gift in memory of Leona Naef Merrill and in honor of her sister, Gladys Porterfield.

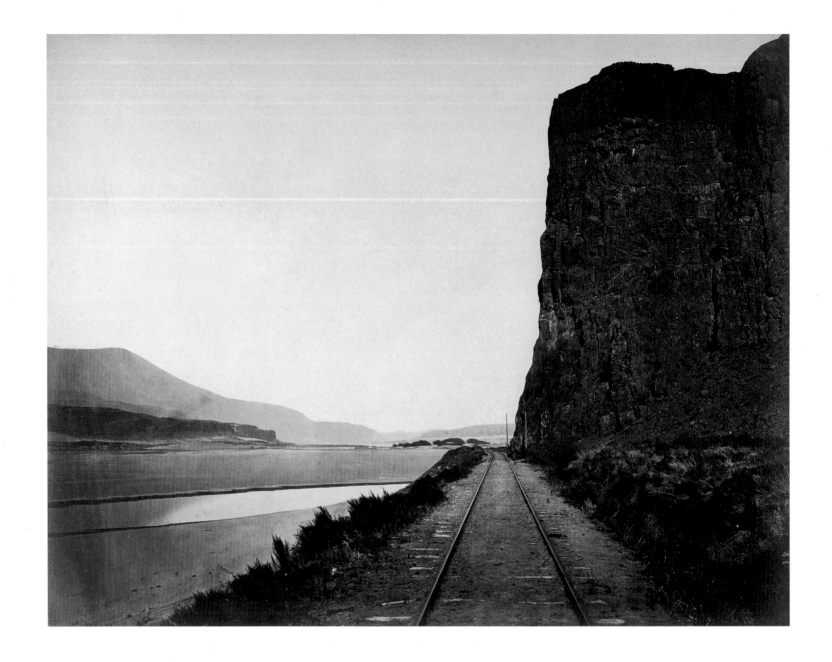

PLATE 70 Carleton Watkins (American, 1829–1916). *Cape Horn, near Celilo,* ca. 1867. Albumen silver print, 40.6 × 50.8 cm (16 × 20 in.). Wilson Center for Photography, LLC.

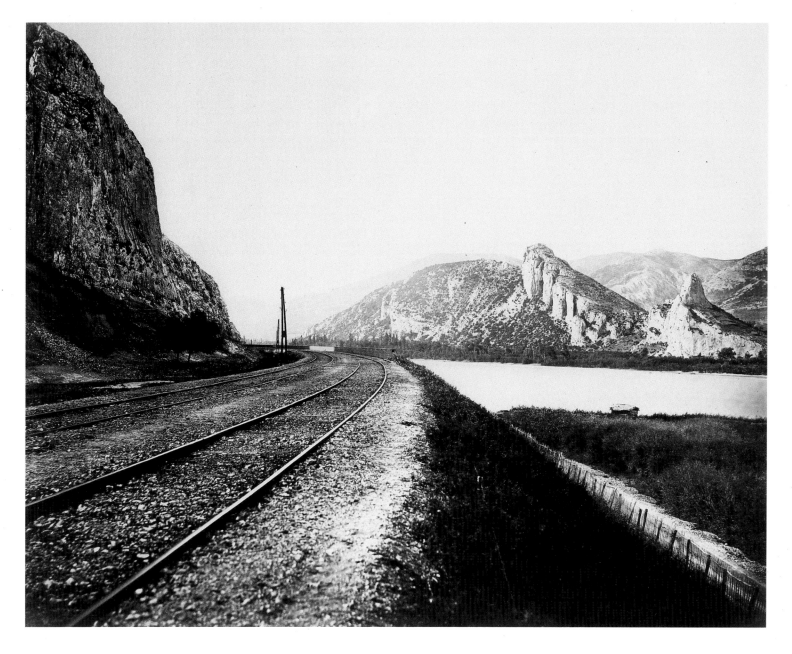

PLATE 71 Édouard Baldus (French, 1813–1889). *Entrance to the Donzère Pass*, ca. 1861. From the album "Chemins de fer de Paris à Lyon et à La Méditerranée." Albumen silver print, 33.7 × 43.2 cm (13¼ × 17 in.). Los Angeles, J. Paul Getty Museum, 84.x0.734.1.20.

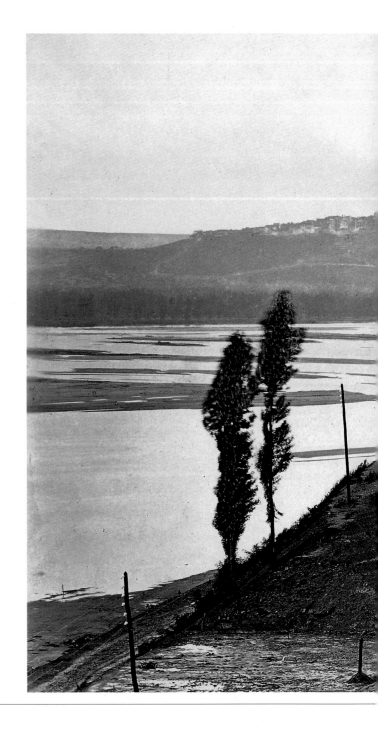

PLATE 72 Hippolyte-Auguste Collard (French, 1812–1897). *View of Sancerre*, July 1862.
From the album "Chemin de fer du Bourbonnais. Moret-Nevers-Vichy." Albumen silver print,
18 × 31.6 cm (7⅛ × 12½ in.). Los Angeles, J. Paul Getty Museum, 84.xo.393.22.

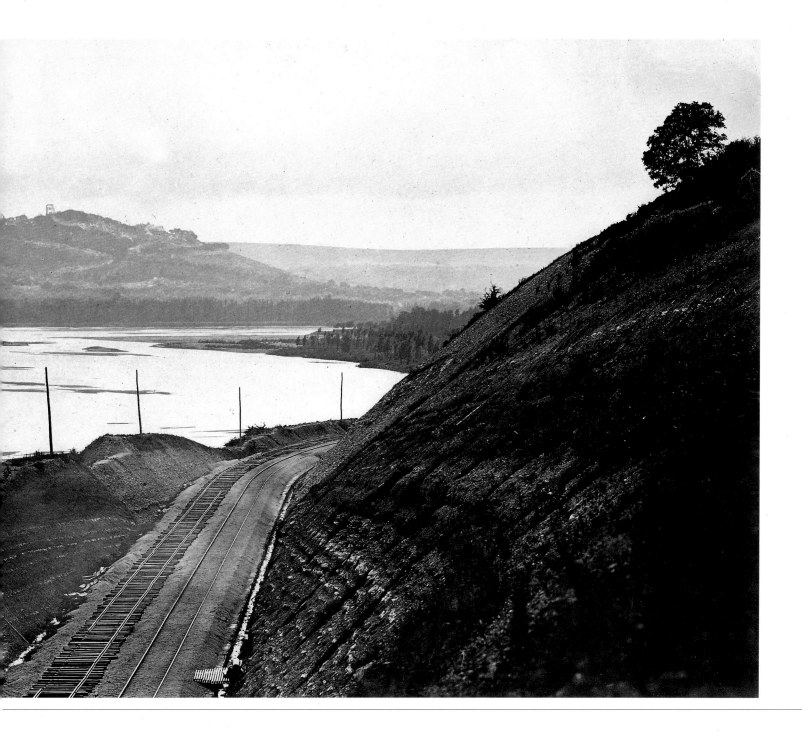

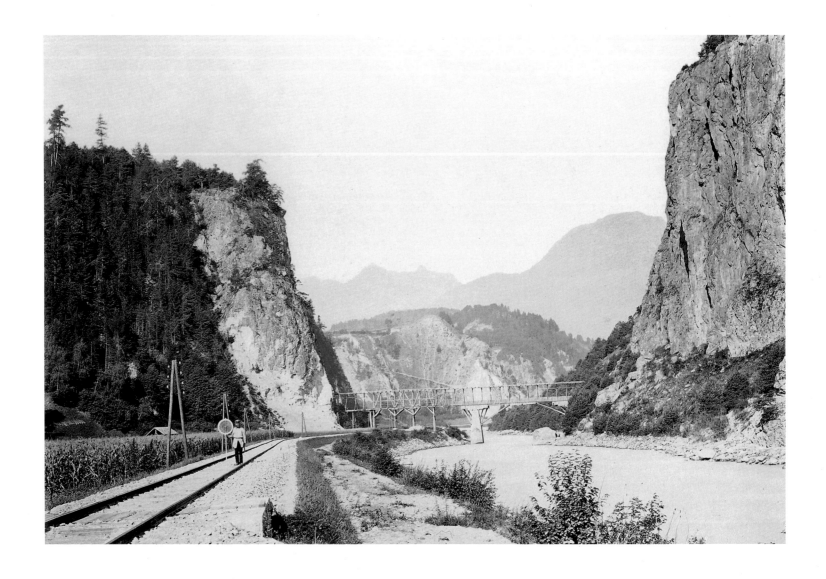

PLATE 73 Carl Alexander Czichna (Austrian, active ca. 1860s). *Roppener Aqueduct*, ca. 1870. From the album "Arlbergbahn. Innsbruck–St. Anton." Albumen silver print, 27 × 40.1 cm (10⅝ × 15²⁵⁄₃₂ in.). Los Angeles, J. Paul Getty Museum, 84.XA.868.2.7.

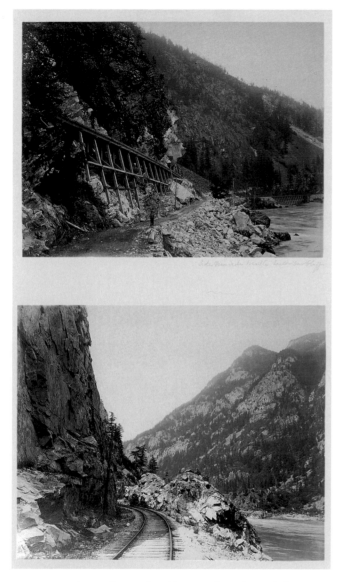

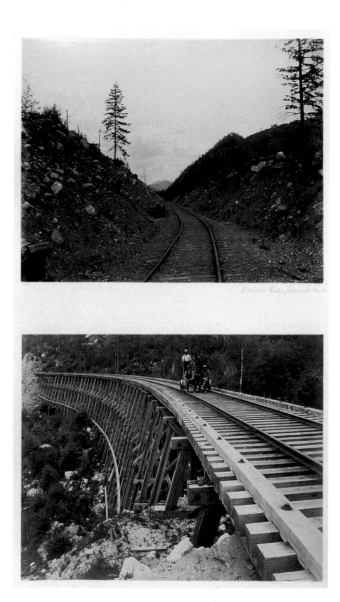

PLATE 74 Unknown photographer. *Side View, Side Trestle* and *Bluff Two Miles above Falls*, 1880s. From the album "Canadian Pacific Railway Views: British Columbia." Albumen silver prints, 19 × 24.2 cm (7⁷⁄₁₆ × 9½ in.) and 19.7 × 24.6 cm (7¾ × 9¹¹⁄₁₆ in.). Los Angeles, J. Paul Getty Museum, 84.XA.1398.27–.28.

PLATE 75 Unknown photographer. *Eight Mile Hill Gravel Cut* and *Trestle below Fournis House*, 1880s. From the album "Canadian Pacific Railway Views: British Columbia." Albumen silver prints, 19.3 × 24.5 cm (7⁹⁄₁₆ × 9¹¹⁄₁₆ in.) and 19.1 × 24.5 cm (7⅝ × 9¹¹⁄₁₆ in.). Los Angeles, J. Paul Getty Museum, 84.XA.1398.29–.30.

PLATE 76 William H. Rau (American, 1855–1920). *Cayuga Lake, Cat's Elbow, L.V.R.R.*, ca. 1895. Albumen silver print, 43.5 × 51.8 cm (17⅛ × 20⅜ in.). Los Angeles, J. Paul Getty Museum, 85.XM.12.12.

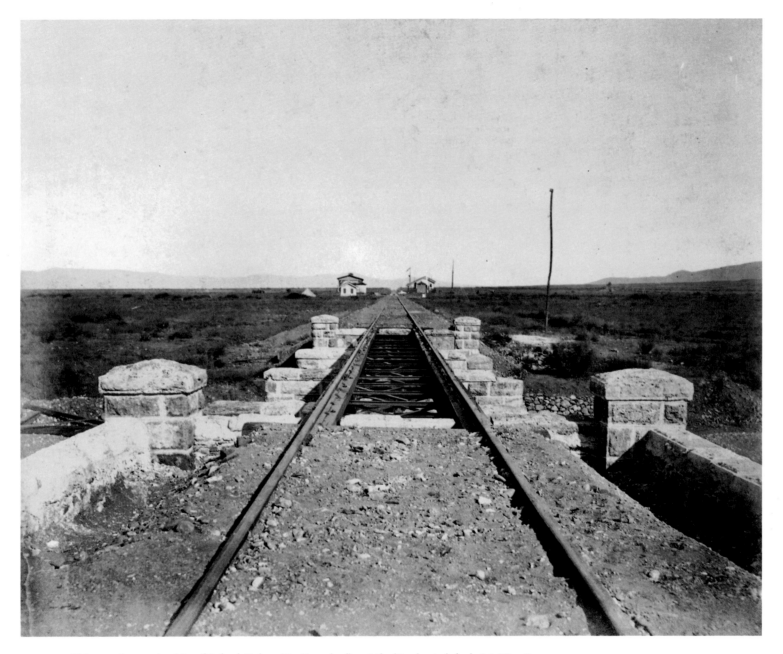

PLATE 77 Unknown photographer. *View of Railroad, Turkey,* 1880s. From the album "Alaschier chemin de fer de Asie Minor."
Albumen silver print, 24.2 × 19.2 cm (9½× 7½ in.). Los Angeles, Research Library, The Getty Research Institute, 96.R.14, pl. 21.

Railroad Visions

THE RAILROAD of the nineteenth century was a new and exciting innovation. It was documented in photographs that typically lauded technological achievements and faithfully recorded novel and unfamiliar landscapes. The early twentieth century ushered in new approaches to the subject. No longer did this phenomenon scare, excite, woo, and awe the traveling public; by then, most people were familiar with train travel. Photography was no longer required to educate people on the workings and appearance of the railroad. Now it would be treated differently. The transfixing nature of the subject caused many photographers to record the railroad for aesthetic reasons alone. Rather than one vision of the railroad—distilled by the photographers commissioned by the railroad companies—there were now multiple visions, as artists responded subjectively, producing images that are abstractions, detailed studies, figurative arrangements, or theatrical compositions.

The Hand of Man of 1902 by Alfred Stieglitz (PLATE 78) captures the transition between the nineteenth- and twentieth-century approaches to the subject. Centered on a smoke-spewing locomotive amid myriad tracks and rows of smokestacks, the image has an "industrial" quality that is perhaps exaggerated by the photogravure print itself. The gleaming rails, picking up the light, offer the promise of new technology and the progress of society, as they map their way across the picture to the backdrop of chimneys and telegraph poles. The dual plumes of smoke rise up in the middle of the composition. While the shrill shriek of the whistle is silent to our ears, the white steam reveals that the engineer has just signaled a warning. The photograph is in fact a visual metaphor, Stieglitz's own signal of the art to come. As Susan Danly has recognized, "It is significant that the dawn of modernism in America should be so closely associated with the image of the railroad in an urban setting."[48] Believing in the artistry of photography, Stieglitz, along with Edward Steichen, founded the Photo-Secession in New York in conjunction with the exhibition American Pictorial Photography, held at the National Arts Club in 1902. The Hand of Man was displayed in the exhibition and was subsequently published in the first issue of the journal Camera Work, which made its debut in January 1903.

Stieglitz, unlike many of the nineteenth-century photographers, was not a commissioned railroad photographer but an artist

FIGURE 28 William Rittase (American, 1887–1968). *Untitled [Six Locomotives]*, 1920s–30s. Gelatin silver print, 20.2 × 25.4 cm (7¹⁵⁄₁₆ × 10 in.). New York, The Metropolitan Museum of Art, 1987.1100.202. Ford Motor Company Collection, Gift of Ford Motor Company and John C. Waddell, 1987.

reacting to the subject on an aesthetic level and offering a poetic vision of modern industry. Other photographers necessarily presented very different views of the subject. Walker Evans was fascinated by trains, and the railroad appears in his work on a number of levels: from a simple record of the urban environment (PLATE 80) to an abstract portrait of the rails themselves (PLATE 81). Like Stieglitz, Evans had not been commissioned by a railroad company. More than anything, Evans was a great chronicler of the structure that makes up daily life in America. Within this rubric the railroad was ever present.

Although the work of the early twentieth century is different in look and feel from that produced in the nineteenth, there are similar patterns and compositional strategies. August Sander's 1910 portrait of German railroad workers (PLATE 91) bears a striking resemblance to Walker Evans's portrait (PLATE 90), separated by a distance of fifty years and thousands of miles. The photographs of Else Thalemann (PLATE 82) and Albert Renger-Patzsch (PLATE 83) feature close-up details of two engines. Both photographers were pioneers of the New Objectivity, a movement that emerged between the two world wars that sought to redefine the notion of beauty in everyday life. By acknowledging that beauty exists in both nature and the machine, these two German photographers were continuing with themes we have already encountered in Stieglitz's *Hand of Man*, but their photographs are not poetic visions. They seem to anticipate an amazing work by Charles Sheeler, made in 1939, *Wheels* (PLATE 84). The photographer has focused on the lead truck, cylinders, valve

gear, and driving wheels of a New York Central locomotive in a composition similar to Thalemann's and Renger-Patzsch's. But whereas Thalemann and Renger-Patzsch are intent on celebrating the abstract beauty of the engine, Sheeler is espousing the beauty of the locomotive by literally showing the nuts and bolts that hold the locomotive together. The palpable existence of the essential components fills the composition, while the steam escaping from the piston at lower right suggests that this image is a fleeting one, that at any minute this behemoth may begin to roll out of view. Sheeler frames the picture so that the ghost-gray disk wheel (typical of this type of modern engine) is juxtaposed with the dark cylinder casing. This subtle play of light and dark, together with the transcendent quality of the steam vapor, makes for an unusually compelling image.

Unlike the earlier photographs of locomotives by Mudd or Stuart, Sheeler's study shows that the entire engine is no longer needed to represent the inherent strength of these machines. The detail fills the entire frame; rather than reducing the sense of power, the cropping has intensified it. Sheeler was an accomplished painter in addition to being a photographer. As part of a commission from *Fortune* magazine he created a number of photographs that he later used as studies for a series of paintings entitled Power (FIGURE 29). Like his nineteenth-century counterparts, Sheeler used his chosen medium to capture images that were rich in detail and tone, and then translated these images into paintings.

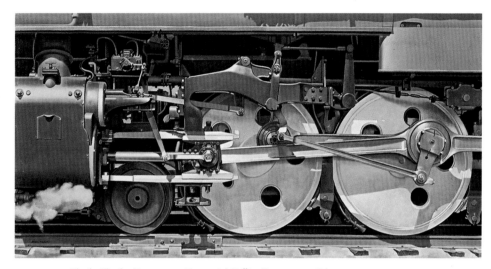

FIGURE 29 Charles Sheeler (American, 1883–1965). *Rolling Power*, 1939. Oil on canvas, 38.1 × 76.2 cm (15 × 30 in.). Northampton, Massachusetts, Smith College Museum of Art, purchased, Drayton Hillyer Fund, 1940.

The railroad photographs of the nineteenth century typically dealt with two major themes: the celebration of railroad technology—including bridges, trestles, tracks, and locomotives—and the presentation of a newly accessible landscape. These themes become fractured in the twentieth century. There are still the celebratory images of great engineering feats—Ralston Crawford's photograph of the elevated railway in New York (PLATE 85), for example—but the interest lies more in the graphic and abstract nature of the structures than in defining their physical properties. Similarly, the notion of landscape as vista becomes more abstract. In Franz Roh's *Untitled* from about 1930 (PLATE 86), the railroad tracks do not recede into some distant romantic landscape but disappear into the darkness of night. Roh evokes the mysterious nature of the journey, but he is concerned less with the promise of travel than with the graphic nature of the rails.

One theme that emerges in the railroad images of the twentieth century is a greater concern with the human side of the rails: the place the railroad occupies in our daily lives. In a 1938–40 print by Edmund Teske (PLATE 87), we are presented with the image of a man writing a letter in a streetcar in Chicago; in 1955 the French photographer Brassaï snapped a photograph as a possible act of mischief, capturing a rail traveler fast asleep on an Italian train (PLATE 88). An idiosyncrasy of modern travel is that public spaces, such as a passenger rail car, are often reserved for our most private moments of reflection. Surrounded by strangers, people journey in anonymity. Indeed, the anonymity of artists is the very thing that allows them to create their candid photographs, for they too are simply passengers. Walker Evans surreptitiously snapped passengers with a hidden camera as they traveled on the New York subway (PLATE 89), in one famous instance focusing on a blind accordion player who is surrounded by seated passengers ignoring his performance. Evans was well aware that his methods for obtaining these photographs were clandestine, and he waited some twenty-five years before publishing them in his book *Many Are Called*.[49]

Around the same time that Brassaï captured the image of his sleeping beauty, O. Winston Link was busy recording the last of the steam age in North America. Link visited a Norfolk and Western station while on a photographic assignment in January 1955 and quickly became smitten by the scene of steam locomotives puffing in the dark of night. The next evening Link returned to the same location and took his first photograph of the Norfolk and Western line. It would be the first of many: he created more than two thousand negatives over a period of five years. Built in the 1850s, the Norfolk and Western was the last rail network in the United States to run with steam locomotives only, hauling both freight and passengers between Virginia and Ohio. Realizing that modern diesel locomotives would eventually replace these engines, Link set about recording them. Although he was not an employee of the company, he gained permission to enter railroad property and became privy to timetables and work schedules. He captured the beauty, grandeur, and power of these locomotives before they became historic relics.

FIGURE 30 O. Winston Link (American, 1914–2001). *Link and Thom with Night Flash Equipment, March 16, 1956*. Negative: March 16, 1956; print: 1984. Gelatin silver print, 49.5 × 39.4 cm (19½ × 15½ in.). Los Angeles County Museum of Art, The Audrey and Sydney Irmas Collection, AC 1992.197.82. Copyright 2002 Museum Associates/LACMA.

Link made NW 1103, *Hot Shot Eastbound, Iaeger, West Virginia* (PLATE 92) on August 2, 1956, in the darkness of night at a drive-in movie theater in Iaeger. He worked mostly at night, which required setting up a large bank of flashbulbs to illuminate the passing engines (FIGURE 30). Link later recalled that the "flashbulbs were all fired simultaneously for illumination. Since I could only see the headlights of the locomotive in total darkness, I did not know until the flash was fired that I had captured this prize — Class A engine with beautiful smoke with all of it in range!"[50]

If one looks closely at the print there are dark spots along the embankment. These spots are in fact the flashbulb reflectors, which shielded the light from the camera and directed it at the locomotive. Another bank of flashbulbs flooded the entire lot. In fact, the light was so strong that it essentially bleached out the image on the movie screen. Link wanted that image to appear. In the beginning he seems to have printed using two different negatives (one of the drive-in, one of the airplane, which was a still from a movie), but after a while this technique must have become rather tedious and so he opted for tipping in another print to an existing photograph and from this composite made a fresh negative.[51] Regardless of his working method, one thing is clear: Link went to considerable trouble to include the image of the plane on the movie screen. Why? Perhaps because it becomes, in effect, a commentary on the demise of the steam locomotive, the rise of car culture in 1950s America, and the ascendancy of airplanes as the next transcontinental carriers. Link arranged his photograph as

if it were a theatrical production, carefully orchestrating the scene of planes, trains, and automobiles.

If the railroad was the leading star in Link's vision, it was the exact opposite in William Eggleston's *Plains* (PLATE 96). In October 1976, just before the presidential election, Eggleston made a series of photographs in and around Plains, Georgia, hometown of Democratic candidate Jimmy Carter. The images, mounted into an album entitled *Election Eve*, reflect the calm, mundane realities of daily life. Yet change was already in the air for the railroad whose tracks are barely identifiable on the street. Car culture dominates the composition, from the centrally placed gas station to the numerous vehicles entering and exiting the frame. The presence of the railroad is very much minimized, but not for the sake of emphasizing a vast landscape, as was sometimes the case in the late nineteenth century. Instead the composition reinforces the truth that the railroad no longer played the same role in American life as the most popular mode of passenger transportation.

Jim Dow, following in the tradition of Eggleston, working with large-scale color prints, chose not to focus on the railroad, its tracks, or its locomotives but instead depicted the empty telegraph office inside the station in San Luis, Argentina (PLATE 97). His image is devoid of people and any obvious connection to the railroad, but two main elements—the telegraph equipment and the clock on the wall—pay homage to the railroad as a driving force in the development of long-distance communication and standardized time. There

is little life in this image, and one has the sense that Link's celebration of an age of travel on the verge of extinction has become a eulogy for an already dead system.

It is no surprise, then, that when we come to the work of Mark Ruwedel, his studies of the shadows left on the land by abandoned tracks create an almost ghostlike quality (PLATES 98–100). There is the sense that something great once passed over these large open tracts of land, but now it is only the skeletal remains of the decaying ties or the faint scarring of the tracks on the grade that lingers as evidence of the railroad. With their vacant expanses, his photographs recall the landscape surveys made before the vast iron networks were built while simultaneously documenting the extinction of the rail system. Ruwedel marks each of his mounts with a carefully crafted graphite inscription, suggestive of the letterpress captions found on nineteenth-century prints. Like the railroads themselves, these faint markings appear to vanish from view as one steps back from observing the photograph.

OF COURSE THE RAILROAD STILL EXISTS throughout the world, and railroad photographs continue to proliferate, but the railroad vision of the twenty-first century, unlike that of the nineteenth, is not dedicated to enlightenment, edification, and promotion. Photography then was a new medium and the perfect tool for documenting the railroads, for it was able to capture the essence of travel by steam locomotive. Both inventions made the physical world

accessible to a greater population; in their different ways, both transported people. Photographic panoramas imitated the spectacular views from the train, the oblique angles of the compositions acknowledging the skew structures that were common to the railroad. Photographers, in responding to a completely modern subject using a distinctly modern medium, rejected many of the traditional modes of composition that had been passed down through the visual arts over many years. A new visual language was employed for depicting the railroad, which resulted in deep recessions and dramatic perspectives within the picture frame.

Photography and the railways enjoyed a mutually beneficial partnership. Not only did photography reproduce the view of the passenger from the safe confines of the car; it also presented the traveler with a more comprehensive account of the journey than any one passenger could experience. As historian John Stilgoe recognized: "Travelers in the mountain west, for example, frequently saw nothing of the superb trestles and bridges crossed by their trains; they saw only the dizzying view from the Pullman window."[52] It is only fitting that photography should step in, as the willing partner, to furnish the missing image of the "superb trestle." A factual account and a memory aid, the photograph filled in the gaps of the physical journey. But it also documented the progress of the railroad and its evolving technology, providing a social history of one of the most important innovations of the nineteenth century. The photograph provided evidence of the impact of the iron rails on the physical world. But it was also subjective, revealing the artistic and intellectual biases of the photographer.

Today it is the innovations of information technology that are shifting our perceptions and rapidly modifying our societies. As we marvel at high-speed electronic messages and digital images sent over wireless telephones, it is possible for us to appreciate the revolutionary nature of these two technologies produced in the first half of the nineteenth century. For when we pause long enough to contemplate today's technology, we realize that its amazing workings are largely invisible to us—just as early locomotives were "strange beyond description" and the first photographic prints were a "delusion of necromancy." Born of two nineteenth-century inventions, railroad vision would prove to be the basis of our modern view of the world.

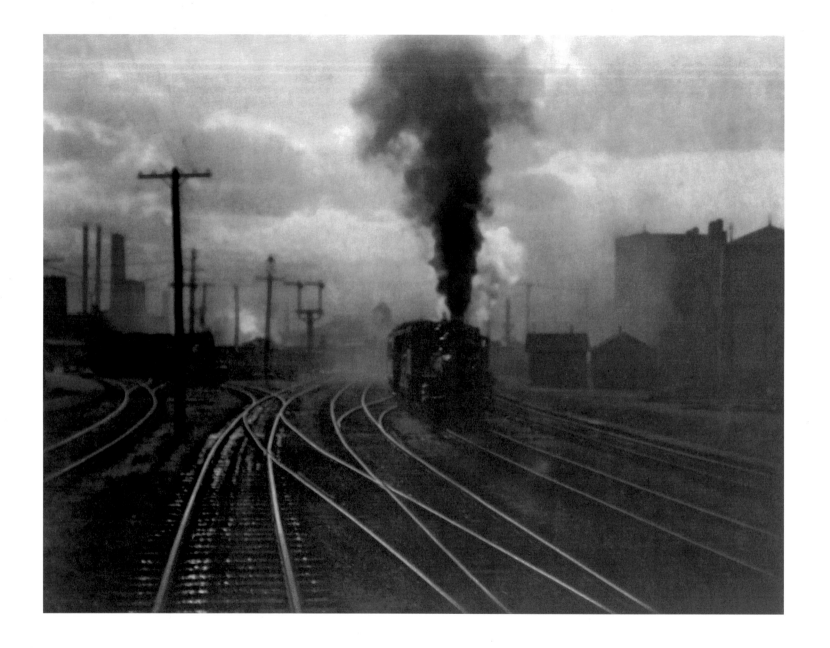

PLATE 78 Alfred Stieglitz (American, 1864–1946). *The Hand of Man*, 1902. Photogravure,
24.1 × 32 cm (9½ × 12½ in.). Los Angeles, J. Paul Getty Museum, 84.XM.695.22.

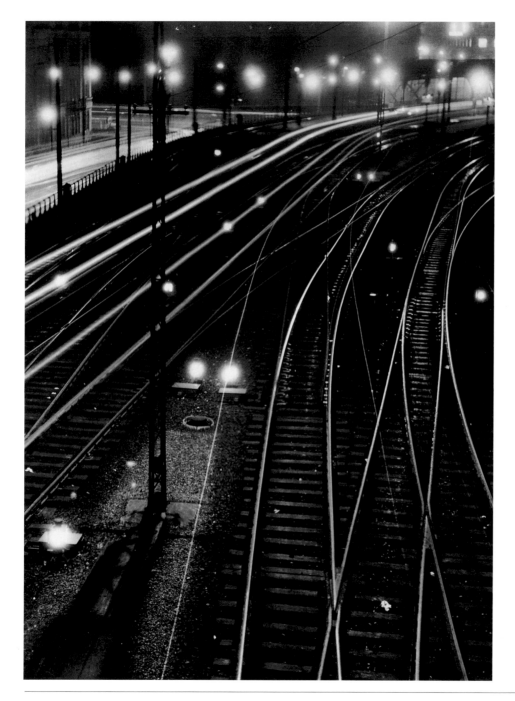

PLATE 79 Willy Zielke (German, 1902–1989).
Untitled (Railroad Tracks), ca. 1933–35. Gelatin silver
print, 24.1 × 18.1 cm (9½ × 7⅛ in.). Los Angeles,
J. Paul Getty Museum, 84.XM.907.20.

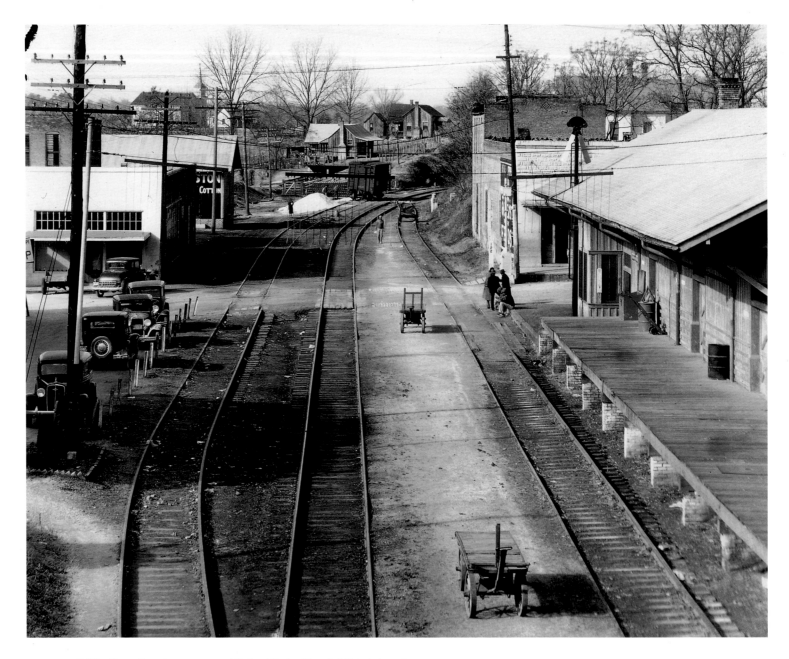

PLATE 80 Walker Evans (American, 1903–1975). *Railroad Station, Edwards, Mississippi*, 1936.
Gelatin silver print, 19.3 × 24.2 cm (7⅝ × 9½ in.). Los Angeles, J. Paul Getty Museum, 84.XM.956.311.

PLATE 81 Walker Evans (American, 1903–1975). *Railroad Track, New York*, 1929. Gelatin silver print,
8.2 × 14.7 cm (3¼ × 5¹³⁄₁₆ in.). Los Angeles, J. Paul Getty Museum, 84.XM.956.36.

PLATE 82 Else Thalemann (German, 1901–1984). *Lokomotivendetail (Locomotive Detail)*, ca. 1926. Gelatin silver print,
17 × 22.4 cm (6¹¹/₁₆ × 8¹³/₁₆ in.). Los Angeles, J. Paul Getty Museum, 90.XM.107.1.

PLATE 83 Albert Renger-Patzsch (German, 1897–1966). *Locomotive Detail*, ca. 1925–28. Gelatin silver print, 17.2 × 23.2 cm (6¾ × 9⅛ in.). Los Angeles, J. Paul Getty Museum, 84.XM.138.8.

PLATE 84 Charles Sheeler (American, 1883–1965). *Wheels*, 1939. Gelatin silver print, 16.8 × 24.4 cm (6⅝ × 9⅝ in.). Los Angeles, J. Paul Getty Museum, 88.XM.22.7.

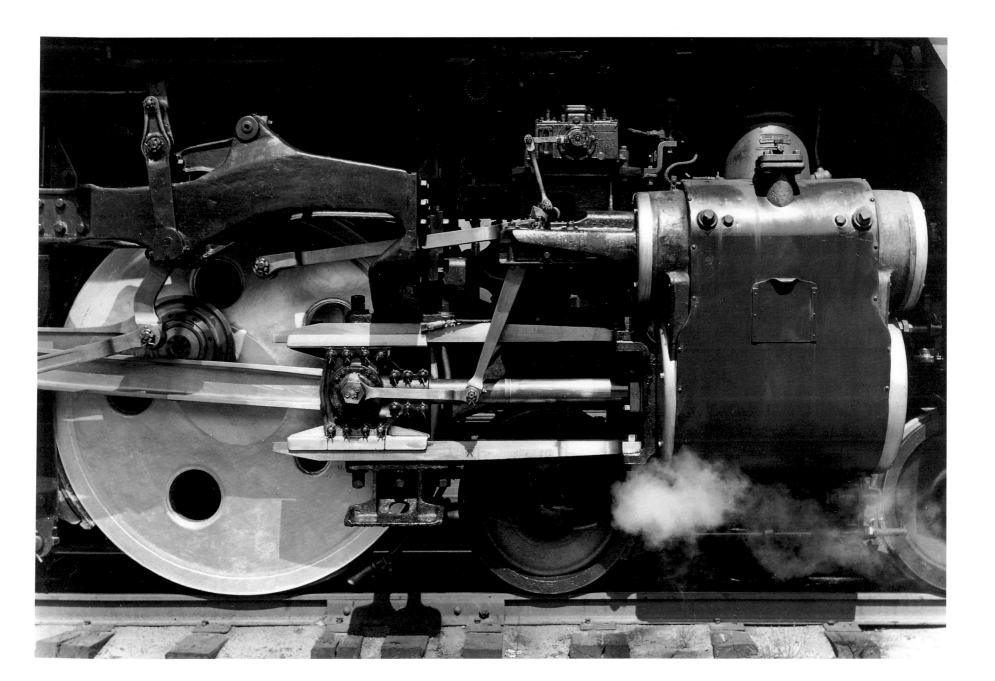

PLATE 85 Ralston Crawford (American, 1906–1978). *Third Avenue El*, 1949. Gelatin silver print, 33.7 × 26.1 cm (13¼ × 10½ in.). Los Angeles, J. Paul Getty Museum, 84.XM.151.143.

PLATE 86 Franz Roh (German, 1890–1965). *Untitled (Railroad Tracks at Night)*, ca. 1930. Gelatin silver print, 20.6 × 21 cm (8⅛ × 8¼ in.). Los Angeles, J. Paul Getty Museum, 90.XM.77.

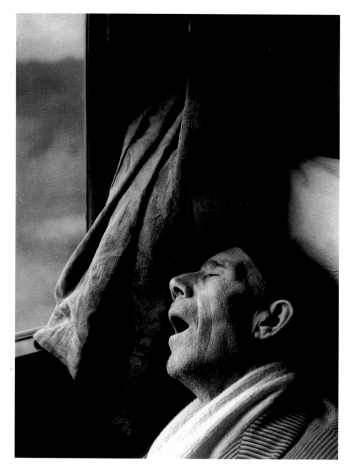

PLATE 87 Edmund Teske (American, 1911–1996).
Streetcar, Chicago, 1938–40. Gelatin silver print, 19.7 × 24.4 cm
(7¾ × 9⅝ in.). Los Angeles, J. Paul Getty Museum, 2001.53.14.

PLATE 88 Brassaï [Gyula Halász] (French [b. Romania], 1899–1984).
On the Train, Rome to Naples, 1955. Gelatin silver print, 39 × 29.7 cm
(15⅜ × 11¹¹⁄₁₆ in.). Los Angeles, J. Paul Getty Museum, 86.xm.3.12.

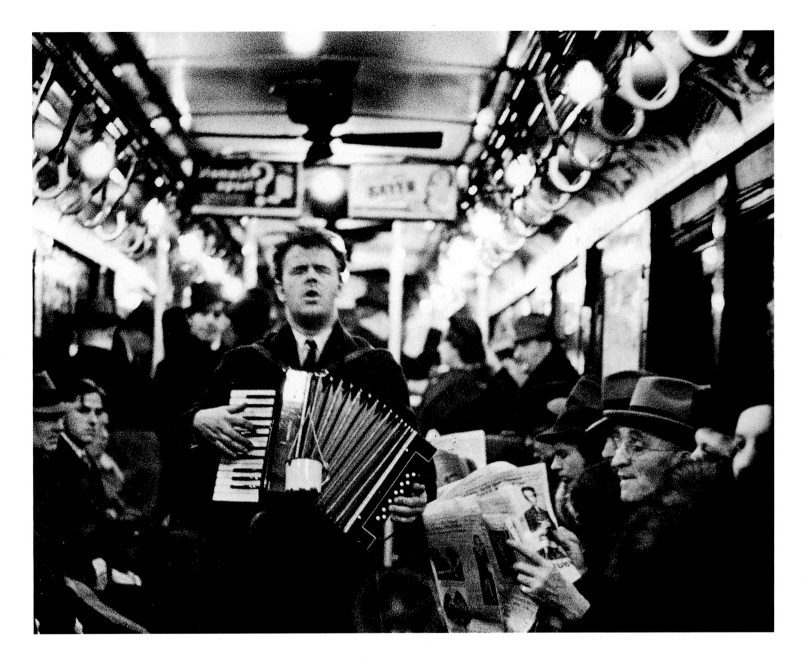

PLATE 89 Walker Evans (American, 1903–1975). *Subway Portrait*. Negative: 1938–41; print: 1968. Gelatin silver print,
20.2 × 25.6 cm (7¹⁵⁄₁₆ × 10¹⁄₁₆ in.). Los Angeles, J. Paul Getty Museum, 84.xm.956.650.

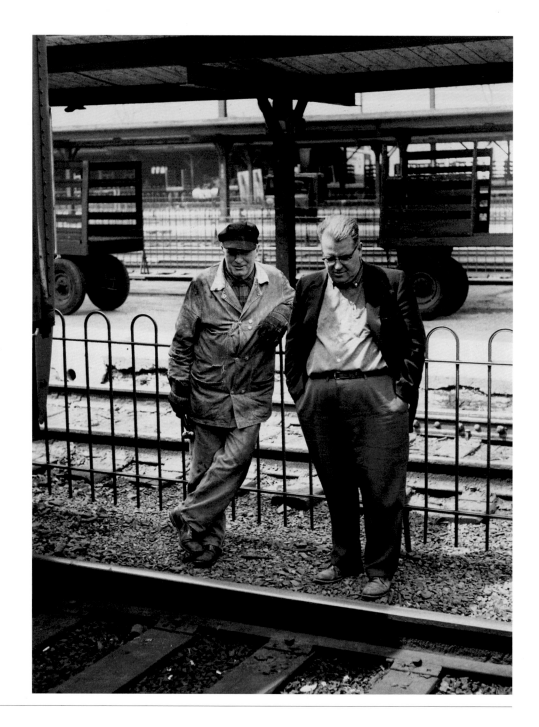

PLATE 90 Walker Evans (American, 1903–1975).
Railroad Yard Men: For the Series "Dress," April 1963.
Gelatin silver print, 30.7 × 23.1 cm (12 1/16 × 9 1/8 in.).
Los Angeles, J. Paul Getty Museum, 95.XM.45.82.

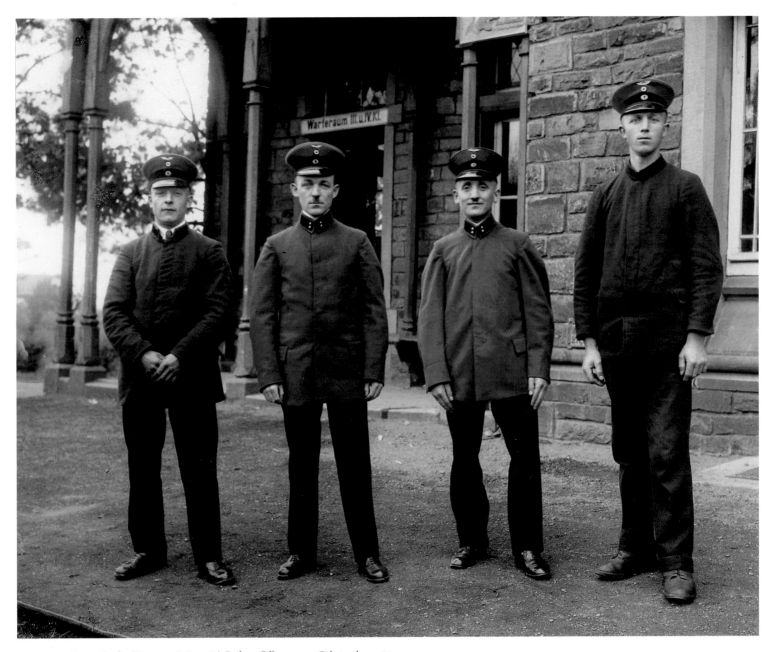

PLATE 91 August Sander (German, 1876–1964). *Railway Officers*, 1910. Gelatin silver print, 22.6 × 27.7 cm (8⅞ × 10⅞ in.). Los Angeles, J. Paul Getty Museum, 84.XM.126.87.

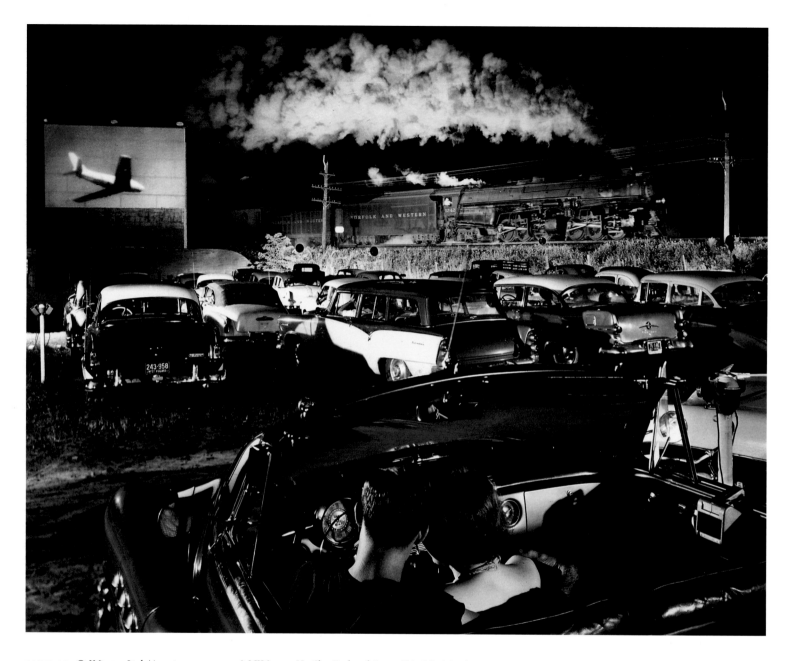

PLATE 92 O. Winston Link (American, 1914–2001). NW1103, *Hot Shot Eastbound, Iaeger, West Virginia, August 2, 1956*. Negative: August 2, 1956; print: January 1985. Gelatin silver print, 39.3 × 49.4 cm (15⁷⁄₁₆ × 19⅜ in.). Los Angeles, J. Paul Getty Museum, 2000.71.

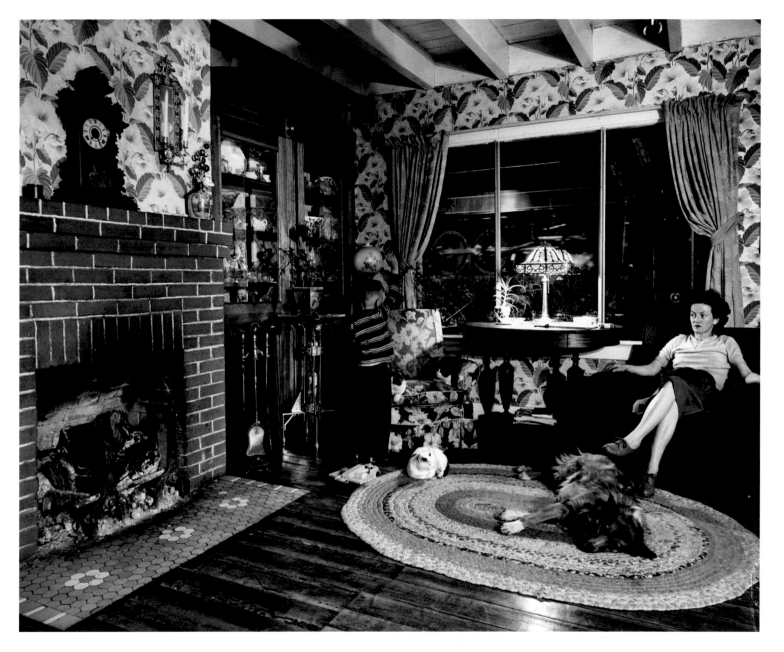

PLATE 93 O. Winston Link (American, 1914–2001). *Fringer's Living Room and View*. Negative: December 16, 1955; print: 1976. Gelatin silver print, 27.4 × 24.2 cm (10¾ × 13½ in.). The Museum of Modern Art, New York. Purchase. Digital image. Copyright 2003 The Museum of Modern Art, New York.

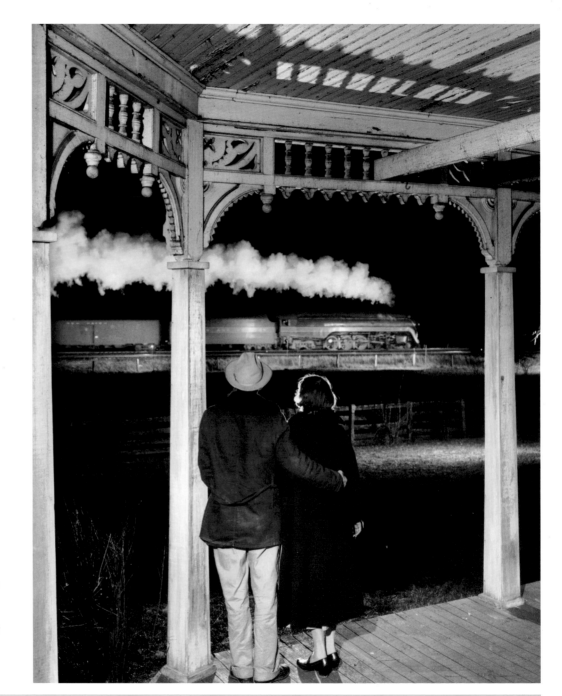

PLATE 94 O. Winston Link (American,
1914–2001). *Last Steam Locomotive Run on Norfolk
and Western, Radford Division, December 31, 1957.*
Negative: 1957; print: 1976. Gelatin silver print,
34.2 × 27.5 cm (13½ × 10¹³⁄₁₆ in.). The Museum of
Modern Art, New York. Purchase. Digital image.
Copyright 2003 The Museum of Modern Art,
New York.

PLATE 95 Walker Evans
(American, 1903–1975).
*Railroad Crossing Sign, New
England*, ca. 1960s. Gelatin
silver print, 24.3 × 24.8 cm
(9⁹⁄₁₆ × 9¾ in.). Los Angeles,
J. Paul Getty Museum,
95.XM.45.96.

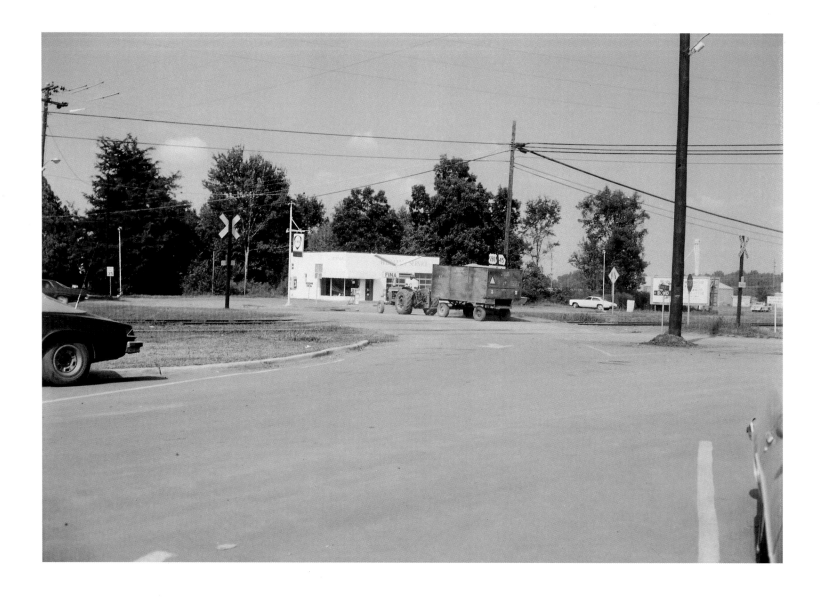

PLATE 96 William Eggleston (American, b. 1939). *Plains*, 1976. From *Election Eve*, vol. 2 (New York: Caldecot Chubb, 1977).
Chromogenic print, 26 × 38.7 cm (10¼ × 15¼ in.). Los Angeles, J. Paul Getty Museum, 98.XB.231.2.18. Gift of Caldecot Chubb.

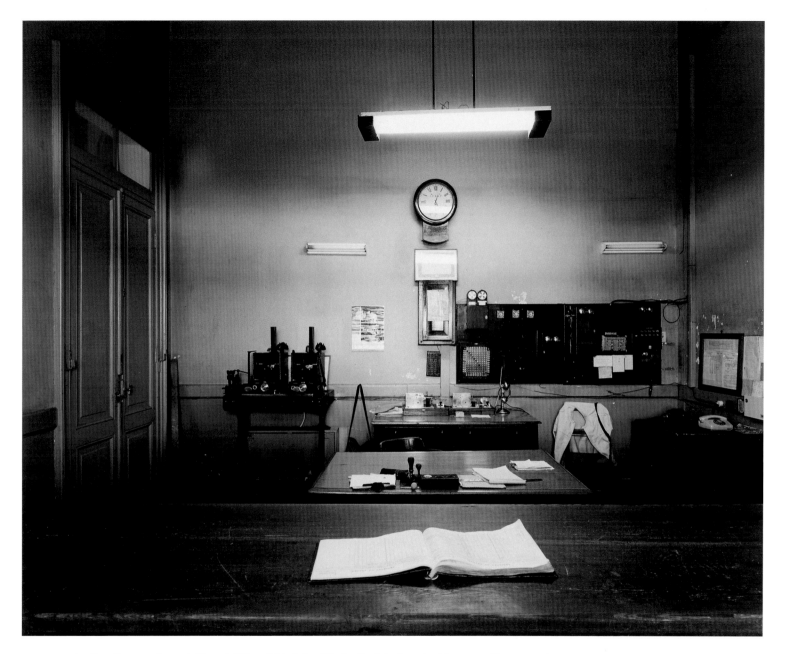

PLATE 97 Jim Dow (American, b. 1942). *Telegraph Office at Main Railroad Station, San Luis, Argentina.* Negative: 1988; print: 1996.
Chromogenic print, 50.8 × 60.9 cm (20 × 24 in.). Los Angeles, J. Paul Getty Museum, 98.xm.207.22. Gift of Nancy and Bruce Berman.

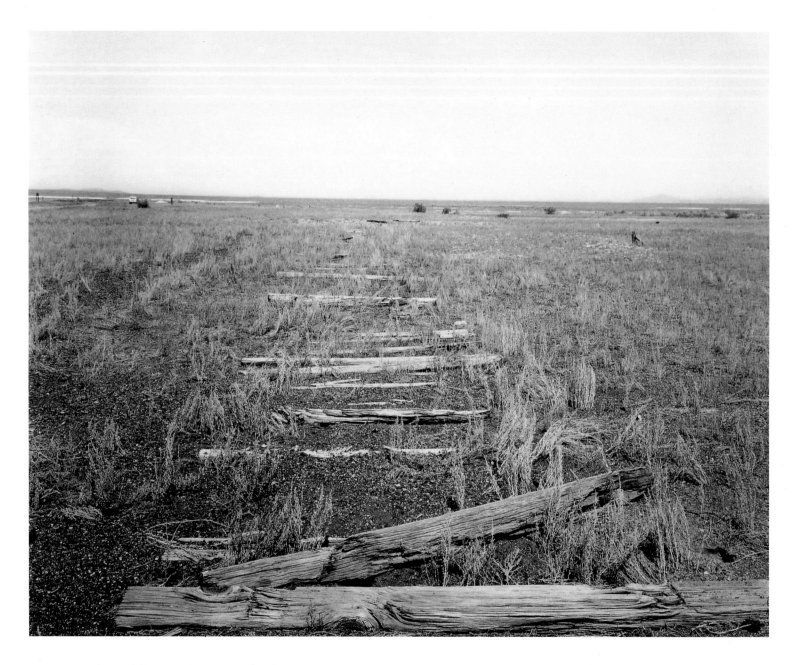

PLATE 98 Mark Ruwedel (American, b. 1954). *Central Pacific #51*, 1995. Gelatin silver print, 19.1 × 24.1 cm
(7½ × 9½ in.). Michael and Sharon Blasgen Collection.

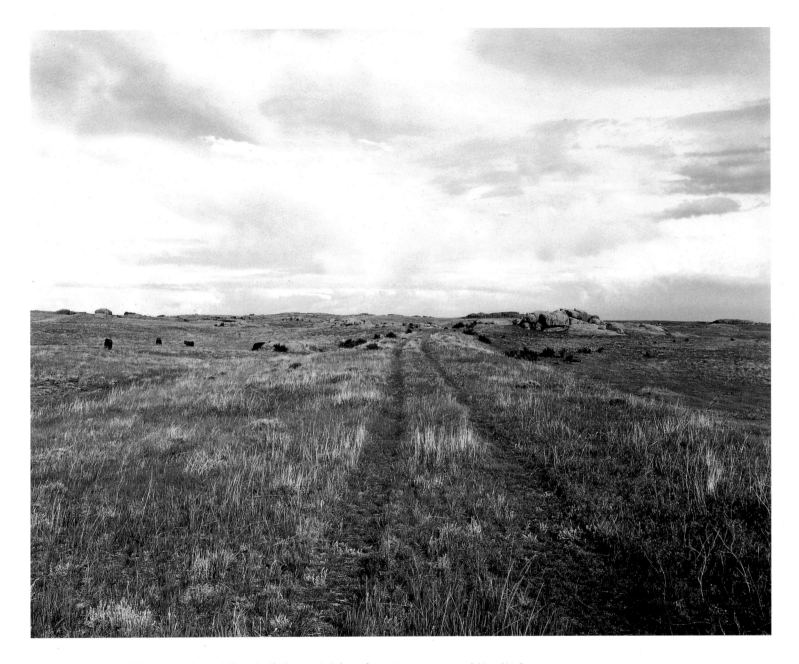

PLATE 99 Mark Ruwedel (American, b. 1954). *Union Pacific #20*, 1996. Gelatin silver print, 19.1 × 24.1 cm (7½ × 9½ in.).
Michael and Sharon Blasgen Collection.

PLATE 100 Mark Ruwedel (American, b. 1954). *Canadian Pacific #3*, 2000.
Gelatin silver print, 19.1 × 24.1 cm (7½ × 9½ in.). Michael and Sharon Blasgen Collection.

Notes

1. "[L]a vision ferroviaire, à l'instar de la captation photographique, n'est pas seulement instantanée, elle est aussi fragmentée et focalisée." Clément Chéroux, "Vues du train: Vision et mobilité au XIXe siècle," *Études photographiques* no. 1 (November 1996) (Paris: Société Française de Photographie), 76.

2. Douglas R. Nickel, *Carleton Watkins: The Art of Perception* (San Francisco and New York: San Francisco Museum of Modern Art and Harry N. Abrams, Inc., 1999), 31.

3. *Quarterly Review* 31, no. 62 (1825), 361.

4. Fanny Kemble as quoted in Cyril Bruyn Andrews, *The Railway Age* (New York: Macmillan Company, 1938), 31.

5. "The abandonment of animal power in favor of steam is experienced as the loss of sensorially perceptible animal power/exhaustion, i.e., as the loss of the sense of space and motion that was based on it. As the natural irregularities of the terrain that were perceptible on the old roads are replaced by the sharp linearity of the railroad, the traveler feels that he has lost contact with the landscape, experiencing this most directly when going through a tunnel." Wolfgang Schivelbusch, *The Railway Journey: Trains and Travel in the Nineteenth Century*, trans. by Anselm Hollo (New York: Urizen Books, 1979), 25.

6. In a letter of August 26, 1830, Fanny Kemble describes engines as "curious little fire horses" and offers a detailed account of one: "two wheels, which are her feet, and are moved by bright steel legs called pistons...The reins, bit and bridle of this wonderful beast is a small steel handle, which applies or withdraws the steam from its legs or pistons." Quoted in Andrews (note 4), 30.

7. Henry Booth, from "Views of Liverpool and Manchester Railway" (1830), reprinted in Jack Simmons, *The Victorian Railway* (New York: Thames and Hudson, 1991), 213.

8. Louis-Jacques-Mandé Daguerre's photographic process was announced at the Académie des Sciences in Paris on January 7, 1839. This announcement prompted Englishman William Henry Fox Talbot to present his own photographic process at the Royal Institution in London later that month, on January 25.

9. Quoted in Beaumont Newhall, "Eighteen Thirty-nine: The Birth of Photography," in *Photography: Discovery and Invention* (Malibu, Calif.: J. Paul Getty Museum, 1990), 22.

10. *The Philadelphia Photographer* 3 (1866), 105.

11. "Voyager en chemin de fer ne fatigue pas, c'est un plaisir, un agrément.... on se sent rouler avec une doucer inconcevable, ou plutôt on ne se sent pas rouler. On voit fair devant soi les arbres, les maisons, les villages....tout cela passe! Passe...bien plus vite que dans une lanterne magique....et tout cela est véritable, vous n'êtes point le jouet de l'optique!...Le chemin de fer est la véritable lanterne magique de la nature." Paul de Kock, "Les chemins de fer" in *La grande ville: Nouveaux tableaux de Paris comique, critique, et philosophique* (Paris, 1842), 1:188, as quoted in Chéroux (note 1), 73. Translation by Gordon Baldwin.

12. Thomas Cook organized the first publicly advertised excursion train in England on July 5, 1841. He convinced the Midland Counties Railway Company to run a special train from Leicester to Loughborough for a temperance meeting. The arrangement became permanent three years later and from this date on, Cook entered into business with the railway company. By the early 1860s Cook no longer conducted personal tours but had become a travel agent for domestic and overseas excursions.

13. On April 2, 1857, Le Gray photographed the station at Sète as part of the inauguration of the Toulouse-Sète section of the Bordeaux-Sète railway. See Sylvie Aubenas, *Gustave Le Gray, 1820–1884* (Los Angeles: J. Paul Getty Museum, 2002), 333.

14. "Between 1850 and 1872 the federal government gave an empire of land to promoters who promised to build railroads across the sparsely settled territory of the West. While Congress dispensed over 100,000,000 acres of the public domain, state and local governments provided an additional $280,000,000 in cash or credit (about 30 percent of the total capitalization of railroads) in the decades preceding the Civil War." Robert William Fogel, *Railroad and American Economic Growth: Essays in Economic History* (Baltimore: Johns Hopkins University Press, 1964), 3.

15. Jim Wilke, personal correspondence, August 2002.

16. After Hart left the employ of the Central Pacific Railroad, his negatives and stock became the property of the company. In 1869 fellow photographer Carleton Watkins acquired more than three hundred of Hart's C.P.R.R. stereoscopic negatives, which he subsequently printed and published as his own.

17. John R. Stilgoe, "An Opening Between Trains" in John Van Horne, ed., *Traveling the Pennsylvania Railroad: The Photographs of William H. Rau* (Philadelphia: University of Pennsylvania Press in cooperation with The Library Company of Philadelphia, 2002), 43–51.

18. For a detailed discussion and analysis on Baldus's railroad albums, see Malcolm Daniel, *The Photographs of Édouard Baldus* (New York: The Metropolitan Museum of Art, 1994).

19. Robert L. Herbert, *Impressionism: Art, Leisure, and Parisian Society* (New Haven and London: Yale University Press, 1988), 25.

20. Ibid., 28.

21. Foreign Railways, Railway Register, St. Louis, 1884. The exchange rate of French francs to U.S. dollars is given as 1 fr. = $.19.

22. Eugène Flachat, *Les chemins de fer en 1862 et en 1863* (Paris: Hachette, 1863), 80, as quoted in Daniel (note 18), 86.

23. Susan Danly and Leo Marx, *The Railroad in the American Landscape, 1850–1950* (Wellesley, Mass.: Oxford University Press, 1981), 14.

24. Emanuel Gottlieb Leutze's *Westward the Course of Empire Takes Its Way* (1861) is now in the Smithsonian American Art Museum. Other artworks bearing this title include Andrew Melrose's painting *Westward the Star of Empire Takes Its Way—Near Council Bluffs, Iowa* (ca. 1865), now in the American Stanhope Hotel Collection, New York; and Fanny Palmer's colored lithograph *Across the Continent "Westward the Course of Empire Takes Its Way,"* now in the Museum of the City of New York and published by Currier and Ives in 1868.

25. Sidney Dillon, "The West and the Railroads," *North American Review* 152 (1891), 443, as cited in Fogel (note 14), 6.

26. With the introduction of the first intercity line in Britain, running from Manchester to Liverpool, the directors of the railway company issued a challenge for the fastest and most reliable locomotive to complete the seventy miles at an average speed of ten miles per hour. The competition was won by the steam engine Rocket, built by George Stephenson and his son Robert.

27. Thomas Carlyle, "Signs of the Times," *Edinburgh Review* 49 (1829).

28. Leo Marx, *The Machine in the Garden: Technology and the Pastoral Ideal* (New York: Oxford University Press, 1967), 176.

29. Charles Dickens, *Dombey and Son* (Chicago and New York: Belford, Clarke and Company, 1882), 273.

30. Michael Freeman provides one example of the dislocation caused by the Inner Circle of London's Underground, which basically consisted of the Metropolitan Railway and the Metropolitan District Railway Company, stating: "7½ miles of line sanctioned as 'The Inner Circle' in 1864 involved the removal of 234 buildings and interfered with almost 900." See M. Freeman, *Railways and the Victorian Imagination* (New Haven and London: Yale University Press, 1999), 132.

31. Neil Cossons et al., *Perspectives on Railway History and Interpretation* (New York: National Railway Museum, 1992).

32. Alan A. Jackson, *London's Metropolitan Railway* (North Ponfret, Vt.: David and Charles, 1986), 30 and 383.

33. Freeman (note 30), 70 .

34. Schivelbusch (note 5), 43–44.

35. *Quarterly Review* 63 (1839): 22.

36. Leo Marx states that the commonly used phrase "annihilation of space and time" actually derives from an obscure poem by Pope ("Ye Gods! Annihilate but space and time, / And make two lovers happy"). See Marx (note 28), 194.

37. Photographer Carleton Watkins was known to have special rail privileges. According to the late Peter Palmquist, a Boston newspaper described Watkins and artist Thomas Keith's traveling arrangements during their 1873–74 trip to Utah in the following terms: "They chartered two railroad cars...one of which contained horses, wagon, hay and feed, while the other was supplied with all the appointments requisite for domestic life." See Palmquist, *In Focus: Carleton Watkins* (Los Angeles: J. Paul Getty Museum, 1997), 54.

38. Quoted in Gerald Best, *Iron Horses to Promontory* (San Marino, Calif.: Goldenwest Books, 1969), 193.

39. William Henry Jackson, *Time Exposure* (New York: G. P. Putnam's Sons, 1940), 177.

40. "Moran became really interested in photography, and it was my good fortune to have him at my side during all that season to help me solve many problems of composition. While learning a little from me, he was constantly putting in far more than he took out." Ibid., 201. Moran and Jackson both worked on the Denver and Rio Grande Railroad in 1885. An 1892 trip on the Santa Fe Railroad to the Grand Canyon and Colorado Rockies saw the two men working alongside each other again. See Danly and Marx (note 23), 49.

41. See Peter B. Hales, *William Henry Jackson and the Transformation of the American Landscape* (Philadelphia: Temple University Press, 1988), 146.

42. Major Joseph Gladding Pangborn, as publicist for the Baltimore and Ohio Railroad, commissioned Jackson in 1892, then again in 1893, under the auspices of the World's Transportation Commission.

43. William H. Rau, "Railroad Photography," *American Journal of Photography: An Illustrated Monthly Devoted to Photography in Its Widest Sense* 18 (no. 208): 169.

44. Ibid.

45. John Coplans as quoted in Palmquist (note 37), 6.

46. It is estimated that Watkins made at least fifty-nine mammoth-plate negatives and more than one hundred stereographs while on this particular trip.

47. Freeman (note 30), 221–23.

48. Danly and Marx (note 23), 52.

49. Walker Evans, *Many Are Called* (Boston: Houghton Mifflin, 1966), 177.

50. O. Winston Link, *Ghost Trains: Railroad Photographs of the 1950s* (Norfolk, Va.: The Chrysler Museum, 1983), 45.

51. The Museum of Modern Art, New York, acquired from the photographer a gelatin-silver print (made in 1976) of *Hot Shot Eastbound, Iaeger* with the image of the plane tipped in to the photograph (acc. no. 272.76).

52. John R. Stilgoe, *Metropolitan Corridor: Railroads and the American Scene* (New Haven and London: Yale University Press, 1983), 89.

Notes to the Plates

Jim Wilke and Anne M. Lyden

PLATE 1

Unknown photographer, *Locomotion*, ca. 1870

Locomotion was designed and built by George and Robert Stephenson in 1825 at the Forth Street Engine Works, Newcastle, at a cost of £500. The engine was adapted from the stationary steam engines that were used for mining in the eighteenth century. It was the first steam locomotive to operate on the Stockton and Darlington Railway in the north of England and marked the beginning of the public passenger railway. After Locomotion was taken out of use, the engine and its tender were displayed as historic monuments on a plinth in the North Road Station, Darlington, as shown in this photograph from about 1870.

PLATE 2

William and Frederick Langenheim, *Niagara Falls, Summer View: Suspension Bridge and Falls in the Distance*, ca. 1855–56

"The Suspension Bridge is the greatest artificial curiosity in the United States. It is situated two miles and a half below the Falls, and its entire length is over 1,000 feet. Length of span between pillars, 800 feet; hight [sic] of pillars on New York side, 88 feet; hight of pillars on Canada side, 78 feet; hight of track above the river, 245 feet; aggregate number of wires, 14,560 feet; depth of anchor pits in rock, 20 to 35 feet; number of wire cables, 4—diameter of each, 10 inches; ultimate strength of cables, 12,000 tons; ultimate strength of cables and stays, 14,000 tons; weight of structure, 1,000 tons; width of Rail Road floor, 24 feet; length of upper cables, 1,261 feet; length of lower cables, 1,193 feet. The river is here 800 feet in width, with perpendicular banks of 325 feet. The hight of the bridge is 258 feet above water. It was constructed under the direction of Mr. John A. Roebling, at a cost of 400,000 dollars, and was first crossed by a locomotive on the 8th of March 1855. Below the railway track is a carriage and footway suspended, from which a very interesting view of the Falls and Whirlpool may be had." Text from Langenheim stereographs of the period.

PLATE 5

John Stuart, *Nielson Locomotive Engine (Caledonian Railway)*, 1870

Nielson and Company, Glasgow, Scotland, built this Caledonian Railway locomotive engine in 1870. It was a prime example of British railway engineering, with its low slab rail frame and rigid 2-4-0 wheel arrangement. British designs favored a simple, straight stack, smooth boiler, and rounded brass steam dome. Concealed sandboxes ahead of the forward-driving wheel housing contained sand to provide traction through pipes to the forward wheels.

PLATE 6

John Stuart, *Nielson Locomotive Engine (Cape Government Railway, South Africa)*, 1880

This Nielson and Company tank locomotive was based on an original American design by Henry Campbell of Philadelphia. Campbell invented the 4-4-0 wheel arrangement in 1836 for use on the rough track in Ohio and Pennsylvania. The flexibility of the lead truck allowed the engine to navigate curves without the risk of derailment. There was little need for such engines on the highly developed lines of Great Britain, but they were used on the colonial railroads of Africa and India. This particular engine, although built in Scotland, was ultimately destined for South Africa.

PLATE 7

Gustave Le Gray, *Pope Pius IX's Railroad Car*, 1859

By 1859, private cars such as this one were extremely popular for the transportation of Europe's nobility and royalty. This large and heavy car built for Pope Pius IX was an ostentatious example of such vehicles. Using the latest technology of the period, the car rode upon two four-wheeled trucks, or bogies, used plate glass for the windows, and had bumpers, chains, and coupling hooks made of polished metal. The extensive carving and ornamentation, from the papal coat of arms to the gilded angels, were entirely fitting for the pope's vehicle.

PLATE 8

Carleton Watkins, *Pullman Palace Sleeping Car (Interior)*, June 1869–July 1870

This Pullman Palace Sleeping Car was most likely traveling on the Central Pacific Railroad when Watkins made this cabinet card. The cars—some of which were given special names, such as Ogden, Wahsatch, and Summit—began transcontinental service in June 1869, only to be canceled the following July because of the lack of passengers and the Central Pacific's decision to favor their own Silver Palace Sleeping Cars.

PLATE 9

A. J. Russell, *Railroad Accident Caused by Rebels*, 1863–65

Two wrecked engines are the focus of this photograph by A. J. Russell. The United States Military Railroads locomotive Charles Minot was built by the New Jersey Locomotive and Machine Works of Paterson, New Jersey, in 1863; the second engine is unidentified. The salvage crews are attempting to pull the locomotives back up the embankment onto the track, but before doing so they have dismantled parts of the engines (for example, removing the connecting rods from the driving wheels).

PLATE 10

A. J. Russell, *Remains of Wreck on the Track*, 1863–65

In this Russell photograph, two wrecked engines are already on the track and prepared for towing to the United States Military Railroads shops in Alexandria, Virginia, for repair. It was common practice to rebuild wrecked engines during the Civil War, and both of the locomotives in this Russell print would later return to service.

PLATE 11

A. J. Russell, *Rails of the Manassas Gap Railroad, Alexandria, Virginia,* about January 1865

Between 1862 and 1865, the United States Military Railroads purchased 21,738 tons of rail from British and American mills. This particular print shows a collection of iron rails or "metal treasure" stored at the U.S.M.R.R. yard at Alexandria, Virginia. The rails were essential for planning and executing wartime military strategies.

PLATE 12

A. J. Russell, *Wyoming Station, Engine 23 on Main Track*, May 1868

Built by the Schenectady Locomotive Works in March 1867, Union Pacific Engine No. 23 is proudly portrayed in this Russell print. The locomotive—which bears the Schenectady trademark of the British-style smooth brass steam dome (clearly visible in the photograph)—had 60-inch drivers and 16 × 24-inch cylinders and weighed 68,600 pounds in working order. The engine was equipped with a diamond stack, a type developed in 1859 for coal-burning locomotives by master mechanic George Griggs. Before 1880 it was common practice to assign one crew to a specific engine, for which they were responsible, even when the engine was not in service. This all-round responsibility resulted in a feeling of ownership for many of the crews, and it was not uncommon to see the locomotives personalized, as can be seen here with the addition of the antlers.

The entire crew can be seen in this photograph. The engineer stands at the front of the engine, next to the polished brass cylinders, and carries a large oilcan. His job included keeping the engine clean, well oiled, and on schedule, the latter responsibility indicated by the large watch and chain hanging from his trousers. Seated in the cab, the fireman was responsible for maintaining enough steam to run Engine No. 23. He was also in charge of polishing the upper works of the engine: the brass steam dome, handrails and bell, the brass cylinders, and the Russia iron boiler jacket. The conductor—standing between the engine cab and the tender—acted as "captain" of the engine. The brakemen stand by the tender—any closer to the engine and they would essentially be trespassing on what was deemed the engine crew's territory. The last member of the crew, the dog, is visible on top of the tender. According to several contemporary sources, dogs were remarkably adept at staying on moving engines.

PLATE 13

Alfred A. Hart, *Scene near Deeth — Mount Halleck in Distance*, April–May 1869
The Central Pacific's Leviathan No. 63 was built by the Schenectady Locomotive Works of Schenectady, New York, in October 1868 and was then shipped around Cape Horn before beginning service in Nevada in April 1869. Painted dark blue and deep crimson, with gold-leaf ornamentation, it was one of four locomotives assigned to the Central Pacific Wadsworth Division in Nevada. The other three engines, numbering 60 through 62, were Jupiter, Storm, and Whirlwind (the last two being attributes of the Roman deity). Hart photographed all four engines around the time that the transcontinental railroad was completed in May 1869.

PLATE 15

Alfred A. Hart, *American River, from Green Bluffs*, ca. 1867
This locomotive is most likely the Central Pacific Auburn No. 22 (also shown in PLATE 20), making its way across the High Sierra Nevada with the American River some two thousand feet below. The excursion train has stopped before an excavated curve, and it would appear that several passengers are taking advantage of the awe-inspiring view from the bluffs. Construction and excursion trains ran only during the daylight hours as the locomotives did not yet have headlights. In fact, no night trains were operated on the Central Pacific Railroad until the tracks crossed the Sierra Nevada.

PLATE 16

Alfred A. Hart, *First Construction Train Passing the Palisades, Ten Mile Cañon*, December 1868–January 1869
The Central Pacific Railroad reached the Palisades, situated 437 miles east of Sacramento, about December 1868. This stereograph by Hart shows the newly laid, unballasted track with a construction train heading east. The engine was built by the Mason Machine Works of Taunton, Massachusetts, and could possibly be the Arctic No. 11 or Sacramento No. 168: they were the only Mason locomotives with distinctive bell stands to run on the Central Pacific Railroad.

PLATE 17

Alfred A. Hart, *Bloomer Cut near Auburn, 800 Feet Long and 63 Feet High*, 1866–69
Bloomer Cut was situated between the towns of Auburn and Newcastle on the Central Pacific Railroad. In this stereograph, the locomotive Arctic No. 11 pulls an eastbound construction train. Arctic was built by the Mason Machine Works of Taunton, Massachusetts, in September 1865 and began running on June 15, 1866.

PLATE 18

Alfred A. Hart, *Bloomer Cut, 63 Feet High, Looking West*, 1866–69
Bloomer Cut, on the Central Pacific Railroad, was excavated by hand by the immigrant Chinese laborers employed by the company during the building of the transcontinental railroad. As the railroad made its way through the Sierra foothills, it became necessary to construct long cuttings and fills, some over a thousand feet long and on average forty feet high. Mountain construction was extremely expensive, but the Central Pacific was able to increase its federal subsidies by falsifying a surveyor's report and so extend the Sierra Nevada several miles westward toward Sacramento.

PLATE 19

Alfred A. Hart, *Rounding Cape Horn: Road to Iowa Hill from the River in the Distance*, 1866–69
It is possible that the locomotive shown in this stereograph is either Truckee No. 12 or Owyhee No. 16. Both engines were heavy "ten-wheelers" (4-6-0 wheel arrangement), built by the Mason Machine Works of Taunton, Massachusetts, in November 1865 and February 1866 respectively. In order to reach California, the engines were shipped around Cape Horn at the tip of South America — a journey that lasted several months. From Hart's vantage point one has a clear view of the Radley and Hunter patented smokestack, which eliminated sparks using centrifugal force and perforated baffles.

PLATE 20

Alfred A. Hart, *View of the Forks of the American River, Three Miles above Alta,* between August 1867–1869

This stereograph by Hart shows the Central Pacific Auburn No. 22, built by the McKay and Aldus Works of Boston, Massachusetts, in August 1866 and in service by August 1867. The heavy locomotive was known as a "ten-wheeler" for its 4-6-0 wheel arrangement—six driving wheels were necessary for traction on the steep grades of the Sierra Nevada. As was typical of all Central Pacific engines until the 1870s, the Auburn was a wood-burning locomotive with a large balloon stack and protective spark net, clearly visible in the print.

PLATE 21

Alfred A. Hart, *Last Rail Laid at Promontory Point, May 10th 1869,* 1869

Sitting atop the Central Pacific locomotive, Jupiter, Hart looks eastward to the Union Pacific No. 119, a coal-burning, 4-4-0 engine built in the Renaissance Revival style by the Rogers Locomotive and Machine Works of Paterson, New Jersey. There were five identical engines including No. 119 allocated to the Utah Division of the Union Pacific. In the distance, at the far right, another train is visible on the Union Pacific spur, a piece of track that ran past the official end of the railroad by about a quarter mile. The actual ceremony took place on the Central Pacific track, clearly visible in Hart's image and identifiable from its neatly hewn ties (as opposed to the rough axed ties of the Union Pacific).

PLATE 22

William Henry Jackson, *Big Tree Station, Santa Cruz,* 1880

The South Pacific Coast Railroad was chartered in March 1876, running from Oakland through San Jose and the coast range mountains to Santa Cruz. The completion of the railroad on May 15, 1880, was celebrated with a special excursion train to Big Trees. The grove of giant sequoias became a popular tourist and picnic spot. In this photograph the main line is shown with a passing siding to the left. The switch stand to the right signals an "all-clear" to passing trains on the main track. Initially the line was narrow gauge (measuring 3 feet across) but was converted to standard gauge (4 feet 8½ inches across) between 1906 and 1908 by the Southern Pacific Railroad (which had acquired the line in 1887).

PLATE 23

Alexander Gardner, *Across the Continent on the Union Pacific Railway E[astern] D[ivision],* 1867

This photograph shows an inspection train for the Union Pacific Railway, Eastern Division, railroad contractors. In the front, a wood-burning locomotive pulls a baggage car, a coach or sleeper car, and a private office car of Shoemaker, Miller, and Co., contractors to the U.P.E.D. The office car likely dates from around 1865, with its monitor-type clerestory, which was prevalent between 1863 and 1866. The passenger coach has a "duckbill" roof, popular from 1866 through 1875. The Union Pacific Railway, Eastern Division, was founded by John C. Fremont and Samuel Hallet (a railroad investment banker) in May 1863. It was originally intended as a competitor of the Union Pacific Railroad in the race to build the transcontinental line. Unfortunately, though, Fremont was forced out of the company and Hallet was murdered. In March 1869 the company changed its name to become the Kansas Pacific Railway Company.

PLATE 25

Hippolyte-Auguste Collard, *Line from Villeneuve-Saint-Georges to Montargis / Viaduct on the Loing (near Montargis),* December 1866

This coal-burning 0-6-0 freight locomotive paused long enough for Collard to make this photograph of the completed bridge in use. The four-wheel tender bears a brass identification plate, a style common on French railways. The engine pulls a train of at least six four-wheel open-hopper cars.

PLATE 27

Hippolyte-Auguste Collard, *Roundhouse for Thirty-two Locomotives at Nevers on the Bourbonnais Railway,* ca. 1860–63

This roundhouse of the Bourbonnais Railway may be newly built: there are no smoke stains visible on the walls or ceiling, the floor is free from oil drips, and there appear to be no signs of tools or workbenches—common clutter found in working roundhouses. Instead, the space is filled with six 0-6-0 coal-burning freight locomotives, standing to orderly attention in their individual stalls. A "smoke jack," or exhaust funnel, is above each locomotive's smokestack.

PLATE 32

Alexander Gardner, *"Westward the Course of Empire Takes Its Way,"* October 19, 1867

In this photograph the construction crew is busy at work laying tracks six hundred miles west of St. Louis, Missouri, for the Union Pacific Railway, Eastern Division. Setting his camera far enough back to capture the entire construction scene, Gardner shows the roadbed already graded and with dirt from the ditches on either side, piled up to make drainage. The men at the front of the line are laying ties, while behind them men are driving spikes and securing the iron tracks. The engine is a wood-burning locomotive, built by the Rogers Locomotive and Machine Works of Paterson, New Jersey, one of thirteen Rogers engines on the line in 1867.

The construction crew operated under Robert M. Shoemaker, whose company, Shoemaker, Miller, and Co., was the main contractor for the U.P.E.D. Shoemaker favored naming engines after Native American nations. The Rogers locomotive shown here might be the Mohawk, Sac, Miami, Osage, Seminole, Pawnee, or Comanche. Engines from the Baldwin Locomotive Works in Philadelphia bore the names Arapahoe, Otoe, Wea, Navajo, and Shawnee. In 1867, the year this photograph was made, thirty-five U.P.E.D. construction workers were killed during Cheyenne raids; in a separate incident Kaw warriors surrounded a U.P.E.D. roundhouse where the inhabitants of a town were seeking shelter.

PLATE 35

Carleton Watkins, *View on Lake Tahoe,* 1877

The four track levels of the narrow-gauge Carson and Tahoe Lumber and Fluming Company Railroad are shown in this large photograph by Carleton Watkins. Built in 1875 on the eastern side of Lake Tahoe, the railroad operated between Glenbrook and Summit, near Carson City, Nevada. Visible in this print are the cuts, fills, and trestles required for the path of the railroad. Also shown is the "Z" track, which was used to increase or decrease elevation within restricted spaces, such as the steep slopes of the Sierra Nevada. The two lumber trains are both pulled by 2-6-0 "mogul" locomotives built in 1875 by the Baldwin Locomotive Works of Philadelphia. The Carson and Tahoe Lumber and Fluming Company was an industrial supply line carrying lumber for use in the silver mines of Virginia City, in addition to use for construction and the railroad. With the decline of silver mining in the 1880s, the replacement of wood by coal as the preferred railroad fuel, and the gradual decimation of the tree-lined slopes, the railroad was finally abandoned in 1898.

PLATE 36

William Henry Jackson, *Marshall Pass—Westside,* 1882–96

This Denver and Rio Grande locomotive is a narrow-gauge 2-8-0 consolidation-type engine built by the Baldwin Locomotive Works of Philadelphia. It is unclear if this engine is No. 265, built in August 1881, or No. 285, built in January 1882, but both were used by the D&RG, which favored the engine because of its ability to scale steep grades. Because of the extreme height of Marshall Pass (one can see in the print the long lengths of railroad track necessary to ascend the 10,856-foot summit), the train had to be short, consisting of five boxcars and a caboose. On top of the cars stand three brakemen and, most likely, the conductor, who is visible in the white shirt at the rear.

The narrow-gauge rail was originally intended to connect Denver with the Rio Grande in order to trade with New Mexico; however, it began to branch out to the Colorado mining districts and ended up connecting to the transcontinental main line at Salt Lake City. The Denver and Rio Grande was one of the first narrow-gauge lines, and the longest lived: the first train ran in 1871, and in 1997 the company was taken over by the Union Pacific network.

PLATE 37

William Henry Jackson, *"The Loop" near Georgetown, Colorado*, 1884–96

"The Loop" of the Georgetown, Breckenridge, and Leadville Railway was built in January 1884 and soon became a popular tourist destination. The GB&L Railway was part of the Union Pacific Railroad and connected railroad facilities in Georgetown with various mining camps on the other side of the Loveland Pass, through Clear Creek Canyon. The locomotives travel from the lower right side of the image, under the bridge, making their way across the canyon and back to pass over Clear Creek on the three-hundred-foot "High Bridge." "The Loop" afforded the engines a means of scaling the steep canyon by gaining 638 feet of elevation within a space of two miles. Without the curving series of double-horseshoes to create a loop the locomotives would have had the impossible task of climbing three hundred feet to the mile.

PLATE 38

Carleton Watkins, *View of "Loop," Tehachapi Pass on the Line of the Southern Pacific Railroad*, ca. 1876

Built in 1876, the Tehachapi Loop provided railroad access through the Tehachapi Mountains in California. Designed by William Hood, a railroad engineer, the loop offered a means of ascending the 4,000-foot Tehachapi Summit by using 3,788 feet of tracks to circle around the landscape, climbing at a constant 2.2% grade.

PLATE 39

John Wheeley Gough Gutch, *South Devon Railway, Dawlish*, 1856–57

"Dawlish is a pretty, bright and sunny place, and quite worth a visit; the red sandstone cliffs, which are pierced above by thousands of rabbits, and the sand-martin, and below by the railway tunnels of the South Devon Coast Railway, standing out in bold relief, and the wash of the sea, forming most picturesque headlands, and isolated rocks in every direction, and all coming out well, in any picture that I took." From "Recollections and Jottings of a Photographic Tour, Undertaken during the Years 1856–7, by J. W. Gutch, M.R.C.S.L." in *The Photographic and Fine Art Journal*, July 1858.

PLATE 43–44

Photophane Company, *Cantilevers Complete, July 9, 1889; Interior of Approach Viaduct*, 1889

"The Public interest which is naturally taken in Engineering Works, is always in proportion to the magnitude and novelty of the undertaking; and as such work is generally more or less of a public character, and always regarded as subservient to public utility, the completion of the FORTH BRIDGE, which may be considered as a national achievement of Engineering skill, cannot fail to attract an enormous amount of attention, not only in this country, but throughout the world." Philip Phillips, 1889.

PLATE 52

William Henry Jackson, *Marshall Pass, Colorado*, negative: 1880s; print: ca. 1914

As the only American company to license the "photochrom process," the Detroit Publishing Company hailed it as "the only successful means yet known of producing directly a photograph in the color of nature." William Henry Jackson, a partner in the company, was a pioneer of the process and worked with a Swiss scientist to bring it to America. A combination of photographic and lithographic techniques, the photochrom process involved using a series of stones for each color in the individual print. It is still not known how the color was actually applied to the prints.

PLATE 53
William Henry Jackson, *Cañon of the Rio Las Animas*, 1882–86
The Denver and Rio Grande Railroad Silverton Branch ran from Durango to the mining town of Silverton in Colorado. Running parallel to the Rio Las Animas for most of the way, the line was hailed as a magnificent engineering achievement. The railroad literally blasted through the solid rock, several hundred feet above the water, to create a right-of-way. Jackson extolled the technological feat by adopting a low viewpoint, emphasizing the grand scale of the cliff face, with the diamond-stacked Baldwin 4-4-0 engine precariously perched on the narrow ledge high above.

PLATE 54
William Henry Jackson, *The Royal Gorge. Grand Cañon of the Arkansas*, 1882–86
The Royal Gorge, Grand Canyon of the Arkansas, part of the Denver and Rio Grande Railroad, was the scene of the "Battle of the Royal Gorge" in 1878. The D&RG and its rival, the Atchison, Topeka, and Santa Fe, engaged in a bitter feud, with armed construction workers attempting to secure ownership of the line. However, because of financial difficulties the D&RG subsequently leased the line to the AT&SF, despite the "turf war" earlier in the year. When it was discovered that the line would be used as leverage in a rate war with the Union Pacific Railroad, the D&RG sought to take back control of the line. During all of this turmoil, railroad entrepreneur Jay Gould—famous for saying "I don't build railroads, I buy them"—purchased controlling interest in D&RG stock and subsequently was able to bring about an agreement between the D&RG, AT&SF, and Union Pacific. In what was known as the "Treaty of Boston," all three railroads agreed to stay out of each other's way for ten years. With its financial situation improved, the D&RG took control of the Royal Gorge once more.

The Royal Gorge was an important location, providing access to southwestern markets and developments, yet the site was physically challenging for a railroad route. The narrow passage between two large cliff faces required special consideration when it came to the construction of the bridge. With the risk of the pilings washing away during the seasonal floods, the suspension bridge was supported from above rather than below.

PLATE 55
William Henry Jackson, *Dale Creek Bridge, U.P.R.R.*, 1887–93
Located near the summit of Sherman Hill in Wyoming, on the western slope of the Black Hills, Dale Creek Bridge was about seven hundred feet long—the longest trestle on the Union Pacific Railroad. The first bridge on the site was a Howe truss and double-bent timber structure from 1868. Built upon solid rock and made of pine, the bridge required guy wires for extra support against strong winds and heavy trains (see fig. 24). The second structure was an iron bridge built in 1876. It was known as the "spiderweb" for its extremely light, weblike structure. The last bridge, shown here, was built in 1885. Constructed of iron girder spans built upon the same trestlework and foundations, the bridge remained in position until 1901.

Jackson's photograph shows a Union Pacific transcontinental express train crossing the bridge, some 130 feet above the Dale Creek. The lead locomotive is No. 1277, a 2-8-0 "consolidation" engine built in 1883 by the Cooke Locomotive and Machine Works of Paterson, New Jersey. Behind the heavy lead engine is No. 766, a regular passenger engine that was one of ten identical locomotives built in October–November 1887 by the Rogers Locomotive and Machine Works, also of Paterson. These engines were designed by Clement Hackney, the Union Pacific Superintendent of Motive Power, and intended to burn slack coal. The design was unsuccessful and the ten locomotives were rebuilt with conventional boilers, most likely between 1887 and 1893. No. 766 was an anthracite-burning type with a "camelback" or "mother hubbard" cab placed directly over the boiler. Anthracite and slack coal required a wide firebox (visible directly behind the cab), and it

was unusual to find such engines in the west, as most of the Union Pacific locomotives used soft bituminous coal from Wyoming or Utah.

The first car of the long train is a mail car, used by United States Post Office clerks to sort mail en route. A hook for grabbing mail sacks while the train was in motion is visible at the front door. Two baggage cars follow behind the mail car, and the train of coaches probably included a Pullman sleeping car and perhaps a dining car.

PLATE 56
William Henry Jackson, *Cameron's Cone from "Tunnel 4,"* 1887–89
This photograph shows the newly built line of the Colorado Midland Railway. Although the line was organized in 1883, construction did not commence until 1886; on July 13, 1887, the first train ran from Colorado Springs to Buena Vista. The C.M.R. was the first standard-gauge (tracks measuring 4 feet 8½ inches across) railroad to cross the Rocky Mountains. To do so required 17 tunnels and 10 snow sheds 2,000 feet long to shelter the tracks from snowfall. The tunnels on the line were sequentially numbered from Colorado Springs, suggesting that this traveling party photographed by Jackson was just beginning its outing.

PLATE 57
William Henry Jackson, *Old Aqueduct at Querétaro, Mexico,* 1886
This passenger train of the Ferrocariles Centrales México, or Central Mexican Railroad, was photographed by Jackson beneath a Spanish aqueduct at Querétaro, capital of Querétaro State, Mexico. The No. 18 locomotive is a standard American 4-4-0 type built by the Taunton Locomotive Works of Taunton, Massachusetts, in 1881. Although equipped with a diamond stack for burning coal, the engine's tender is full of poor-quality wood. A hose is wrapped around the front number plate, possibly connected to the engine's water supply for dousing sparks.

The F.C.C.M. was incorporated in 1880 under the General Railroad Laws of Massachusetts, with construction beginning in the same year, and by 1882 the railroad reached Querétaro. During the nineteenth century, the majority of Mexican railroads were connected to or run by American and European companies. Such examples include the Imperial Mexican Railway Company Ltd., which was organized in 1864 by British interests, using locomotives from Dubbs and Company of Scotland, while the Sud Pacífico de México was an extension of the Californian Southern Pacific Railroad.

PLATE 59
William H. Rau, *On the Conemaugh near New Florence, Pennsylvania,* 1891–95
In this photograph the Main Line of the Pennsylvania Railroad is shown near New Florence, along the western slope of the Alleghenies on the Conemaugh River in western Pennsylvania. Earlier, in May 1889, a dam had burst after days of heavy rainfall, leading to the tragedy of the Johnstown flood, which killed many people. Both the towns of Johnstown and Florence were destroyed by the deluge, which wiped out ten miles of P.R.R. track, catching several complete trains in its path. The "New" Florence referred to in the title of this photograph was built after the flood, when the tracks were rebuilt.

PLATE 60
William H. Rau, *Main Line and Low Grade Tracks at Parkesburg,* 1891–95
Known as the "Standard Line of the World," the Pennsylvania Railroad was constructed between 1848 and 1853. Running through the Conemaugh River Valley from Harrisburg to Pittsburgh, the line was the first all-rail line between the Ohio River Valley and the Philadelphia seaports. The Low Grade tracks were used for slower, usually freight traffic, while the elevated Main Line was reserved for express and passenger trains.

PLATE 65
Carleton Watkins, *The Ferryboat "Solano,"* after 1879
Berthed at Port Costa, California, the ferryboat Solano is shown loading passenger trains for the trip across the bay to Benicia on the Carquenez Straits. The Solano was built at the Central Pacific Railroad yards in West Oakland in 1879, partly from salvage components of the Sacramento River steamer Chrysopolis (the "Golden City" of San Francisco), which previously sailed from Sacramento to the city for which it was named. At the time of its completion the Solano was the largest ferry in the world: 424 feet long, 64 feet wide, and capable of carrying 36 freight cars or 24 passenger cars, plus locomotives on four tracks.

Two walking-beam engines (having a vertical piston connected to an overhead beam, transferring the motion to the paddle-wheel shafts) propelled 30-foot paddle wheels, which moved independently for greater maneuverability. Pratt trusses to prevent "hogging," or sagging, under the 8,500-ton load stiffened the wooden vessel. These are visible in the photograph as the poles with heavy cables across the length and width of the hull. Eight boilers paired up under four stacks supplied the necessary steam. The ferry was steered from a pilot house upon an elevated platform at each end, with Greek Revival railings. The Solano ran from 1879 to 1930, at which time the Martínez-Benícia railroad bridge allowed for an unbroken rail link into Oakland.

PLATE 67
Carleton Watkins, *The Devil's Slide, Utah,* 1873–74

Against the dramatic rock formation of the Devil's Slide, Watkins photographed a Union Pacific passenger train thirteen miles east of Ogden, Utah. The locomotive is one of several built for the Union Pacific in 1867–68 by the Rogers Locomotive and Machine Works of Paterson, New Jersey. The engine and its tender had been repainted (the tender originally had an ornate Renaissance Revival medallion with the engine number on it, surrounded by scrollwork) and a Union Pacific diamond stack was fitted on. On the front of the locomotive a rock guard was placed on the cowcatcher to force snow and debris off the tracks. The stationary engine continued to build up steam, but an automatic safety valve released the excess steam from the polished brass dome and in so doing prevented a boiler failure.

PLATE 70
Carleton Watkins, *Cape Horn, near Celilo,* ca. 1867

The Oregon Steam Navigation Company opened a line between Celilo and the Dalles in April 1863 as part of a portage railway system that transported passengers and freight between navigable portions of the Columbia River. By offering both steamboat and railroad service, the O.S.N. created a unified transportation system. As early as 1851, wooden tram roads were in operation on sections of the line at the Cascades; when the O.S.N. took control of the line, steam power was introduced on five-foot gauge tracks. Four locomotives were imported by sea in 1863–64 from Danforth, Cooke, and Company of Paterson, New Jersey, to run on the line. The route later became part of the Oregon Railway and Navigation Company, which subsequently was taken over by the Union Pacific Railroad.

PLATE 82
Else Thalemann, *Lokomotivendetail (Locomotive Detail),* ca. 1926

This is a detail of the driving wheels of a freight locomotive belonging to the Deutsches Reichesbahn, or German State Railway. The name *Borsig* stamped into the wheel refers to the Borsig Locomotive Works of Berlin, a major manufacturer of railway locomotives and equipment. The Deutsches Reichesbahn was a government-run railroad founded in 1922.

PLATE 84
Charles Sheeler, *Wheels,* 1939

In this photograph of a New York Central J3a class 4-6-4 Hudson locomotive, Sheeler has concentrated on the lead truck, cylinders, valve gear, and driving wheels. The driving wheels are of the disc type rather than the traditional spoked version. The style was introduced in the 1930s and was marked by small oval or round holes within the disc; on this engine the round hole type is known as a Scullen disc. The J3a class Hudson locomotive was one of the best passenger engines in America, and it was used to transport the 20th Century Limited between New York and Chicago, a journey that took only sixteen hours by 1939. The industrial designer Henry Dreyfus created a new streamlined casing for the engine boilers, which resembled a sleek gray bullet. The workings of the engine were left open to view and the drivers were painted a pale, ghost gray color; in this way the beauty of the machine was accentuated and highlighted. Dreyfus had the lights specially rigged to illuminate the wheels at night.

Index

Note: Page numbers in **BOLDFACE** indicate photographs.